AN ARTIST'S HANDBOOK
MATERIALS AND TECHNIQUES

AN ARTIST'S HANDBOOK
MATERIALS ANDTECHNIQUES

MARGARET KRUG

Abrams Studio
Abrams, New York

Cover and frontispiece:
Photography by Pamelia Markwood

Book design: BLOK
Cover design: Sarah Gifford

Library of Congress Cataloging-in-Publication Data

Krug, Margaret Manning.
 An artist's handbook : materials and techniques / Margaret Manning Krug.
 p. cm.
 ISBN-13: 978-0-8109-9401-0 (pbk.)
 ISBN-10: 0-8109-9401-1
 1. Painting—Technique. 2. Drawing—Technique. I. Title.

 ND1500.K78 2007
 751.4—dc22
 2006038331

First published in 2007 by
Laurence King Publishing Ltd, London

First published in North America in 2007 by
Abrams, an imprint of Harry N. Abrams, Inc.

Printed and bound in China
10 9 8 7 6 5 4 3 2 1

HNA
harry n. abrams, inc.
a subsidiary of La Martinière Groupe
115 West 18th Street
New York, NY 10011
www.hnabooks.com

For John
and for my mother and father,
Helen and John

CONTENTS

Acknowledgments

I am most grateful to Pamelia Markwood, the photographer for the book, for going every step of the way with me. Her exquisite eye, fierce enthusiasm, optimism, love, and support were indispensable. Her acute observational skills as a painter brought the highest level of sensitivity to every aspect of the photography and have allowed the ideas (from minute to large) and concepts explored in the text to speak without words.

Many thanks also to Jerry L. Thompson for his careful photography of several key artworks in the book.

Thank you to Laurence King and Lee Ripley for their openness to and confidence in all my early thoughts, and for offering me this most valuable opportunity to share what I care so deeply about. I am so very grateful to Anne Townley and Donald Dinwiddie for being wonderful editors and lovely people to work with. Their careful support and constant attention to every aspect made this an incredible learning experience for me. Bob Alderette of the University of Southern California, Frank Bramblett of the Tyler School of Art, Temple University, Allison Neal of Herefordshire College of Art and Design, and Paul Croft of the University of Wales, Aberystwyth reviewed the manuscript and their comments and suggestions were immensely helpful and contributed to the shaping of the book. Many thanks also to Annabel Cary and Jamie Ambrose who copy-edited the manuscript, to the picture researcher Jenny Silkwood for her hours of hard work on my very extensive list of images and to Sam Wolfson of BLOK for her beautiful design. Thank you also to Eric Himmel, Sarah Gifford, and Aiah Wieder at Harry N. Abrams.

My deep appreciation goes to Dina Helal for her initial reading and editing of each chapter and for her enthusiastic support, her keen eye and intellect, her ready access for advice at any and every moment, her contributions as an artist, and most of all for her friendship.

Many thanks to all my friends at the Whitney Museum of American Art and in particular to my colleagues in the Education Department for their generosity, thoughtfulness, and understanding. I am especially grateful to Adam Weinberg, the Whitney's Director, for his support and encouragement, and to Anita Duquette, Rights and Reproductions Manager, for her advice and for doing everything possible to obtain images for the book.

I owe a great debt of gratitude to all my personal artist friends and to all my students who, over the years, have shared my interest in this subject and have contributed immeasurably to this text. A special thanks goes to my colleagues and students at Parsons School of Design where I have taught many of the drawing and painting courses that have informed the content of the book. I am particularly grateful to the artists and students who contributed their work for the images illustrating the processes and finished examples, and for their valuable input and ideas: Samanta Batra Mehta, Ledlie Borgerhoff, Suzanne Cole, Bruce Cook, Dionisio Cortes, Leticia Ortega Cortes, Jacqueline Edmundson, Medora Falkenberg, Alfredo Garzón, Lisa Libicki, Kevin McCarthy, Barbara McGavin, Elizabeth Mihaltse, Nicola Montemora, Doe Risko, Rhonda Shade, Barbara Sterling, Rachel Summers, Diane Teubner, Barbara Velasquez, and Efram Wolfe. I never cease to be amazed by what I learn from my students, artist friends, and colleagues. That is in part why this text or any other on this subject could never be a finite statement. The information and experience continues to evolve and change.

I am grateful to everyone at Castello di Spannocchia, where all the Italian studio illustrations were photographed for the book, and the Spannocchia Foundation for their endless supply of grace, beauty, kindness, and generosity.

Amongst all the people who have helped make this book possible is a group who have been there with advice, insight, and support at every important step in my career. So, thank you to, dear friend, Harold Bloom for his wisdom and advice. I am profoundly grateful to Frank Piatek and Robert Loescher from the School of the Art Institute of Chicago. The enormous inspiration and the opportunities they provided opened the way to the paths I chose to follow that led to the writing of this book. Thank you to Antonio Romano for teaching me fresco painting. Thank you also to Craig Neff for his invaluable knowledge, most generous support and encouragement on so many levels, his artistic contributions, and his friendship. And to Sydney Licht, a dear friend, who introduced me to Rebecca Shore and many thanks to Rebecca who suggested the project. I am very appreciative of Mary Pamelia Richardson Markwood Voris for all her love, support, encouragement, and invaluable assistance in organizing images.

Many thanks also to John Wickersham for his friendship and valuable advice, and Peter Herbert and John Charles Thomas who gave me careful and wise council. A huge thank you goes to Jack and Ann for their love and care from the very beginning.

And it is with pleasure that I recall my grandmother and mother who through their example of fiercely joyful involvement with making exquisitely beautiful objects just to share—ignited the fire in me to be constantly involved in creative endeavors.

Most of all thank you to John Krug, who, from the moment I met him has offered limitless support, bright, clear thinking, creativity, and unconditional love

PREFACE

"The creative gesture exercises a continuous influence over the inner life. The hand wrenches the sense of touch away from its merely receptive passivity and organizes it for experiment and action. It teaches man to conquer space, weight, density, and quantity. Because it fashions a new world, it leaves its imprint everywhere upon it. It struggles with the very substance it metamorphoses and with the very form it transfigures. Trainer of man, the hand multiplies him in space and in time."

Henri Foçillon (The Life of Forms in Art, 1992)

Artistic processes are not, in themselves, difficult, and this book was written to demonstrate exactly that. *Materials & Processes of Drawing and Painting: An Artist's Handbook* provides students with the information they need and encourages them to explore various materials used in drawing and painting, such as pencil, charcoal, ink, encaustic, egg tempera, and oil paint using a variety of techniques. More than two hundred images were created especially for this book by Pamelia Markwood and myself to illustrate each step. By understanding the options open to them, students build up their confidence and facility allowing them greater freedom to focus on artistic expression.

With the potentially endless variety of media available to the artist, the book encompasses a range of traditional, non-traditional, widely used, and lesser-known media. I also discuss the historical roots and contemporary application of these materials and processes, covering methods and providing technical suggestions in a direct and accessible way.

Learning is directly tied to the experience of art—the smell, the feel, and the touch. Although the book is not encyclopedic, each chapter provides the essential foundation on which the artist can build. To help stimulate an expansive, creative exploration, well-illustrated, step-by-step exercises have been devised to accompany each process. Furthermore, the book is abundantly illustrated with works from masters of each medium and quotations from these artists' revealing his or her own experiences. These provide important examples of what has been and can be done.

Materials & Processes of Drawing and Painting: An Artist's Handbook is a starting point. Designed to be used as a handbook in the studio and for instruction in the classroom, the text and images follow the actual processes taking place in the studio workshops, classes, and courses I teach.

Margaret Krug
New York, winter 2006

"Love alone makes me remember. It alone makes me alert"

Leonardo da Vinci

1
INTRODUCTION TO DRAWING MATERIALS AND PROCESSES

In this chapter, I will provide a definition of drawing and a brief overview of its qualities, function, and history. In Chapter 2, I will cover the basic drawing materials, and in Chapter 3, I will introduce a series of exercises that will explore the various media and promote an understanding of the methods and techniques through a hands-on experience. The process can then be taken forward in a more creative, experimental way, as students and artists can adapt and change the exercises to suit their needs. Once the materials and methods are more clearly understood, the process will come naturally and intuitively.

A deep exploration of works of art as historical documents is encouraged to achieve both an intellectual and a physical understanding of drawing, and to provide an insight into current art practice.

I will limit my brief discussion of drawing to that of the creative fine-art application. The boundaries have blurred between drawings and other art forms as we continue to expand and deepen our idea of what a drawing—and the process of drawing—can be. I regret that I will not be able to discuss prints in this book, although I do consider them to be drawings. Please see Further Reading for suggestions.

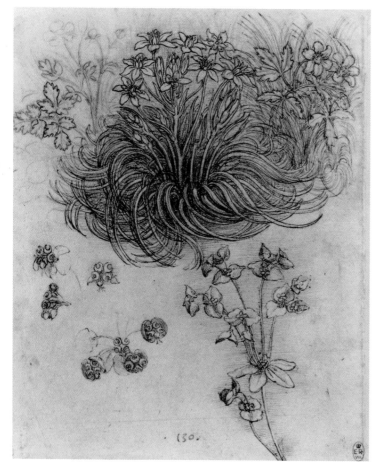

◀

Leonardo da Vinci
"Star of Bethlehem" and Other Plants
*c.*1504–08
Pen and ink and red chalk
7 ¹³⁄₁₆ x 5 ⅞ in (19.8 x 14.9 cm)
The Royal Collection,
Windsor Castle, Windsor

Leonardo considered all forms— including sea, land, trees, animals, grasses, and flowers—with acute observation.

WHAT IS DRAWING?

Drawing is learning to see. When we begin, we draw what we *think* we see. For instance, we may draw the trunk of a tree tilting diagonally, and are amazed when someone points out that the actual trunk is pointing straight up from the ground to the sky. We might say, "Why didn't I notice that?" As we look more closely, we begin to recognize shapes and relationships accurately; we engage with the subject and we begin to read and interpret the marks of the drawing itself, and we allow the subject and the marks of the drawing to guide us through the process. This is the beginning of drawing and learning to see.

> "For the artist, drawing is discovery. And that is not just a slick phrase; it is quite literally true. It is the actual act of drawing that forces the artist to look at the object in front of him, to dissect it in his mind's eye, and put it together again— or, if he is drawing from memory, that forces him to dredge his own mind, to discover the content of his own store of past observations. It is a platitude in the teaching of drawing that the heart of the matter lies in the specific process of looking. A line, an area of tone, is not really important because it records what you have seen, but because of what it will lead you on to see. Following up its logic in order to check its accuracy, you find confirmation or denial in the object itself, or in your memory of it. Each confirmation or denial brings you closer to the object, until finally you are, as it were, inside it, the contours you have drawn no longer marking the edge of what you have seen, but the edge of what you have become. Perhaps that sounds needlessly metaphysical. Another way of putting it would be to say that each mark you make on the paper is a stepping-stone from which you proceed to the next, until you have crossed your subject as though it were a river—have put it behind you."[1]
>
> *John Berger*

◄

Mu Ch'i
Six Persimmons
*c.*1269
Ink on paper
14 ¼ in (36 cm) wide
Daitoku-ji, Kyoto

Mu Ch'i carefully explored the variation and subtlety of a singular subject and medium. What has he chosen to leave out in order to enhance the essential qualities of the subject? Notice the restrained and specific exploration of light, the amount of material used to produce varying degrees of opacity and translucency in the individual forms, and the use of line in some areas and solid form in others.

INTRINSIC QUALITIES OF DRAWING

While the process of drawing is part of learning to see the object or view in front of you, the physical drawing itself is about making marks on a surface as the drawing instrument is drawn across it. The Latin *trahere* ("to draw") also means "to pull" or "to drag." The mark left either lies flat on the surface or is absorbed into it, which is the result of an initial and direct application of an image to a ground. This drawing is primarily a two-dimensional expression, even though it may convey the illusion of three dimensions. The physical act of drawing is also by its essential nature or constitution a process initiated by an impulse in response to a fleeting thought that must be recorded. Each drawing is unique: it can either be a contemplation of subject and form, an urgent response to a phenomenal event, an obsessive process, or a spontaneous and freely gestural response to a lived reality.

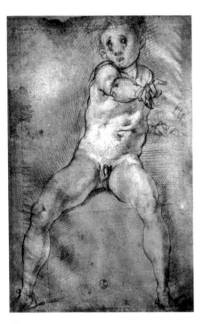

▲
Jacopo da Pontormo
Nude Boy Seated
*c.*1518
Red chalk
16 ⅛ x 10 ⅞ in (41 x 26.5 cm)
Uffizi Gallery, Florence

A sense of emotional urgency is conveyed through a variation in line and form, which describe a series of movements having just occurred in rapid succession. Notice the evidence of the artist's hand and body movements as, followed his eyes, he made quivering and sweeping lines; sharp, staccato chalk marks; and insistent corrections—all to achieve a visual completeness. The ovals of the mouth and the rising shoulder—as well as the hand gesture, the firmly planted feet, the twisting torso, and the single tear—emphasize the pathos in the widely elongated ovals of the eyes.

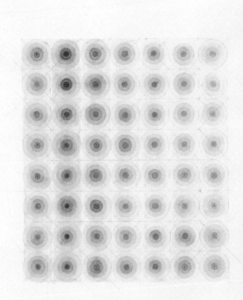

▲
Eva Hesse
Untitled
1966
Watercolor and pencil on paper
25 x 13 ¾ in (63.6 x 34.8 cm)
Museum of Modern Art, New York

Working within the discipline of the prescribed formal conventions of a grid, Hesse created an ink wash and pencil drawing of rows of concentric circles. The fluidity of the ink provided a counterpoint to the grid. She has created an ethereal, sensitive, fragile, translucent field of flux, which offers the possibility of infinite variation and the opportunity to engage in the obsessive nature of the process.

n Henry
n Children Like to Run Races

ercolor
 8 in (12.7 x 20.3 cm)
ction of the author, New York

ted by a seven-year-old girl using an
omy of means, this drawing conveys
tuitive understanding of the cadence
nning by the horizontal and vertical
ing of the subjects. The marks made
est speed as they describe the figures
ng across the page.

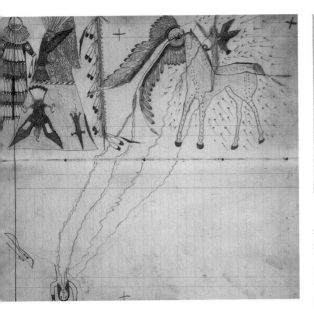

▲

Jean Arp
Automatic Drawing
1917–18 (Inscribed "1916")
Ink and pencil on paper
16 ¾ x 21 ¼ in (42.6 x 54 cm)
Museum of Modern Art, New York

derson Ledger Artist "A" (Arapaho)
dicine Vision (pages 24–25)
2

cil, colored pencil, and ink
x 24 in (38.1 x 61 cm)
Charles and Valerie Diker Collection,
w York

ive American peoples of the Great
ins in the United States had a long
ory of chronicling their lives pictorially.
white settlers began to infiltrate their
ritory, Plains Indians adopted a new
dium for recording their visual
tories, obtained through their contacts
h whites. They began to draw with
ns, pencils, and watercolors in bound
gers commonly used for inventory by
ders and military officers. *Medicine
ion* documents a vision witnessed by the
rrior figure depicted on page 25. The
nbols conveyed in such visions as
rtrayed on page 24 became the
tective medicine of the particular
rrior who viewed them.

In this drawing of branches, roots, stones
and pebbles on the shores of Lake
Maggiore, Switzerland, Arp simplified the
forms into what he referred to as "fluid
ovals," according to Maurice Tuchman.[2]
Believing that nature was beyond rational
control, his process was spontaneous and
freely gestural. It involved drawing with
pencil in continuous, curving lines and
irregular strokes; then, with a brush,
opaque black ink was applied evenly into
the shapes. Traces of the pencil lines at
variance with the final drawing are left
exposed. *Automatic Drawing* is not the
literal rendering of nature but the
evocation of the presence of natural forms
and their processes of germination,
growth, fruition, decay, and erosion
through asymmetrical movement of lines
and shapes. Shapes and compositions
assume the approximate form of ovals by
letting the pencil meander freely.

DRAWING IS THE FOUNDATION

"HOW YOU SHOULD START DRAWING WITH A STYLE AND BY WHAT LIGHT
... And then take a style of silver, or brass, or anything else, provided the ends be silver, fairly slender, smooth, and handsome. Then, using a model, start to copy the easiest possible subjects, to get your hand in; and run the style over the little panel so lightly that you can hardly make out what you first start to do; strengthening your strokes little by little, going back many times to produce the shadows. And the darker you want to make the shadows in the accents, the more times you go back to them; and so, conversely, go back over the reliefs only a few times. And let the helm and steersman of this power to see be the light of the sun, the light of your eye, and your own hand: for without these three things nothing can be done systematically. But arrange to have the light diffused when you are drawing; and have the sun fall on your left side. And with that system set yourself to practice drawing, drawing only a little each day, so that you may not come to lose your taste for it, or get tired of it.

FUNDAMENTAL PROVISIONS FOR ANYONE WHO ENTERS THIS PROFESSION
You, therefore, who with lofty spirit are fired with this ambition, and are about to enter the profession, begin by decking yourselves with this attire: Enthusiasm, Reverence, Obedience, and Constancy."[3]

Cennino d'Andrea Cennini

These words of Cennino d'Andrea Cennini, from his late fourteenth-century treatise, *Il Libro dell'arte*—an introduction to the methods of painting for art students—may sound quaint, but they hold practical advice that is still absolutely relevant to the student and artist today. My text is informed and imbued with the sensibility embodied in these words. So with this in mind, set aside ten minutes a day to draw and choose the easiest subjects available, such as a ball, a bottle, or a box. Cennino Cennini's students used a "style of silver" to draw on little wood panels; you can use a pencil and a sketchbook.

As the foundation and the beginning of art practice, drawing is the most intimate and personal of the arts. Artists of the early Renaissance established the drawn sketch as central to the process of artistic creation; thoughts and images were spontaneously rendered through the sketch as a means to record and generate ideas. Drawings, as we now understand them, came into existence and gained a new importance as the foundation for artistic theory, training, and practice, and as the embodiment of artists' ideas. It was then recognized that an artist could possess an individual drawing style, through which a new kind of pictorial realism could be achieved.

The foundational process of drawing is about mapping the artist's thoughts. Drawing is thinking: it can manifest the desire to bring a thought into material existence and represent the thinking process. In a broad sense, drawing contributes to the formation of art objects. Every line and edge created by an artist is the result of a drawing process. In a sense, while at work, the artist is always drawing: through his creation of forms with lines drawn on paper; physical fragments placed adjacent or overlapping; or a handprint on a cave wall. The direction of line and placement of forms engages the process of drawing.

To develop and maintain an artistic practice, a studio or place to work is essential. Drawing as thinking and reflection is the beginning of studio practice, which requires a personal space, but the lack of a perfect space should not hinder you from beginning to

pursue your art practice. A studio or place to work can be an alcove in a room, a converted closet, a movable easel, or even a sketchbook.

Draw to study, record, express, and clarify your ideas as you engage in a direct and spontaneous, often pleasurable, response to a range of momentary stimuli. As you engage in the process, you may see that a passage is awkward and needs changing; in other areas allow your pencil to glide around on its own. At certain points in the sketching or drawing process, I ask myself to stop thinking—stop trying to "figure it out"—and just let my hand follow my eye.

To create a drawing, only the most basic art materials are required. The history of drawing can be a valuable resource for drawing practice. In the twenty-first century, experimenting with historical techniques can help the modern artist to expand upon and deepen their understanding of the term "drawing."

▶

Albrecht Dürer
Design for a Gothic Table Fountain
1500
Pen and brown ink with watercolor and
traces of red chalk
22 x 14 in (56 x 35.8 cm)
British Museum, London

Contrary to normal sixteenth-century practice, Dürer treasured his sketches and signed many of them with his monogram and date, even though they were not intended for sale but were generally gifts for close friends. Approximately 1,000 of these sketches have survived.

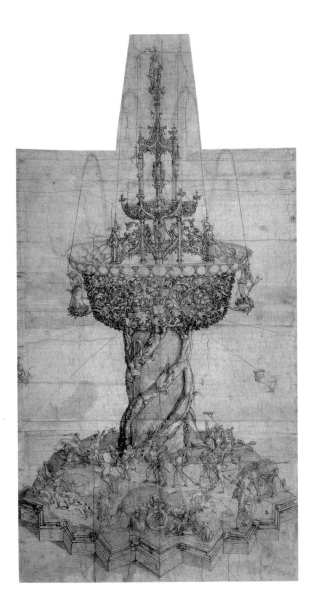

CHANGING AND ENDURING FUNCTION

Drawings can function as either independent, finished works of art or as preparatory drafts for a final work. The latter include stylistic exercises such as contour drawing, figure (life) drawing, drawing from the antique or cast, and drawing from the flat (drawing a copy of a painting or another drawing). Also in this category are the sketch, the note, the study, and the cartoon. A note is often of a detail to capture an ephemeral element, which might entail a written description of colors, shapes, light, and atmospheric effects. A study is a more carefully detailed representation used to clarify themes and techniques. The cartoon is a full-sized, detailed preparatory drawing on paper. Preliminary drawings for other works of art that are incorporated into those works—such as *sinopia* and *abbozzo* (underdrawing for fresco and panel painting)—also fall into this category.

Since the Italian Renaissance, drawing has implied spontaneity and has been regarded as the embodiment of artists' ideas, free expression, and the foundation for training in all the arts. It now encompasses a broad and deep range of expression.

◄

Agnes Martin
Untitled
Undated
Ink and watercolor on paper
8 ½ x 8 ½ in (21.6 x 21.6 cm)
Collection of Mr. and Mrs. Daniel W Dietrich

Influenced by nature, but not replicating it in a realistic sense, Canadian-born artist Agnes Martin wanted viewers to experience the same feelings when looking at her minimalist abstractions as they encountered when confronted by nature itself. The muted pastel colors and spare use of form also reflect her deep spirituality and interest in Asian philosophy.

"Learn how to meditate on paper. Drawing and writing are forms of meditation. Learn how to contemplate works of art."[4]

Thomas Merton

HISTORICAL ROOTS

Drawn animal imagery on the walls of caves in Lascaux, France; linear geometric designs decorating archaic Greek vases; and etched figures on Etruscan bronze mirrors represent some of the oldest surviving examples of material and artistic culture. Art was placed in the service of magic, ritual, and religion from the beginning of recorded history. The earliest drawings may have been the tattoos created with red-earth pigments in the Paleolithic period (350,000 BC) to decorate the body, or they may be the imprints and outlines of human hands found on the walls of the oldest Franco–Cantabrian caves.

Illuminated manuscripts commissioned for the clergy, aristocracy, or monarchy are examples of medieval (third through fifteenth century AD) drawing practices, and show that art continued to serve religion while it also acquired a more secular clientele. Practical treatises were also produced, such as maps, architectural plans, and scientific illustrations. Additionally, studies of figures, ornamental and architectural motifs, and narrative scenes were copied into pattern books, which were to be reused by artists for specific commissions and helped to streamline workshop production and to convey standardized formal and iconographic elements in the late Middle Ages (AD 1300–1500). In the early fifteenth century, Cennino Cennini affirmed the central role that drawing held in the training of the apprentice, whose artistic formation evolved from copying the master's drawings and workshop models to working from nature or casts.

olithic cave drawing
the Pech Merle cave
,000 BC
nated pigment
France

echnique used to create this negative
e of a hand on a cave wall may have
blowing colored dry pigment from
mouth onto a hand pressed against
vall.

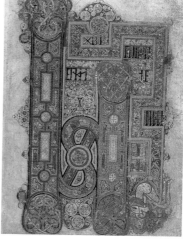

"The Beginning of St. Mark's Gospel,"
Folio 34r from the Book of Kells
c. AD 800
Colored ink on vellum
13 x 9 ⅘ in (33 x 25 cm)
Trinity College, Dublin

This page opens the Gospel of Mark in the Book of Kells, an ornate manuscript created by Celtic monks, containing the four Gospels of the Bible in Latin. The decoration is so lavish as to be almost illegible. Colors were derived from such sources as red lead, orpiment, lapis lazuli, and copper.

The medieval pattern-book tradition then transformed into that of the modern sketchbook during the early Renaissance. In the fifteenth century, paper became more available and less expensive, which encouraged a trend toward active and incidental drawing brought about by the renewed interest in the ancient Greek and Roman preoccupation with the importance of the individual and with everyday secular life. The fixed imagery of the pattern book was replaced by instantaneous responses to natural phenomena and contemporary events. An artist could conceive complex narrative compositions on paper, which was permanent yet portable—unlike a wall or large canvas. Drawing gained new importance as the foundation for artistic theory and training, and, combined with a renewed interest in science, the practice also included anatomical studies.

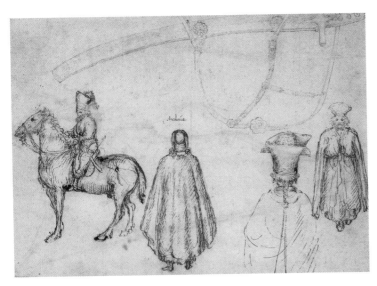

◀

Antonio Pisanello
Sketches of the Emperor John VIII
Palaeologus, a Monk, and a Scabbard
1438
Pen and brown ink on ivory laid paper
7 ½ x 10 ½ in (18.9 x 26.5 cm)
The Art Institute of Chicago, Chicago

Pisanello carefully observed subjects from different locations to create these pen-and-ink sketches on one sheet that exemplify the transition from pattern book to a modern sheet of studies.

An individual rather than a shared or communal mode of graphic expression informed the Renaissance sensibility, and sketching and sketchbooks were a vehicle for enquiry into this concept.

Drawing practice facilitated the exploration and revival of theories and models based on classical antiquity. The rediscovery of the principles of linear and aerial perspective enabled artists to render the play of light and shade on solid forms in space, and the optical effects of spatial recession within ambient light and atmosphere. The rules of linear perspective were developed by painters such as Paolo Uccello (c.1396–1475), Piero della Francesca (c.1420–92), Albrecht Dürer (1471–1528), and Leonardo da Vinci (1452–1519), as well as architects including Filippo Brunelleschi (c.1377–1446) and Leone Battista Alberti (1404–72). The primary system used by artists to represent three-dimensional objects on a two-dimensional surface is linear perspective. Represented objects appear to recede in space by being drawn progressively smaller and closer together toward a horizon, and they are projected on the picture plane by means of a system of guidelines ruled to a point or points on the horizon line known as *vanishing points*. The parallel vertical lines—such as those of structures and roads—converge, when extended, on one or more points. Aerial or atmospheric perspective, written about and employed by Leonardo da Vinci, is usually regarded as an adjunct to linear perspective, and artists often use linear and aerial perspective in conjunction with each other. In aerial perspective, an illusion of

recession is achieved by the depiction of atmospheric effects, and variations in air allow us to see and perceive different distances. Colors of a distant scene or objects appear progressively fainter, and, depending on the amount of moisture in the air, progressively bluer or cooler. The background should appear less distinct in outline and color than the foreground.

Great painters were great draftsmen in Renaissance Italy. By 1500, Leonardo da Vinci's practice of employing personal, casual, and exploratory drawing was established as the first step in solving design problems. Often using small, prepared-paper pocket books, he united conceptual power and thematic schemes with a delicacy of touch and precision of handling in the application of silverpoint, pen and ink, or chalk.

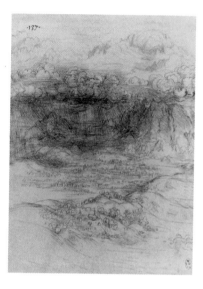

◄

Leonardo da Vinci
Storm in an Alpine Valley
c.1508–10
Red chalk on paper
7 ¾ x 5 ⅞ in (19.8 x 15 cm)
The Royal Collection,
Windsor Castle, Windsor

**In this drawing, Leonardo explores
different distances. He shows a valley
in the foreground with rain and clouds
in the background, through which can be
discerned a valley and mountains beyond.**

Drawing was acknowledged as the foundation of all the arts of design in the sixteenth century. In the workshops of Raphael (Raffaello Sanzio; 1483–1520) and Michelangelo Buonarroti (1475–1564) in Rome, formal and technical experiments of the painters of the previous century came together to produce a rational procedure based on drawing. This procedure was employed throughout the essential preparatory stages of the development and execution of monumental compositions, including frescos, tapestries, and paintings on canvas. A systematic approach was established for developing a composition through a progressive sequence of drawings: sketch; schematic composition drawing; study sheets of individual motifs; detail studies of figures, drapery, and heads; a finished composition drawing squared for transfer; cartoons; additional cartoons for details; and drawings for the workshop records. The procedure allowed the master and workshop to complete numerous large-scale commissions at a rate never achieved before.

Artists of northern Europe who visited Italy were influenced by the style and technique based on modern artistic ideals, such as the re-examination of classical antiquity, the depiction of the human figure in motion and at rest, and curiosity about the natural world. After two visits to Venice, Albrecht Dürer returned to Nuremberg to publish treatises on perspective and human proportion. He adapted a practice, based on Venetian dyed-blue paper, of preparing blue-ground drawing supports. The Venetian artistic tradition of

drawing on blue paper came about at the beginning of the fifteenth century as a result of several factors. There was a thriving fabric-dyeing industry in Venice, which made the dyeing technology available for papermakers as well as providing access to colored rags for use in papermaking. Venice also imported indigo (a blue dye). It was the interest Venetian painters had in rendering atmospheric phenomena that led them to discover the specific suitability of blue paper for drawing.

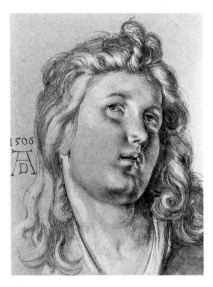

▲
Albrecht Dürer
Head of an Angel
1506
Brush drawing on blue Venetian paper
10 ⅗ x 8 ⅕ in (27 x 20.8 cm)
Graphic Collection, Albertina, Vienna

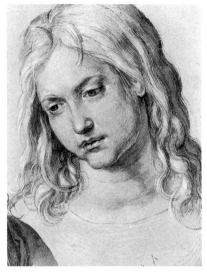

▲
Albrecht Dürer
Head of the Twelve-Year-Old Christ
c.1506
Brush drawing on blue Venetian paper
10 ⅞ x 8 ⅓ in (27.5 x 21.1 cm)
Graphic Collection, Albertina, Vienna

In the northern Netherlands, a great contribution was made to the graphic arts by Rembrandt van Rijn (1606–69), who left an enormous, direct, and robust personal artistic diary, executed with an economy of means. Not one drawing has been attributed to his contemporaries, Frans Hals (1582/3–1666) or Jan Vermeer (1632–75). They may not have been as prolific at drawing as Rembrandt, but it is hard to believe that neither of them made drawings. It is estimated that about 50 percent of Rembrandt's drawings have survived to the present, which amounts to about 1,400. Most were made for his private use, rather than for the public or posterity, out of his impulse to observe and record his everyday life. As he made few studies for larger works, most drawings and sketches were incidental observations from which portions may have ended up in finished paintings. As though he were taking notes, he drew on everything: funeral notices, bills, and other printed matter. He made self-portraits, portraits, and sketches of busy streets, beggars, mothers and children, nudes, birds, pets, wild animals, architecture, landscape, the countryside, works of art, and episodes from classical mythology, ancient history, and the Bible. He preserved them in bound books between blank pages. Twenty-four books of his drawings and two parcels of sketches are listed in an inventory from 1656, with some of the books

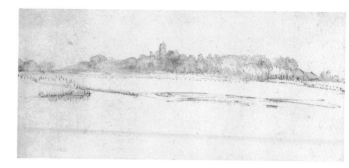

Rembrandt van Rijn
Landscape with the House
with the Little Tower
Early 1650s
Pen and brown ink and brown wash
13⁄16 x 8 7⁄16 in (7.6 x 20.3 cm)
Paul Getty Museum, Los Angeles

In this sketch, Rembrandt emphasized
important elements, including only what
was necessary to communicate to the
viewer. The house and tower exist, and the
view has been proven to be topograph-
ically correct. By distilling information
expeditiously, he suggested space, light,
and atmosphere with just a few strokes.
A sheer wash of ink creates a blurred and
luminous effect over the mass of trees.

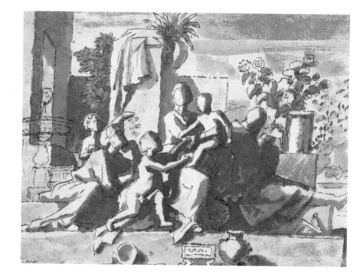

Nicolas Poussin
Holy Family
1648
Pen and bister wash
7¼ x 10 in (18.4 x 25.3 cm)
The Pierpont Morgan Library, New York

Poussin simplified stone, leaf, drapery,
and the human figure, treating them all
as pure form in this sketch.

described as containing drawings devoted to a single subject: nudes, figure studies, landscapes, animals, and so on.

The establishment of the Académie royale de peinture et de sculpture in Paris in 1648 influenced the history of drawings through its teaching program based on the figure- or life-drawing class. Because of this institution and from the drawings produced there (male nudes studied from life), the term "academy" came to refer to all drawings of nudes. Academic artists such as Nicolas Poussin (1594–1665) focused on the rigorous analysis of human form.

The intellectual and philosophical foundations of the modern age were established in the eighteenth century within the period of the Enlightenment. A significant development was the appreciation of drawings as an independent artistic form, without regard for their original purpose. During this period, Venice was a hub of artistic production; the dominant Venetian mode employed by artists such as Giovanni Battista Tiepolo (1696–1770) and Giovanni Battista Piranesi (1720–78) was an optical and atmospheric approach to convey form through pen and vaporous washes on brilliant-white paper.

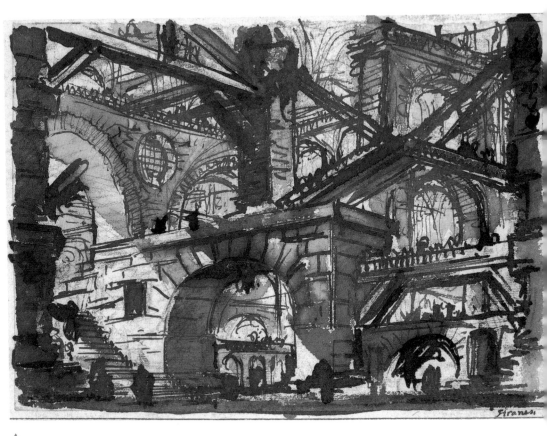

Giovanni Battista Piranesi
Interior of a Prison
1744–5
Pen and brown ink with wash over black chalk
8 ½ x 9 ⅞ in (21.7 x 25.2 cm)
Hamburg Kunsthalle, Hamburg

**The complex interior, described with
passages of light and dark washes of ink,
can metaphorically and conceptually convey
the interior realm of the human psyche.**

Venetian artists developed new types of drawing to explore the realms of the imagination, dreams, and personal fantasies. One such invention was the *capriccio*, a landscape in which identifiable monuments and sites have been rearranged according to the artist's fancy. In his wash drawings, the Spanish artist Francisco de Goya y Lucientes (1746–1828) examined a realm beyond the light of reason, where witchcraft flourished in the dark world of nightmare.

In the nineteenth century, the invention of photography impacted the practice of drawing by forever alleviating the necessity of drawing to represent what is seen in the material world. However, nineteenth-century neoclassical artists still adhered to academic and antique precepts in the pursuit of perfect form. The roots of the academy lie in the garden near Athens where Plato taught. Art academies developed from the medieval guilds or workshops, such as those that existed during the era of Cennino Cennini (referred to on

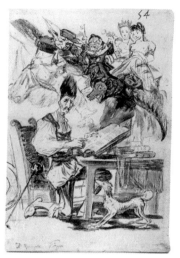

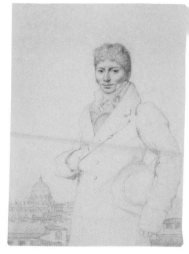

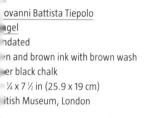

ovanni Battista Tiepolo
ngel
ndated
n and brown ink with brown wash
er black chalk
¼ x 7 ½ in (25.9 x 19 cm)
itish Museum, London

epolo explored direct light (on the
ht) and reflected light (on the left) using
aphanous washes of ink to offset the
illiance of the white paper.

Francisco de Goya y Lucientes
Don Quixote
1812–23
Brush drawing in gray ink and wash
8 ⅛ x 5 ⅝ in (20.7 x 14.4 cm)
British Museum, London

Goya's application of ink in jagged
lines and shaky planes suggests an
urgent excitement to record and
express an emotional state.

Jean-Auguste-Dominique Ingres
Portrait of Dr. Robin
c.1808–09
Lead pencil on paper
11 ⅓ x 8 ⅘ in (28 x 22.3 cm)
The Art Institute of Chicago, Chicago

An intense stillness is presented
with Ingres' highly refined finish
and use of precise line.

p. 14), to become schools for the practical and theoretical training of artists. Rigorous study
of the human form and structured teaching characterized most academies. In France, Jean-
Auguste-Dominique Ingres (1780–1867) attained a high degree of refined elegance in an
exploration of the quality of line using the graphite pencil (usually referred to as the lead
pencil), which became widely used in the early 1800s. He created precise, delicately
nuanced drawings of sitters silhouetted against a pure white, smooth drawing surface
provided by machine-woven paper. Conversely, Eugène Delacroix (1798–1863) explored the
rich possibilities of the human figure in sometimes dramatic or violent situations in his
drawings of tiger hunts, odalisques (female slaves depicted as reclining nudes), and other
subjects considered to be exotic at the time.

American artists such as John Singer Sargent (1865–1925) and James Abbott McNeill
Whistler (1834–1903) lived abroad and sought to immerse themselves in a European
artistic sensibility through their standards in form and technique.

In England, the watercolors of Joseph Mallord William Turner (1775–1851), John
Ruskin (1819–1900), and John Constable (1776–1837) portrayed atmospheric effects with
tone and color, while the Pre-Raphaelite artists such as Dante Gabriel Rossetti (1828–82)
chose to depict nature in the most minute detail, using a sharp, clear technique in order to
illustrate morally serious subject matter gleaned from the medieval era.

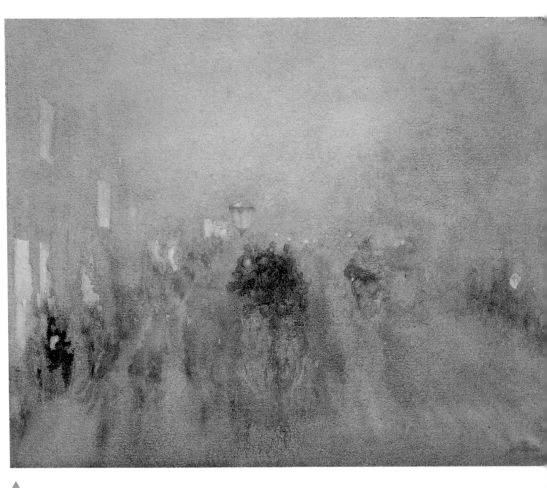

▲

James Abbott McNeill Whistler
Nocturne in Gray and Gold—Piccadilly
1881–3
Watercolor
8 ¾ x 11 ½ in (22.2 x 29.3 cm)
National Gallery of Ireland, Dublin

▶

Eugène Delacroix
An Arab on Horseback Attacked by a Lion
1849
Graphite on tracing paper, darkened
18 ⅛ x 12 in (46 x 30.5 cm)
Fogg Art Museum, Harvard University
Museums, Bequest of Meta and Paul J.
Sachs, 1965.269

**Delacroix employed line to describe form
and suggest movement in his depiction of
a dramatic, action-filled event.**

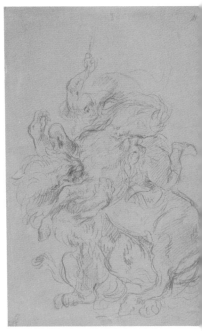

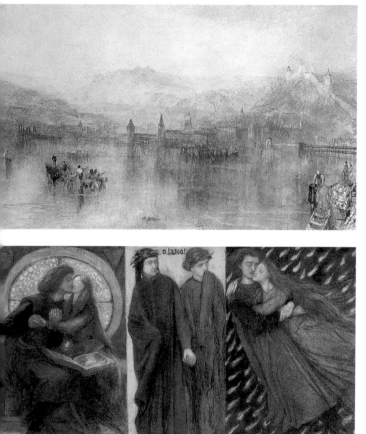

At the end of the century, French artists Edgar Degas (1834–1917) and Paul Cézanne (1839–1906) rejected the academy and absorbed new influences, ushering in the era of the modern drawing. Degas explored Japanese prints that had a focus on contemporary urban life and reflected the everyday lives of common people. He also embraced the invention of photography, which encouraged him to probe modern perceptions of time, sequence, and motion. In selecting and framing haphazard details for his paintings and drawings, he seemed to view the world as if through the camera. For Degas, the camera was a useful agent of modern vision, helping him to read and record the temperament of the modern era through a glimpse of a posture or a gesture. He made photographs that often re-stated the formal structures of his painting and informed his work in painting.

The artists of Impressionism focused on developments in color theory and experiments in optics to find new ways to represent the effects of light. In pastel and watercolor drawings, Impressionist artist Claude Monet (1840–1926) explored this new direction. Cézanne discovered that light could be employed to create space, volume, and atmosphere through the use of watercolor and other materials such as chalk or pencil.

Throughout the twentieth century, Pablo Picasso (1881–1973) and Henri Matisse (1869–1954), who worked to find new forms of expression based on graphic means, had a major influence on artistic practice. Their intention was to revolt against the strictures of the academy, which were based on rigorous study of the human form, and to inject new life

▶

Edgar Degas
Three Studies of a Dancer
c.1878–81
Black chalk, conté crayon and pink chalk,
heightened with white chalk, on blue paper
faded to light brown
8 ¾ x 24 ¾ in (47.5 x 62.8 cm)
The Pierpont Morgan Library and Museum,
New York

**Degas made photographic studies of
models in the studio that generated
forms he recirculated into his pastels,
paintings, and sculptures. Among these
photographic studies are a series of three
photographs of ballet dancers.**

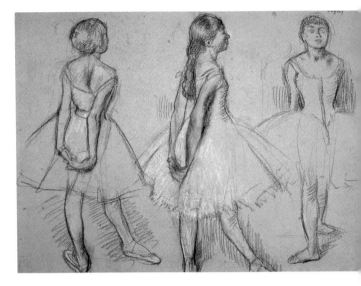

▶

Claude Monet
Maisons près de la mer (Houses by the Sea)
1865
Black chalk on paper
9 ¾ x 13 ¼ in (24.6 x 33.4 cm)
Museum of Modern Art,
New York

▶

Paul Cézanne
Still Life with Pears and Apples,
Covered Blue Jar and a Bottle of Wine
1902–06
Watercolor over black chalk
18 ¾ x 24 ¹⁵⁄₁₆ in (47.6 x 61.7 cm)
The Pierpont Morgan Library and Museum,
New York

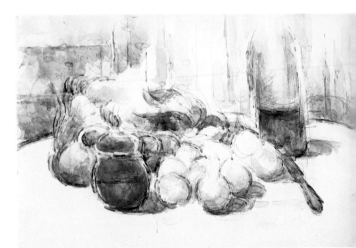

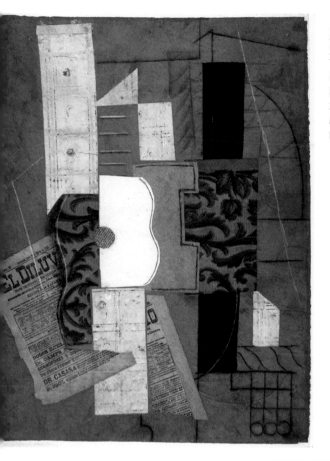

Pablo Picasso
Guitar
1913
Pasted paper, charcoal, ink, and chalk on
blue paper, mounted on rag board
26 ⅛ x 19 ¼ in (66.4 x 49.6 cm)
Museum of Modern Art,
New York

rt Schwitters
ened by Customs
37–8
per collage, oil, and pencil on paper
pport, on paper
x 9 ¹⁵⁄₁₆ in (33.1 x 25.3 cm)
Tate 2007, London

hwitters called his collages "Merz
tures"—*Merz* being a syllable of the
rman word for commercial. He
covered the syllable while he was
tting the word into pieces. His "Merz
tures" were put together from the
ntents of the gutter and trash basket.

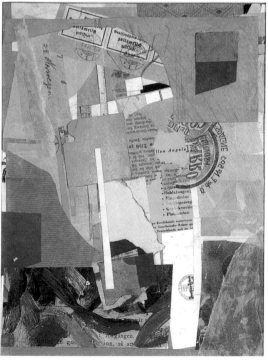

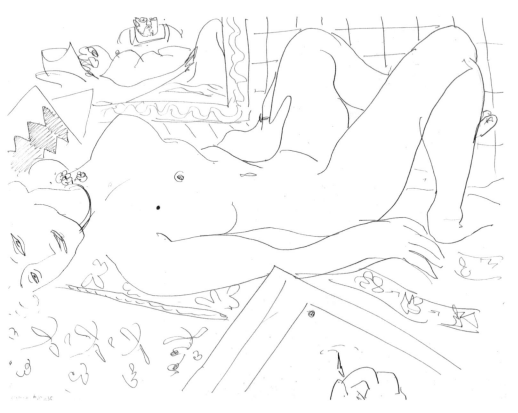

Henri Matisse
Reclining Nude (Artist and Model)
1935
Pen on paper
17 ¾ x 22 ⅜ in (46 x 57 cm)
Hermitage, St. Petersburg

into academic tedium. Art critic Michael Kimmelman quoted art historian Kirk Varnedoe as saying that the modern artist believed that the old rules of academic style were "not something you play *by*," they were "something you play *with*." With Picasso and Matisse, the old rules were ingrained in the new works, sustaining the memory of what was rejected.[5]

The boundaries between drawing and other art forms became increasingly blurred as the practice of collage evolved: the technique of creating a two-dimensional pictorial composition by gluing paper, fabrics, and other materials to a flat portable surface. Collage was followed by the application of found objects and assemblage: the technique of creating three-dimensional works of art by combining various elements, such as found objects and/or elements produced by the artist, into an integrated whole (see Kurt Schwitters [1887–1948], p. 27).

The function of drawing changed significantly in the twentieth century. Some artists persisted in their exploration of the observed world, while others favored abstraction and nonrepresentational imagery. Early twentieth-century artists such as Wassily Kandinsky (1866–1944), Paul Klee (1879–1940), and Hilma af Klint (1862–1944) (see p. 60) explored the spiritual in art—the spark of inner life or the core of spiritual experience.

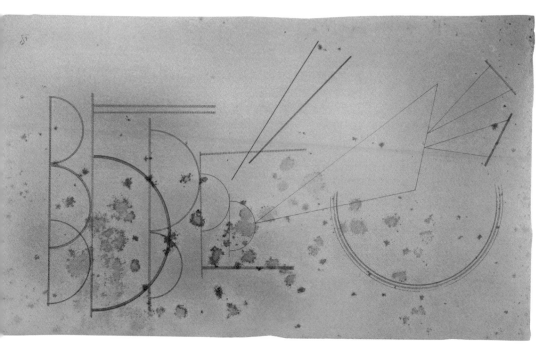

Vassily Kandinsky
ometrical Forms, 1928
28
n, black ink, and watercolor on laid paper
16 x 19 ⅟16 in (28.1 x 48.4 cm)
iladelphia Museum of Art,
iladelphia

Surrealist artists such as Jean Arp (1886–1966) employed automatic drawing—creating a graphic form without thought or will (see p. 13). Surrealism is an art movement based on the expression of the true function of thought, where thought is dictated in the absence of all control exerted by reason.

Contemporary artists continue to examine historical drawing practices to develop new applications. They use nontraditional materials such as dirt, hair, gunpowder, or chalk and blackboard as they purposefully explore the intrinsic meanings of the materials in their drawings. The notion that drawing is an entirely autonomous form of art has escalated as it has become more complex in technique and larger in scale. The blurring of boundaries between distinct art forms predominates in works by installation artists such as Toba Khedoori (1964–) and Gary Simmons (1964–); conceptual artists such as Sol LeWitt (1928–); and by artists such as Ana Mendieta (1948–85), Frank Moore (1953–2002), Vija Celmins (1939–), and Joana Rosa (1959–). Installation art is made for a specific site and is intended to surround the viewer by art, as in a mural-decorated public space or an art-enriched cathedral. In conceptual art, the artist's thinking can make any idea or thought a potential work of art, and the idea rather than the object is paramount.

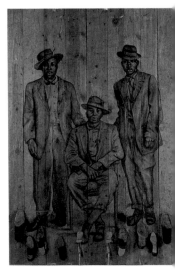

Whitfield Lovell
Shine
2000
Charcoal on wood and found objects
107 ¾ x 74 ¾ x 42 in
(273.7 x 189.9 x 106.7 cm)
Whitney Museum of American Art,
New York

Using found photographs as source mater
Lovell drew the images in charcoal on old
wood, giving careful thought to the latter'
grain and texture. Found objects were ad
to create a 3-D tableau.

▲

Ana Mendieta
Rastros Corporales (Body Tracks)
1982
Blood and tempera paint on paper
Three works, each 38 x 50 in (96.5 x 127
Rose Art Museum, Brandeis University,
Waltham, Massachusetts

This drawing, created during a performa
operates as an installation piece where
process of drawing and the drawing itse
combine into a work of art.

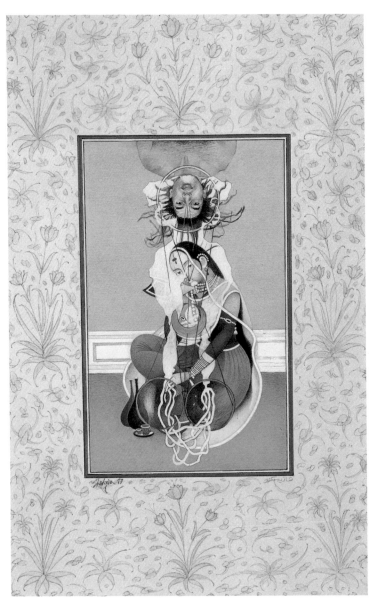

▲
Shahzia Sikander
Reinventing the Dislocation
1997
Vegetable pigment, dry pigment,
watercolor, and tea water on paper
12 ¹⁵/₁₆ x 9 ¼ in (32.9 x 23.5 cm)
Whitney Museum of American Art,
New York

Sikander's miniature paintings bring
together traditional Hindu and Islamic
techniques and compositions with her
own invented symbols.

◀

Toba Khedoori
Untitled
1994
Wax, oil, hair, and staples on paper
in three parts
Installed (irregular) 135 ¼ x 220 ½ in
(343.5 x 560.1 cm)
Whitney Museum of American Art,
New York

During the creation of *Untitled*, Khedoori's
dog pranced through and around the
piece, leaving hairs embedded in the wax
as she sometimes executed parts of it on
the floor. Materials of everyday life in the
studio became the materials of a finished
work of art.

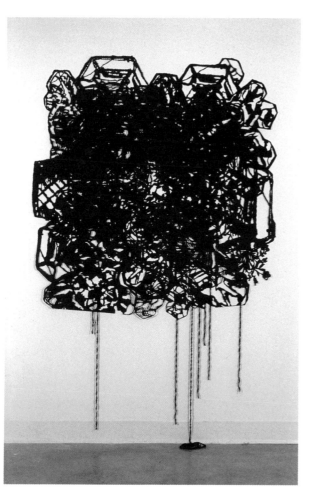

◀

Ann Glazer
The Neighbors Are Getting Closer
2002
Paper and string
44 x 83 in (111.7 x 210.8 cm)
Women & Their Work Gallery, Austin, Texas

Glazer used paper and string to create an
installation piece that is deeply rooted in
drawing in both concept and facture.

▲

Gary Simmons
Ghoster
1996
Paint and chalk on wall
Four panels, each 9 x 11 ft (2.7 x 3.4 m)
Whitney Museum of American Art,
New York

Simmons executed this "erasure drawing"
on fiberglass with an aircraft-aluminum
core. The first layer is composed of black
chalkboard paint and slate ground in an
oil base. The surface was then dusted with
pure titanium pigment, sprayed with
fixative, sanded, and sprayed again.

▶

Robert Gober
Untitled
1985
Graphite on paper
11 x 14 in (27.9 x 35.6 cm)
Whitney Museum of American Art,
New York

Drawing is an integral part of Robert
Gober's sculptural practice, used as a tool
for actualizing ideas—for working out the
physical appearance of the forms running
through his mind. Gober's fascination with
the formal and psychological resonance of
commonplace objects is exemplified in a
series of sink drawings, where he conducts
an obsessive and sustained investigation

▶

Ed Ruscha
Motor
1970
Gunpowder on paper
23 x 29 in (58.4 x 73.7 cm)
Whitney Museum of American Art,
New York

Ruscha has invented distinct types of
lettering and graphic techniques that
correspond to what he wants to say. He
has experimented with various techniques
and materials, including substances such
as fruit and vegetable juices, blood, egg
yolk, chocolate—and gunpowder, as used
in this drawing.
 Motor is one of a series of more than
three hundred drawings that Ruscha began
in 1967 using gunpowder, a medium he
preferred to charcoal. He could control and
correct layers of fine, dry gunpowder by
rubbing it with cotton balls into the fibers
of rag paper.

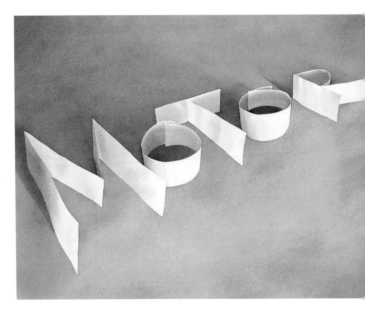

R. Gober '85

Celmins
...tled #6
...4
...rcoal on paper
...⁄₁₆ x 18 ¹⁄₁₆ in (61.1 x 45.9 cm)
...tney Museum of American Art,
... York

...le meticulously observing the
...tographs she uses as source material,
...nins builds the surface of her drawings
... thousands of individual strokes
... gestures.

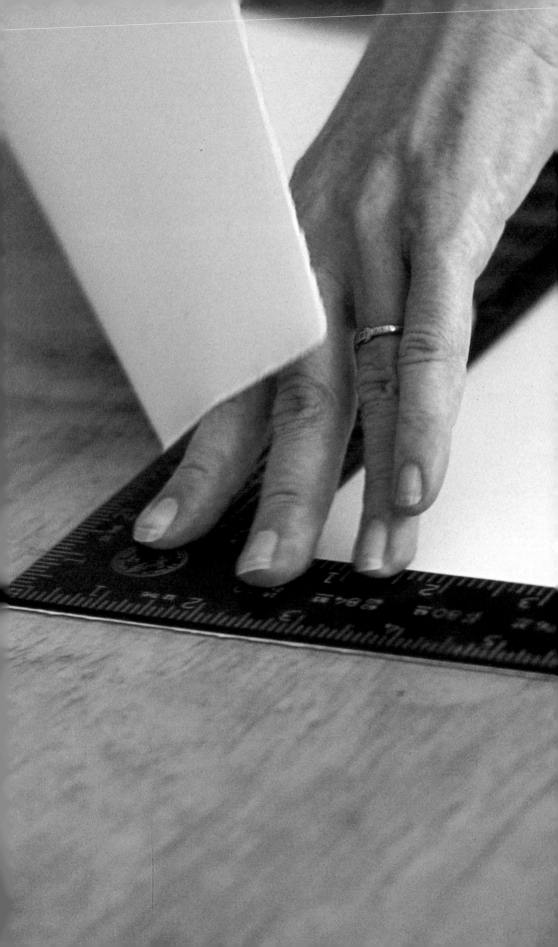

2
DRAWING MATERIALS

There is little separation between painting and drawing; paintings can be "drawn" and drawings can be "painterly," and a piece of paper and a pencil is all you really need. In this chapter, I will cover the basic drawing media, and in the following one I will explore the methods used and diversify the materials as we engage in experimental combinations, alternate media, and vehicles for manipulating media.

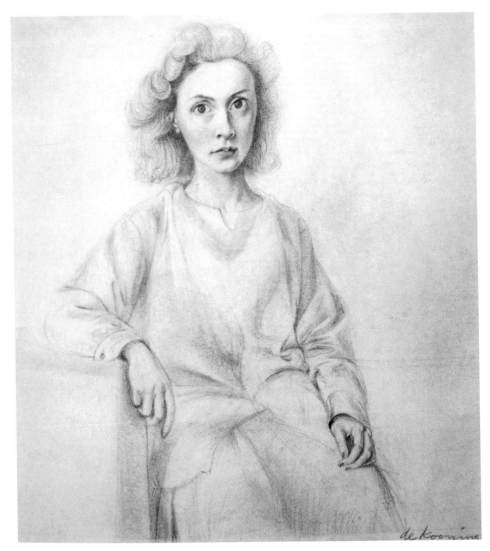

▲

Willem de Kooning
Portrait of Elaine
1940
Pencil, 31.1 x 30.2cm (12 ¼ x 11 ⅞ in)
Private Collection

In this drawing of his wife, the artist demonstrates his rigorous academic training. While the theme of woman permeated his drawings throughout his life, the degree of finish to be found in this early work was anomalous. De Kooning saw his abilities as a draftsman as much a bane as a boon, and created challenges for himself with new movements of the hand and new obstacles for it to surmount. To bring in vitality he erased and defaced, and sometimes closed his eyes while drawing. De Kooning continuously drew on paper and rarely considered the differences between a preparatory sketch, a notation, and an individual work. He tore up drawings and recombined them with sections of other torn-up drawings.

rgaret Krug

sée des Beaux Arts W. H. Auden

ritten by Hand, 1, 2, 3, 4)

05

e, two, and three: graphite on paper;

r: indigo drawing ink on paper

4 ¾ x 4 ¾ in (12 x 12 cm)

ection of the author, New York

eated these four drawings as part of a
formance piece. The images (sorrow, the
ods, a dog, water) came to mind while
ding a favorite poem by W. H. Auden,
usée des Beaux Arts." I had digital prints
de of the drawings so that visitors at an
ibition where the drawings were shown
ld choose one. Before giving the print
ay, I wrote on it, by hand, the words that
respond to the image.

n D. Graham

dy after Celia

4–5

ncil on tracing paper

⅞ x 18 ¾ in (58.2 x 47.7 cm)

seum of Modern Art, New York

Graham, repetition, a critical element
is aesthetic, led to discovery. He wrote
same sentences over and over and,
h few variations, he drew the same few
es an almost infinite number of times.
repeated motions became a form of
yer leading to a state of grace. He
instakingly adjusted his line until the
et was too messy to read or erase, then
ced the contours to obtain most closely
perfection of form he sought, keeping
naster set of his endeavors to be used
ny times over.

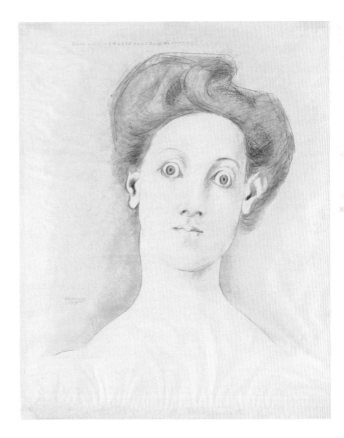

Drawings can be executed on a wall, papyrus, parchment, tablecloth, or floor. The most common support and ground for drawing is paper, reputedly invented in China in the first century AD and made from hemp. Eventually rag papers made from old cotton and linen cloths replaced hemp, tree bark, bamboo, and other plant fibers as the only acceptable paper for artists from the thirteenth century onwards in Europe.

One of the great European paper manufacturers, which has played a pivotal role in the history of Western papermaking is the Italian Fabriano paper mills. They were the first manufacturer to use water power in the pulping process, eliminating the labor-intensive

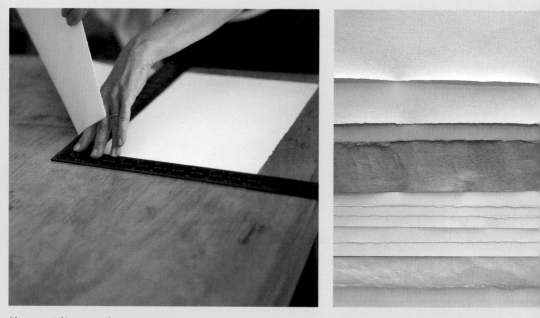

Place a metal L-square ruler on your paper with the longer side where you wish to tear it. Hold the ruler firmly at the corner of the L-square with one hand as you tear the paper along the long edge of the ruler with the other.

Papers come in a wide range, such as a) Fabriano Umbria, b) J. Green Vintage Tovil Christus, c) Japanese Kitakata, d) Japanese Persimmon, e) Arches 90 lb (185 gsm) hot-pressed, f) Fabriano Artistico 90 lb (185 gsm) hot-pressed, g) Aqaba, h) Fabriano Tiziano, i) Arches Text Wove, j) Japanese tissue pink, k) Canson Ingres laid.

manual process. They began making paper in 1283 and by the fourteenth century were producing one million sheets of paper each year. Fabriano invented the practice of watermarking—a mark visible in the paper when it is held up to the light—and examples of watermarked Fabriano paper have been found dating to the end of the thirteenth century. By the mid-fourteenth century, each of their forty artisans had their own particular watermark. Fabriano still uses the same methods today to produce high-quality paper.

Rag papers were used solely until the early 1800s, when a papermaking machine called the Fourdrinier was invented by Frenchman Nicholas-Louis Robert and was developed in England for the production of wood-pulp paper. Wood-pulp paper, such as newsprint, deteriorates quickly because the fiber is acidic, causing it to disintegrate. Artists

Vincent Van Gogh
Landscape in Drenthe
1883
Pen, brush and ink, graphite,
and opaque watercolor
on laid paper
12 ⅜ x 16 ⅝ in (31.4 x 42.1 cm)
Private Collection

Van Gogh's drawing shows a visible texture produced by the pattern of the laid paper.

require paper made from long, acid-free fibers that create strength by interlocking more effectively than shorter fibers. So, to ensure artworks' longevity, you should use high-quality artists' paper, which is made in this way. Artists' paper is strong and will not discolor with age. Also consider using 100 percent rag papers—made from either cotton, linen, or a combination of the two—to ensure your work will last. Various plant fibers, such as mulberry, are used in the Far East to make very strong, nonacidic papers, often referred to as "rice paper."

High-quality artists' paper can be handmade, mold-made or machine-made. Handmade paper has a slightly irregular surface and four "deckle" edges: rough, unfinished edges left by the metal frame, or deckle, used to contain the paper pulp in a mold during the papermaking process. It is thought to be the most stable and, because the fibers mesh or "felt" together randomly, the strongest. Mold-made paper is strong and has two deckle edges, resulting from the two ends of the cylinder-mold machine on which it is produced. Machine-made paper has a more uniform dispersion of fibers, so it has less character and strength. Paper is produced in large sheets and rolls, to provide the accurate-sized sheet for your needs. To produce an edge similar to the deckle edge that most artists prefer, it is easiest and best to tear your paper along the edge of an L-square ruler.

The process employed is essentially the same to make paper by hand or machine. For rag paper, a slurry of water and rag fibers is cast onto a screen and agitated, which causes the fibers to felt together as the water drains out. A sheet is formed, then removed from the screen and dried. During the process of making artists' paper, starch or gelatin is added to "size" the paper, eliminating excessive absorbency and making a suitable surface for drawing and painting.

Fine papers come in three surfaces: rough, cold-pressed (medium finish), and hot-pressed (smooth finish). After drying, paper goes through a finishing process. With heavy pressure, a metal plate applied to paper that has been placed between two pieces of smooth pasteboard will produce a medium surface, as will paper run through a series of cold, polished metal rollers to compress it in varying degrees. Heat is used in these processes to provide a smooth surface. The term "tooth" is often used to describe the

roughness of the surface of the paper. Papers that are not pressed during the finishing process have a rough surface. Cold-pressed paper has more tooth than hot-pressed paper, and the range from very rough to very smooth is broad; consequently, the relative smoothness and roughness varies with each manufacturer.

Paper is produced in weights; thin paper is lightweight and thick paper is heavy. Paper weight is designated by numbers indicated in pounds (or grams per square meter; gsm). The lightest weight is 72 pounds (150 gsm). Another common weight, 140 pounds (300 gsm), is twice as heavy. Paper less than 280 pounds (600 gsm) should be stretched on a drawing board for use with wet media to prevent it from buckling, which will cause washes to "pool" in certain areas.

There are two types of paper: wove paper, which is formed on a tightly woven mesh tray that leaves no visible marks; and laid paper, which shows the pattern of the mesh of wires laid over each other at right angles in the paper tray.

You should consider the specific medium you intend to use when selecting a paper, and paper type can also be selected for specific media:

- *Pencil paper*
Pencil can be used on most papers, including newsprint or multipurpose paper for inexpensive sketching, or on fine-art paper. For finished works, use 100 percent rag paper. I prefer the smoothest hot-pressed paper, such as Fabriano Artistico Hot Press, or vellum—also very smooth and tough. Cold-pressed paper is preferred by some artists whose work requires more texture.
- *Charcoal, pastel, and chalk paper*
You will find these in white, pale tints, and colors. The colors and the tints can provide a middle tone to which dark and light values may be applied, an undercolor to serve as a warm or cool inflection, or a background. They have a rough, grainy tooth, which holds the charcoal, pastel, or chalk more effectively than a smooth surface.

Commercial papers may have been tinted or colored with fugitive (not lightfast) dyes or pigments, which can fade very quickly when exposed to light. Check with your dealer to make sure the tinted or colored paper you purchase is lightfast. You can tint paper yourself to ensure stability by stretching the paper and applying a tint. Stretch a 100 percent rag paper (see Chapter 5, p. 119 for instructions on stretching paper). Wet the stretched paper and let the water soak in for a few minutes, then apply a thin watercolor wash with a large wash brush or soft varnish brush such as those recommended on p. 160 for applying gesso to panels. If you require a deeper tint, apply an additional wash of color. It is not necessary to have a perfectly applied wash, because pastel, chalk, and charcoal are relatively opaque media, and an inconsistent tint should not show through subsequent layers of marks. That said, you can apply a wash without wetting the stretched paper, but the wash will lie mainly on the surface of the paper, which is desirable for watercolor but not necessary for pastel, chalk, and charcoal drawing. The wash will not take on the appearance of a stain, and it may not be as even as it would be if applied onto a wet surface.

Textured papers are also used for pastels, such as those with a very fine sand coating. I like to make my own textured paper by mixing one part inert pigment—

such as fine pumice, marble dust, or gypsum—with ten parts acrylic emulsion medium. Mix the inert pigment with a small amount of the acrylic emulsion to form a smooth paste. Then mix the paste into the entire amount of acrylic emulsion, and apply the mixture to a stretched piece of paper of your choice. If you require a surface with more tooth, add more inert pigment to the initial paste the next time you make a textured paper. Let the paper dry for one to three hours to ensure that it is completely dry.

- *Pen-and-ink paper*

For pen and ink, most artists prefer a smooth-surfaced medium-weight paper. Again, as with pencil, I use Fabriano Artistico Hot Press in a medium weight, but there are many papers from which to choose. If you will be working with the ink in a very wet manner, you should either use a weight above 280 pounds (600 gsm) or a watercolor paper block, or you should stretch your paper to prevent buckling (see instructions for stretching paper in Chapter 5, p. 119).

- *Brush-and-ink paper*

Rice papers and *sumi* papers come in an extensive variety and are appropriate for brush and ink because they absorb ink evenly and limit uncontrolled spreading. For a less absorbent surface for use with dry brush and washes, you can use a heavy, cold-pressed, rough watercolor or drawing paper.

- *Silverpoint paper*

For silverpoint (drawing with a piece of silver inserted into a mechanical pencil, silverpoint holder, or wooden dowel), choose any smooth, 100 percent rag paper. The paper will need to be stretched and then coated with a fine, even wash of pigment to create a receptive surface in which tiny particles of the metal can embed (see p. 124 for instructions on laying a wash). Zinc-white watercolor or casein is commonly used. If you want a colored surface, use a colored watercolor wash or a colored casein wash.

There is an endless variety of papers available to the artist. One of the pleasures of being an artist is to find the right surface, and the pursuit can be a valuable component of the drawing process. The right paper—plain and inexpensive, or handmade antique Japanese paper—can help yield magnificent results.

I recommend inexpensive papers for the beginning student who is working on introductory exercises because cheaper paper will facilitate a less tentative approach and will eliminate the worry of ruining a more valuable one. That is not to say that one should not look for just the right surface for a particular work or curtail the effort to find exactly what suits specific requirements. For artists at any level it is always advisable to experiment with a variety of papers—inexpensive to expensive—to understand their individual properties. There are many options for cheaper papers: newsprint, brown craft paper, white butcher paper, or chipboard, to name but a few.

You can use a large newsprint pad (which is nonarchival and yellows badly with age) for incidental sketching such as quick gestures at the beginning of a figure-drawing session. All sketchbooks should be easily portable, so I would also recommend an 11 x 14-inch (28 x 35.5 cm) sketchbook for drawing sessions and a small sketchbook to carry everywhere as well.

DRY MATERIALS

Pencil
Graphite
Charcoal
Crayon
Colored pencil
Pastel
Silverpoint

Drawing encourages creativity and experimentation, but until you have a command of drawing what you see, it is best to start with a medium that will enable quick sketching and present the fewest obstacles for learning to see and draw. There is an extensive range of drawing media available, which can be combined, rubbed, smudged, blended, and erased. All of these combine well with each other, and you can add or subtract material at any time, or even continue on a drawing after letting it stand for an indeterminate length of time.

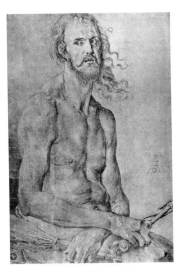

◄

Albrecht Dürer
Self-Portrait as the Man of Sorrows
1522
Lead pencil on blue-green primed paper
16 x 11 ⅜ in (40.8 x 29 cm)
Kunsthalle Bremen, Bremen, Germany

Dürer signed this drawing with his initials, which is significant, as at the time few artists had portrayed themselves at all or signed their finished works, much less their drawings. Dürer is said to be the first artist to create an independent self-portrait; in that particular work, he assimilated his features to those of Christ—similar to the way in which he identifies with Christ in *Self-Portrait as the Man of Sorrows*. The artist was convinced that creative gifts came from, and were a part of, the creative power of God.

Pencil

Until the seventeenth century, the term "pencil" referred to a tiny finishing brush, and so "pencil" is the archaic name for "brush." What we usually refer to as lead pencils are made of graphite (a crystallized form of carbon) and clay encased in wood. "Black lead" was the original name for graphite, which has been used for drawing since at least 2500 BC. The term "lead" is used to refer to the size of the drawing instrument by manufacturers, and the diameter of a lead is smaller than the diameter of a crayon. The addition of clay makes the graphite harder and produces a finer, lighter mark. Pencils with more pure graphite are softer and produce a darker mark; they range from 6H (the hardest) to 6B (the softest). Graphite ebony pencils create a deep, velvety, black mark that leaves a shiny, metallic deposit on the drawing surface. Pencils can also be charcoal, conté, colored, litho, and pastel. Charcoal and conté are also carbon-based; charcoal is produced by burning wood, and conté crayons are composed of pigment, clay, and a binder. The latter are somewhat more difficult to erase than graphite and charcoal.

Graphite

Graphite sticks have the same degrees of hardness and contain the same materials as pencils, but they are not encased in wood, whereas graphite crayons—larger than lead pencils—*are* encased in wood. It's also possible to find cylindrical sticks of graphite encased in lacquer to protect your hands, or pure powdered graphite, which can be manipulated with a chamois, a tortillon (a small stump of tightly rolled paper used to blend graphite, charcoal, and pastel), a brush, or your finger.

◄

Elsie Driggs
Study for Pittsburgh
1927
Graphite on paper
12 x 14 ½ in (30.5 x 36.8 cm)
Whitney Museum of American Art,
New York

This study is part of Driggs' ongoing exploration of a Pittsburgh steel mill. These forms began to appeal to her during childhood viewings while on train trips with her father, and related to her fascination with similar forms used by Piero della Francesca (1410/20–92).

Charcoal

Charcoal is produced by baking willow twigs or pieces of grapevine until they are almost pure carbon. Vine charcoal sticks come in various degrees of hardness and thickness; like graphite, charcoal is an old, universally used drawing medium. For drawing, it is best to use charcoal paper, but charcoal is also used for the initial drawing on an oil painting ground. Charcoal is easily manipulated with a chamois, tortillon, or your finger; however, be aware that your skin will deposit oil on the drawing surface that will combine with the charcoal to produce marks that will be darker and denser than areas without oil. That being said, in works of art the fingerprints produced by the artist's manipulation of the materials can be an integral part of the content of the drawing, recording aspects of the process and literally providing evidence of the artist's touch. Because charcoal smudges easily, it should be handled very carefully or sprayed with a fixative. Vine charcoal is also available in powdered form. Compressed charcoal is vine charcoal in pencil or uniform stick form. Both forms can produce very dark, dense, or precise marks, and the pencil can be sharpened.

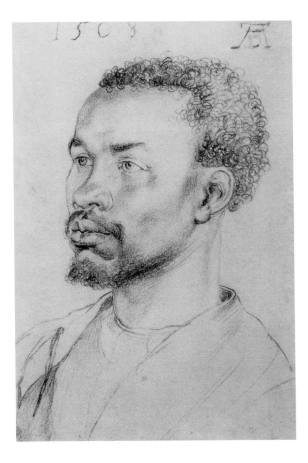

Albrecht Dürer
Head of a Negro
1508
Charcoal
12 ⅝ x 8 ⁹⁄₁₆ in (32 x 21.8 cm)
Graphic Collection, Albertina, Vienna

Crayon

The term "crayon" can be applied to any drawing medium in stick form within the fine arts, including chalk, conté crayon, and pastels, as well as charcoal, grease crayons, litho crayons, oil sticks, oil pastels, and wax crayons. Crayons are essentially instruments that are thicker than leads.

Charles Sheeler
Interior, Bucks County Barn
1932
Conté crayon on paper
15 x 18 ¹⁵⁄₁₆ in (38.1 x 48.1 cm)
Whitney Museum of American Art,
New York

A source for *Interior, Bucks County Barn* was a photograph Sheeler made and followed closely with the drawing. Using the conté crayon and the white of the paper, he emphasized the light and invented a broad series of textures for the many illusionistic surfaces he needed to describe.

The black chalk referred to in fine-art drawing is usually made up of vine charcoal. Conté crayons—a compound of pigment, clay, and binder—are usually in the form of a square stick or are encased in wood. Conté crayons are water soluble, so you can create washes with them. They are available in three grades of black (soft, medium, and hard), sanguine, sepia, white, and the less popular primary and secondary hues. Litho crayon is usually used for lithographic prints, but is also often used in drawing. It is an oily crayon, stick, or pencil, made in varying proportions of wax, soap, and lampblack carbon, and it comes in seven degrees from soft to hard (#00 to #5).

Grease pencils or crayons are used in industrial settings and may not be lightfast or archival. Oil sticks are basically oil paint in stick form, and they can be used with or without turpentine or mineral spirits. Oil pastels or oil crayons can be used in the same or a similar manner to oil sticks, and they may not be lightfast. Used by children, wax crayons are completely nontoxic and are neither permanent nor lightfast. All pigments suitable for artists' use should be lightfast in order not to fade or darken under normal indoor light conditions, with indirect sunlight or artificial light of average intensity.

er Paul Rubens
dy for Mercury Descending
3–14
ck and white chalk
⅞ x 15 ½ in (48 x 33.5 cm)
toria and Albert Museum, London

ɔens defined movement with
ɔng, curving chalk outlines and
irling volumes.

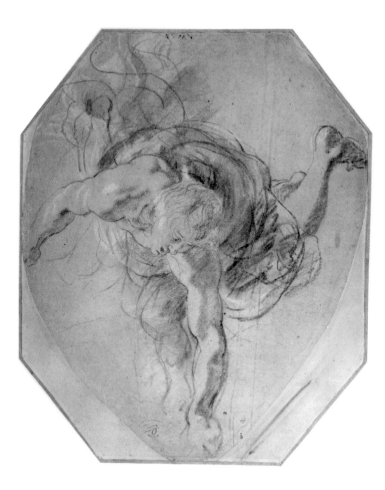

Colored Pencil

Artists' insoluble, water-soluble, and turpentine-soluble colored pencils are made with lightfast pigments and are encased in wood. Water-soluble pencils can be used as regular colored pencils, and can then be manipulated with a brush and distilled water to create washes. Watercolor sticks encased in a cellophane wrapper are also available, and they can be used in the same or a similar manner to water-soluble colored pencils. Turpentine-soluble pencils can be used like colored pencils as well, and then they should be diluted with mineral spirit instead of turpentine, which will stain and yellow your paper. Your paper will need to be sized with rabbit-skin glue or gelatin size to protect it from deterioration by the oil content in the mineral spirit (see Chapter 6, p. 142 for instructions on preparation of rabbit-skin glue). Gelatin size is made with half an ounce of gelatin soaked in one pint of water in the top of a double boiler for two hours. Heat the solution to melt it, but do not boil it. Let it cool to room temperature, and apply it with a brush to a stretched piece of paper. Let your paper dry for six hours to one day.

Pastel pencils are thin pastel sticks encased in wood that are softer than regular colored pencils. Unlike pastels, they can be sharpened.

◀

Jim Nutt
Hi—I'm so Happy (If a Bit Silly)
1981
Colored pencil on paper
10 ⅞ x 16 in (27.6 x 40.6 cm)
Whitney Museum of American Art, New York

Nutt used intense colors and tightly controlled lines and forms to explore a world of sexually charged imagery from the common culture of suburban life and the media.

Pastel

Pastel—the name for works executed in pastel—can refer either to drawing or painting. Colors are applied in masses rather than in lines, and because of this, pastels are often referred to as paintings rather than drawings. It is considered the most pure painting medium because pure color is applied directly to the paper without a brush, tool, or liquid medium. Colors can be blended and smudged with a tortillon or a finger, or they may be combined optically by placing them adjacent to each other. When viewed from a distance, small dots of blue and yellow will combine in the viewer's eye to appear as green. Specially prepared papers for pastels are mentioned above in the section on paper (see p. 40).

François Le Moine
Head of the Goddess Hebe
Undated
Colored chalks on blue paper
12 ¼ x 10 ⅛ in (31.1 x 25.8 cm)
British Museum, London

Pastels are crayons composed of pigments and very little binder—usually gum tragacanth. Pastel painting or drawing is the descendant of the prehistoric practice of applying earth pigments combined with weak binders to surfaces such as walls. There is a varying amount of inert or white pigment incorporated into most colors to create opaque tints, and the deepest in tone are pure pigment. You can make your own pastels with the same pigments used for watercolor. It is not a difficult or complex process, but it requires a great deal of experimentation to adjust the amount of inert pigment to make tints. Also, rigorous safety precautions have to be in place because of the extended exposure to larger quantities of dry pigments. Personally, I prefer to purchase pastels, and I suggest looking for those that have pure pigment with no additives or extenders.

The completed works are very fragile. Finished pastels should be stored in portfolios with glassine (thin, acid-free paper sold in sheets and rolls) between each work. For exhibition, pastels should be matted and framed. The mat should be made with a stiff material such as cardboard cut out in the center so that it forms a border between the outer edges of the pastel and the inner edge of the frame. The thickness of the mat prevents the pastel from coming in contact with the glass. Pastel is meant to be a fresh, opaque medium, and unfortunately fixative can deaden and render the colors transparent and weak. Although I do not use fixative, it can be beneficial, since pastel has the least amount of binder of any medium. To limit the deadening effect of fixative, apply it during the drawing/painting process to hold the colors to the surface, and then apply more fresh colors on top of a fixed layer. On completion, a very thin spray of fixative can be applied just to set the colors.

Silverpoint

For silverpoint drawing, a piece of silver wire approximately two to three inches long is held in a mechanical pencil, silverpoint holder, or wooden dowel. If the wire has jagged edges, it should be rubbed on fine sandpaper to remove any edges that could cut the paper. When drawn across the surface of a rag paper prepared with a wash of white or colored watercolor, silverpoint leaves a faint gray line that will darken as it tarnishes. It was used extensively for underdrawing in panel painting and for fine-art drawing on prepared paper during the Italian Renaissance, but it was superseded in the seventeenth century by the graphite pencil, which is easier to remove. It endures as an artist's technique for its refined delicacy. The drawings have a light, airy quality, and the marks produced have a narrow value range somewhat like those produced by a harder lead such as the HB. It is not possible to erase unless you draw on a glue gesso panel, which will allow marks to be sanded away. It is advantageous to use silverpoint underdrawing on wood panel for tempera and watercolor paintings because it shows through far less than pencil or charcoal. Silverpoint is the traditional medium, but aluminum, platinum, and gold have also been used.

◄

Raphael
St. Paul Rending his Garments
1514–15
Silverpoint and white gouache heightened
on lilac-gray prepared paper
9 ⅟₁₆ x 4 ⅟₁₆ in (23 x 10.3 cm)
J. Paul Getty Museum, Los Angeles

Test sheets for dry materials

Create test sheets for each medium as you acquire it. Experiment with different types of lines and planes with value gradations.

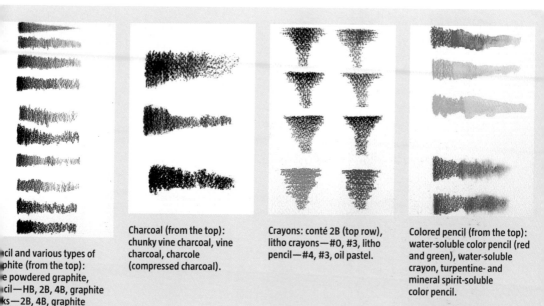

... cil and various types of
... phite (from the top):
... e powdered graphite,
... cil—HB, 2B, 4B, graphite
... ks—2B, 4B, graphite
... ased in lacquer—HB,
... nky graphite crayon—4B,
... ebony graphite pencil.

Charcoal (from the top): chunky vine charcoal, vine charcoal, charcole (compressed charcoal).

Crayons: conté 2B (top row), litho crayons—#0, #3, litho pencil—#4, #3, oil pastel.

Colored pencil (from the top): water-soluble color pencil (red and green), water-soluble crayon, turpentine- and mineral spirit-soluble color pencil.

... pastel.

Silverpoint crosshatched.

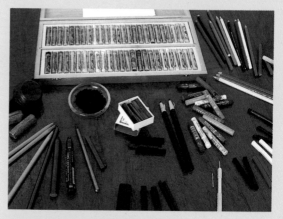

A selection of dry media (clockwise from top): soft pastels, water-soluble color pencils and watercolor crayons, turpentine/mineral spirit soluble color pencils, conté crayons, silverpoint holder and silver, charcoal—vine, charcole (compressed), chunky charcoal stick, various graphite—graphite sticks, graphite encased in lacquer, chunky graphite, crayons, ebony pencil, pencils, wax rubbing crayons—also referred to as "heelball" for rubbings/frottage. Inner area from left: powdered graphite, litho crayons, litho pencils, oil pastels.

WET MATERIALS

Types of inks
Pen and ink
Crow-quill pen
Steel pens and various nibs
Bamboo reed and feather quill pens
Brush and ink

Ink is the basic wet medium for drawing that I will be discussing here, but it is possible to draw with any wet medium. Writing inks are made from soluble dyes that are not lightfast, and because of this they are not considered suitable for permanent works of art. Since writing is not generally exposed to light, it can remain legible for centuries. For fine-art practice, though, it is advisable to use inks that are a compound of pigment (not dyes) and shellac to ensure that they are lightfast and durable. Ordinary drawing ink made for use in

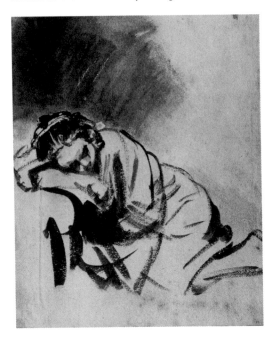

◄

Rembrandt van Rijn
Young Woman Sleeping
(Hendrickje Stoffels?)
*c.*1654
Brush drawing in brown ink
9 ⅜ x 8 ⅟₆ in (24.5 x 20.3 cm)
British Museum, London

pen or wash is usually called *india ink* in the United States, but it is also known as *shellac ink*, shellac being the ingredient that makes these inks water-resistant. They can be gone over with a wash or watercolor. Shellac inks can be diluted with distilled water or shellac, and thinned with distilled water.

India ink was originally used by the ancient Chinese and Egyptians (with the carbon-black pigment deriving from India), but it was not widely used in Europe until the seventeenth century. Carbon was produced by soot such as that produced by the charcoal of many kinds of woods or burning oils. The pigment was ground to a powder, then mixed with gum and resin, and finally hardened by baking. When applied to a surface, it dried water-resistant and did not turn brown or fade. Manufactured india inks are made of carbon-black pigment ground in water with shellac, which makes them water-resistant. Lightfast in normal indoor light conditions, they can be applied in washes with a brush or with pens such as steel pens with a variety of nibs, crow-quill pens, feather quill pens such

as turkey, goose, or swan, and reed or bamboo. Drawing inks may also be bound with acrylic, and they will dry water-resistant. If the inks are made with pure pigments (not dyes), they will be lightfast in normal indoor conditions, and you can also find drawing ink that is re-soluble in water.

Chinese ink and Japanese ink, called *sumi* ink, are similar to india ink, and are usually not lightfast. They are dried and molded into sticks, then put into a solution for use by rubbing the ends on an ink stone with a little water.

Most Renaissance pen-and-ink drawings were made with iron-gall ink, a medium for writing. It was obtained from the nutgalls of oak trees. Iron-gall ink was almost black when first applied, but it turned brown with time, and its acidic nature can cause holes in paper.

Sepia ink is made from a pigment extracted from the ink bag of the cuttlefish or squid. The hue can range from black to yellow-brown. Sepia ink can fade rapidly in bright light and is not generally approved for use as artists' ink.

Most colored drawing inks do not claim to be permanent or lightfast. The ones that are made with permanent pigments are usually labeled with the pigment names rather than the names of the hues (such as red or blue).

Papers for pen and ink, and brush and ink, are discussed above in the section on paper (see p. 41). Paper can be stretched if you anticipate working in a very wet manner.

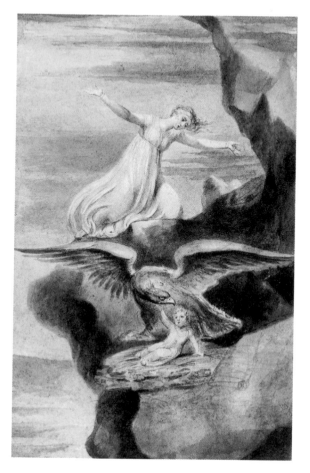

◀

William Blake
The Eagle
1802
Sepia washes with traces of color
3 ⅝ x 5 ¼ in (9.2 x 13.3 cm)
The Pierpont Morgan Library and Museum, New York

Test sheets for wet materials

Create test sheets for each medium as you acquire it. Experiment with different types of lines and planes with value gradations.

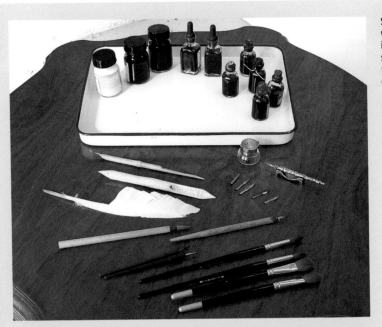

Selection of inks (in the tray, from left): white shellac ink, black india ink (shellac ink), water-soluble iron-gall ink, water-soluble indigo ink, water-soluble *terre verte* ink, water-soluble inks in various colors.

Pens and brushes (from the top): bamboo reed pens, feather quill pen, ink well, steel pen and various nibs, bamboo brush, wood holder with metal nib, crow-quill pens, sable brushes for ink washes.

Water-soluble ink—indigo and iron-gall.

Water-soluble ink—washes.

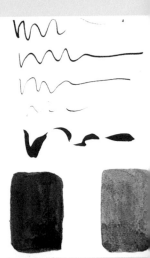

India ink (water-resistant shellac ink), black and available in colors (from the top): marks made by bamboo reed pen, feather quill pen, steel pen, crow-quill pen, brush, and washes.

Bruce Conner
Inkblot Drawing
1990
Ink on paper
23¼ x 23⅜ in (59.06 x 59.37 cm)
Whitney Museum of American Art,
New York

In his inkblot drawings, Conner
determines ahead of time where
the inkblots will be placed, but the
plan may alter after the process starts.
To begin, he uses a ruler and a stylus
to mark out the page and score the
paper, and uses a crow-quill pen and
ink to create the drawing. The paper
is then folded along its full length, and
a print is made. If scored lines are
vertical and parallel to one another,
they become a part of the artwork and
help create a series that enhances
variations. Viewing the finished work
can be a cinematic experience. One
inkblot affects the response to the next,
engaging the viewer in a process with
the potential for change and renewal.

◄

Frank Piatek
Drawing-Dyad
2002
Graphite pencil on
Basingwerk paper
29 x 26 ¾ in (73.6 x 67.9 cm)
Collection of the artist

Intertwining tubular forms
suggesting ascending movement,
life, and growth beyond the picture
plane are imbued with lumines-
cence by Piatek's use of the deep,
dark, richness of ink offset by the
white of the paper.

TOOLS

Erasers
Tortillons
Chamois
Incising tools—craft knife, etching needle
Natural sponge
Other Materials
 Plastic ruler
 Clamp
 Drawing board
 Pencil sharpener and fine sandpaper
 Porcelain palette with indentations
 Distilled water

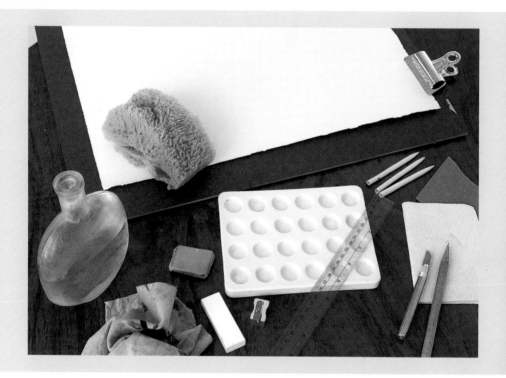

There is an extensive array of drawing materials, many of which are for graphic-reproduction purposes, and because the work to be viewed is the reproduced image, the materials for the original are not meant to be durable, lightfast, or archival (permanent). Professional artists' materials, on the other hand, should always be permanent and lightfast, so I have, for the most part, limited my focus to those materials that will survive. I have made an effort to suggest only media that are permanent, but you should always check with your supplier and/or the manufacturer if it is at all unclear as to the permanence of a specific item. You may choose to use an impermanent material, and if you do, you should be aware of the way in which the materials may deteriorate, taking into account the presumed effect as you conceptualize and plan your work.

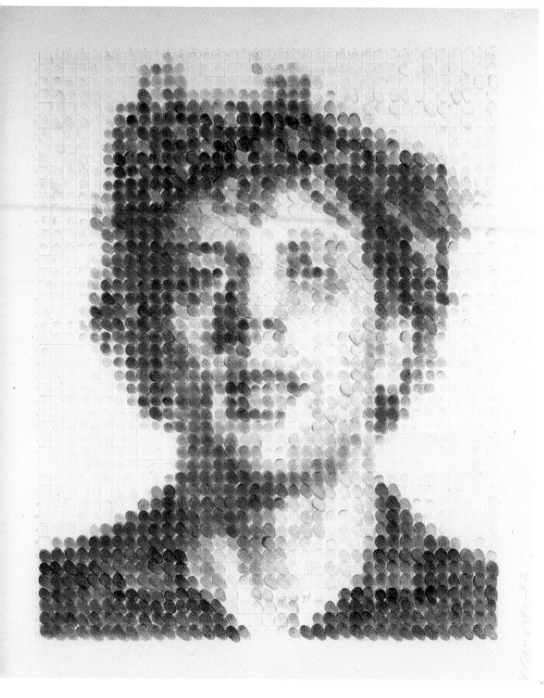

ck Close, Phil/Fingerprint II
8
mp-pad ink and graphite on paper
4 x 22 ½ in (73.7 x 58.9 cm)
tney Museum of American Art, New York

g his finger, Close applied stamp-pad
to each segment of a grid, creating a
es of marks to represent the facial
tures of his friend, composer Philip Glass.
eticulously observing a photograph of
ss with a corresponding grid, Close began
e top left and worked his way down,
n right to left, on each line.

3
THE DRAWING PROCESS

Drawing is an intimate language that can reveal what we see or experience, what we imagine or remember; it is a visual record of ideas, concepts, emotional states, or non-verbal symbols, and is a means to communicate ideas. A successful drawing could incorporate all of these characteristics, some of them, or just one.

Drawings are a document of the process and a direct reflection of thinking and artistic decision-making. In this chapter, we will address the importance of the unfinished aspect of the drawing process and the drawing as an exercise—an exploration of ideas, an embodiment of transition and flux in the act of experience. Drawing can record and reveal the stream of your ideas and impressions as they flow in and out of your visual field. I suggest that you focus on the importance of regular sketching and drawing as a daily activity in order to bring about a level of skill and comfort with drawing itself, and the use of various materials. Historical methods and experimental techniques will be incorporated into the suggested exercises.

Workshop of Benozzo Gozzoli
Madonna and Child, Putto,
Angel, and Sketches of Hands
c.1460–75
Pen and ink and point of the brush
8 ⅞ x 6 ⅒ in (22.5 x 15.5 cm)
Museum Boijmans van Beuningen,
Rotterdam

Copying the drawings of a master artist can be of great value for the practical understanding of the language of drawi and to gain a drawing vocabulary. Copyi also provides an insight into what and h a particular artist sees.

Cennino Cennini suggested that students copy their masters' drawings a an essential part of their training. It is believed that this sketch was created by a student in the workshop of Benozzo Gozzoli. The standing *putto* was copied from a Gozzoli drawing that is now in Dresden, Germany. The student artist copied the angel from another Gozzoli drawing (now in Chantilly), and he copi hands that Gozzoli studied from life.

Annibale Carracci
Three Studies of Men
Mid-1560s
Black chalk
10 ⅞ x 8 ⅛ in (27.7 x 20.7 cm)
J. Paul Getty Museum, Los Angeles

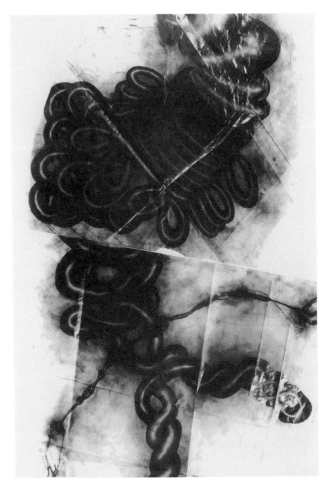

◀

Joana Rosa
Doodles (detail)
1994
Graphite on vellum
Collection of the artist, Lisbon, Portugal

The proposition that creating works of art
that are always in a state of coming into
being is a metaphor for our own emergen
identity; this is reflected in Rosa's
awareness that her works may never arri
at the point where they can be identified
as finite things with an identity of their ow
Rosa created a series of wall pieces, each
of which consists of hundreds of heavily
worked doodles on vellum. They were
collected over a period of several months
and then assembled free-form directly on
the wall. Underlying motifs can emerge
from the improvised structure, while the
configurations are not to be interpreted
as a final state of the work.

The open-ended process of making an
assembling is a reflection of the artist's
need to impose a conscious structure ove
the unconscious activity of the mind at re
in doodling. I have seen these drawings i
various locations, in different configurati
each time, on large expanses of wall, or
occupying entire rooms. Motifs can appe
in turn as early industrial machine parts,
meandering intestinal forms, or futuristi
weapons. *Doodles* is an articulation of a
contrast between the hundreds of
accumulated hours and the fragility of th
framework that holds it together. The
delicate skin-like appearance of the vellu
which in actuality is very tough and stan
up to vigorous manipulation, adds anoth
layer of material ambiguity.

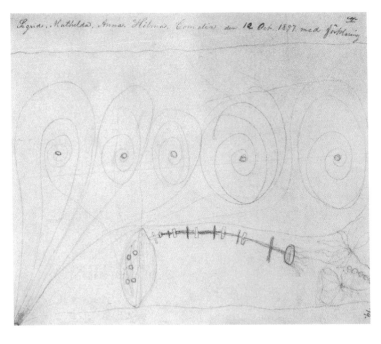

◀

Hilma af Klint
Page from Automatic Séance Sketchboo
1890s
Pencil on paper
12 x 10 ¼ in (30.5 x 26 cm)
The Hilma af Klint Foundation, Verk

Af Klint's automatic sketches document
her experience of being in a trance.

▶

Pages from
The Diary of Frida Kahlo
by Frida Kahlo

Kahlo documented her physical and emotional shifts and changes in a raw, direct style, using color, marks, and language to accentuate emotional states and create a visceral intensity.

Exercise: doodling

Materials: graphite, pencils, chamois, plastic eraser, kneaded eraser, tortillon (a stump of rolled paper used for blending), vellum, cellophane tape, sketchbook, dust mask, and etching needle or other sharp instrument for incising lines.

Doodling is a way to become familiar with the feel and individual characteristics of various media. It is a viable exercise to begin using drawing materials and to experiment with new materials. Let your mind rest as you doodle freely in your sketchbook and elaborate on your doodles. Do motifs emerge and reoccur?

Doodle on small, irregular pieces of vellum. If you incise lines with an etching needle, graphite will collect to form visible lines. Graphite will also collect where your fingers have left a print, due to the moisture in your skin. Spread a small amount of loose graphite onto vellum, blend and smooth it out with your chamois, and alternately erase and then smudge with a tortillon (also called *stumping*) as needed. Then doodle back into the graphite with a pencil. When you have several doodled sketches that you have developed over a period of time, assemble them, with tape if necessary, into a free-form wall piece.

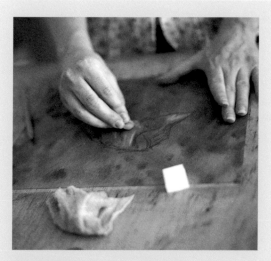

While doodling, you can blend and smooth with a chamois, erase with a kneaded eraser, and smudge with a tortillon.

Grouped doodles can reveal underlying motifs.

LOOKING CLOSELY TO DOCUMENT EXPERIENCE

Learning to see and draw

Looking closely at your subject while applying drawing media to paper can give you a deeper understanding of the material world, and will encourage the creation of a visual analogue of what you are seeing. Just as with any exercise requiring the body or mind to learn a new language, your body will become adjusted as you continue over an extended period to engage in the practice of drawing what you see. Your hand will learn to guide your drawing instrument while it follows the movements of your eye as you build your drawing muscle and hand-eye coordination. You will gain skill, confidence, and an understanding of how to translate the three-dimensional visual world you know into a two-dimensional representation of how it appears. Try not to think about what you know about the world you navigate daily, and just draw what you see, not what you *think* you see.

Techniques and terms relating to documenting what you see

There is an extensive amount of information on each of these techniques and terms. I will refer to them in the exercises in this chapter to indicate examples. Please see Further Reading to find resources with greater detail.

- Contour: the line following the outer edge of forms to describe volume.
- Gesture: in gesture drawing, the hand duplicates the movement of the eye and replicates what you see, at first glance, of the general characteristics of the subject: mass, movement, weight, and shape. Gesture enlivens the work and establishes the composition; it is the essential element in establishing unity between drawing and seeing.
- Shape and volume: shape and volume represent height, width, and depth of a form. A shape is two-dimensional when it has the same value or color on its entire surface. If you tilt a shape, you can give it dimension by making it move diagonally into the picture plane (the two-dimensional surface on which you work). If a line used to define a form varies in thickness or darkness, or when the line breaks, the shape will become less flat. Volume appears when you use imprecise edges, blurred texture, smudging, and shading. Defining the change from light to dark across a shape by modeling brings shape and volume together by creating the illusion of three-dimensionality.
- Value: value is the gradation of tone from light to dark, no matter the color. Value is an important element for spatial development, and you can define value variations by shading (merging or blending one value into another), crosshatching (fine, closely set, crisscrossed lines) or hatching (fine, closely set, parallel lines), to create the illusion of volume.
- Line: can describe a subject and express the feelings of the artist. The line you choose and the individual way you employ it will convey something of your identity to the observer. The kind of line chosen must correspond in character to the content and mood of the work of art.

Some types of lines are:

Cross-contour: like contour, but goes across forms to describe volume;

Outlines: outline shapes and renders the subject flatter than a contour line;

Calligraphic: resembles free-flowing, continuous handwriting (see Rembrandt van Rijn, *Young Woman Sleeping (Hendrickje Stoffels?),* Chapter 2, p. 50); and

Implied and blurred: stop or are broken, smudged, blurred, or erased, and the observer fills them in conceptually.

Lines that discontinue, break, change in width, and change from light to dark are more dimensional than flat lines of one width. Horizontal and vertical lines create a shallow space. When a line penetrates the picture plane diagonally, the illusion of three-dimensional space appears. In this chapter, Annibale Carracci's *Three Studies of Men* (see p. 59) shows a variety of lines in one work such as contour, cross-contour, hatched, crosshatched, blurred, and broken lines.

● Texture: there is the *actual* texture of the materials, such as the texture produced by conté crayon; *represented* texture, achieved by imitating the texture of the subject drawn; and *transferred* texture, which is produced by applying a wax rubbing stick or other crayon to a drawing surface that is resting on a textured surface.

● Spatial illusion: line (linear perspective) or tone (atmospheric perspective) which gives the impression of three-dimensionality and depth on a flat surface creates spatial illusion. Objects appear to diminish in size as they recede into the distance until, given enough space, all objects disappear. Diminishing size, color, clarity, and overlapping of forms all provide the illusion of receding space. The term "foreshortening" refers to the use of perspective in depicting an individual form. The term "perspective" refers to the depiction of an entire scene and structures.

◄ ▲
Susan Toplikar
Pages from Bird sketchbook
Collection of the artist

Toplikar spent a year looking at these birds while convalescing from an illness. At first she was hesitant to draw them, but as the days passed she noticed that the birds assumed the same positions, which allowed her to practice drawing what she saw, to build hand-eye coordination, and to track her life and theirs.

Exercise: continuous curved-line drawing (contour line: following the outer edge of forms); observational writing/creating a book

Materials: graphite, pencils, chamois, plastic eraser, kneaded eraser, tortillon, vellum, sketchbook, dust mask, heavy thread, awl (a pointed instrument for making small holes) or hat pin, and heavy paper.

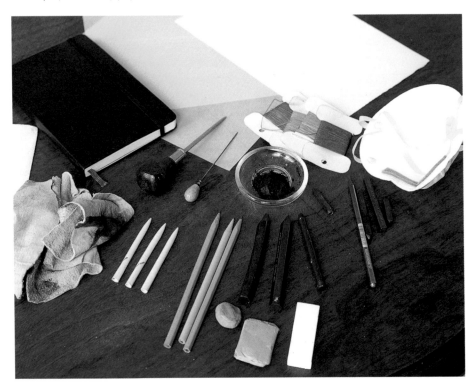

- Fold a piece of vellum in two.
- On one half of your vellum make a small, continuous curved-line drawing of an everyday object, or go to a museum to observe a sculpture. While drawing, do not lift your pencil from the paper and look only at what you are drawing, not at the paper.
- On the other half of your vellum write your observations in the form of an informal sketch poem.
- Since vellum is translucent, the words and images will visually combine when you fold the halves together.
- Add sheaves of vellum until you have at least five to create a book. Choose another type of paper for a cover. Make at least two small equidistant holes with an awl or heavy pin. Draw a heavy thread through the holes and tie it. Make these small books to develop other ideas and follow a thought wherever it leads you.

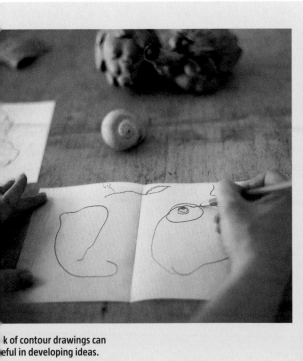

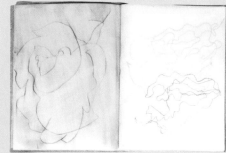

k of contour drawings can
eful in developing ideas.

Punching holes through sketches allows
them to be bound together with heavy
thread.

Examples of students' contour drawings
collected in observational book form.
Layered imagery occurs as the lines
forming words and the lines forming
subject matter combine.

◄

Alexander Calder
The Handstand
1931
Ink on paper
22 ¾ x 30 ¾ in (57.8 x 78.1 cm)
Whitney Museum of American Art,
New York

Calder used wire and more conventional drawing media such as ink to engage in ongoing investigation of forms with the continuous curved line.

◄

Elie Nadelman
Head of a Woman with Hat
c.1923–5
Graphite on vellum
16 ½ x 10 ¾ in (40.64 x 25.4 cm)
Whitney Museum of American Art,
New York

Nadelman employed only the curved line to describe the forms in *Head of a Woman with Hat*. Even the hatched lines, which used to indicate shadows and variation value, have a slight curve.

Jensen
k Line Drawing
3

phite and charcoal on vellum
19 in (61 x 48.3 cm)
tney Museum of American Art,
York

rawing on both sides or by leaving
es of early exploration of the drawing
on translucent vellum, Jensen has
ted an active space and revealed the
ving process. The heavy compound
built with thick sticks of graphite and
coal meanders in, out, and around
buoyant strength.

THE THUMBNAIL SKETCH

A thumbnail sketch is a small, concise drawing representing the main features of an object or scene; it generally omits detail, focusing instead on capturing the essence of a subject. The term "thumbnail" refers to the size of the drawing—usually a one-inch square or a one- by one-and-a-quarter-inch rectangle—which is often made as a preliminary study for a larger drawing or work of art. It can also be a memory marker: a record for later reference.

Exercise: the thumbnail sketch
Materials: sketchbook, a variety of pencils (HB to 6B, colored, etc.), pastels, charcoal, erasers, tortillon, card, utility knife, and straightedge.

- While on your way to your daily activities, stop at a few locations that are of particular interest to you, and make a thumbnail sketch at each place. Use a viewfinder to frame and isolate the forms that interest you. Always hold the viewfinder at arm's length in a true vertical plane so it can serve as a tool to portray vertical, horizontal, and proportional relationships and measurements accurately, and to provide a consistent view. You may also want to keep written notations.
- At the end of the day choose one thumbnail sketch. Using charcoal or pastel, enlarge your sketch to fill an entire page of your sketchbook. Blend and smudge with a tortillon to create value variations and to combine colors.
- You may want to incorporate your notations into your larger sketch.

To prepare a viewfinder, use a straightedge to measure a one-inch square on a small piece of cardboard. Outline it with a pencil and lay your straightedge along the lines to cut out the square with a utility knife.

A pencil will also work as a measuring implement. Hold it at arm's length and in a true horizontal or vertical position in order to measure vertical, horizontal, and proportional relationships accurately.

Always just look at your subject. Use visual aids initially to direct your first steps, and then occasionally to clarify relationships and identify areas for correction as you draw. Do not rely heavily on aids as you develop independent judgments and hand-eye coordination.

◄
Georgia O'Keeffe
Drawing No.8
1915
Charcoal on paper mounted on cardboard
24 ¼ x 18 ⅞ in (61.6 x 47.9 cm)
Whitney Museum of American Art,
New York

O'Keeffe made thumbnail sketches to examine the forms in nature that interested her. She then made larger drawings to explore her subjects further.

g a straightedge and a utility knife
eate a viewfinder from cardboard.

A pencil held horizontally or vertically can
also function as an accurate measuring
device.

ving with a viewfinder helps students
eve accurate perspective.

Thumbnail sketches. At the end of the day,
pick one to work up into a large drawing.

"And when you begin to draw, form in your own mind a certain principal line
(suppose a perpendicular). Observe well the relationship of the parts to that
line, that is, whether they intersect it, are parallel to it, or are oblique to it."[6]

Leonardo da Vinci

KEEPING A SKETCHBOOK

Take a small sketchbook with you wherever you go, and draw for ten minutes every day. Doodle, draw from memory and imagination, from sounds in the environment, from nature and everyday objects, and use other artistic resources such as museums, theaters, and botanical gardens.

Draw what you see; look at an object to analyze the relationships of shape, value, proportion, and texture. Create a corresponding set of relationships on paper as a graphic record of your observations.

Looking from one point of view, translate what you see in the three-dimensional world to a two-dimensional surface. Then look at the object from at least four different locations to record the four points of view sequentially, or one on top of the other. Record how things appear as opposed to how you know them from your experience in the three-dimensional world.

Exercise: composite sketch/sequential sketch

Materials: sketchbook, long rectangular paper, pencil, eraser, and tortillon.

- Form a circle around a sculpture or an everyday object such as a chair.
- Rotate once every minute at the beginning of the exercise; then gradually move every two minutes until you have completed the circle and returned to your original position.
- Notice the shapes of the "negative space"—the space surrounding the sculpture—formed by the sculpture.
- Use only the most essential lines to describe what you are seeing.
- Sketch from at least four points on the circle.
- Sketch right on top of your previous sketch.
- When you have returned to your original location, you will have a composite sketch of the sculpture or object from several points of view.

 Or

- Fold a long rectangular piece of paper into four equal sections by folding your paper in half and then folding it in half again, or draw four small squares on a page in your sketchbook.
- Rotate once every two minutes around a sculpture or other object until you have sketched four different points of view: one in each section or square of your paper.
- When you have returned to your original position, you will have sketches from four different points of view.

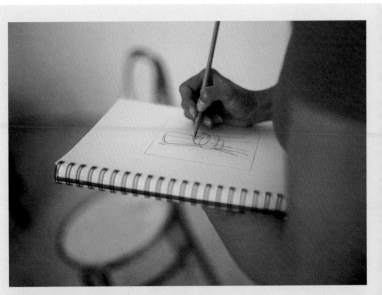

Drawing the same object from four different points of view helps focus on the relationship between negative space and that occupied by the object itself.

Exercises to encourage seeing and drawing

Gesture

Materials: indigo, iron-gall, and other inks; crow quill pen; feather quill pen; bamboo reed pen; sable brush; large newsprint paper for quick sketches; various papers such as mulberry and persimmon, and handmade antique paper.

While observing the figure, make a few 15- to 30-second gesture drawings. Make a few three-minute gesture drawings. Use large-format paper.

Gesture drawing with a feather quill pen—playing with wet materials....

...and with a brush and wash.

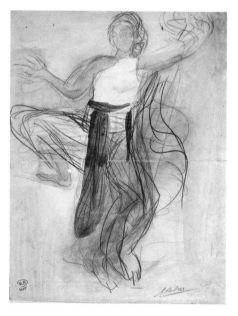

A successful gesture drawing captures the essence of a subject in a few lines.

◄

Auguste Rodin
Cambodian Dancers
1906
Graphite and watercolor
13 ⅔ x 10 ½ in (34.8 x 26.7 cm)
Rodin Museum, Paris

In 1906, royal dancers of King Sisowath of Cambodia came to Paris to perform. Rodin had the opportunity to draw them for a few days before they left for Marseilles.

Exercises to encourage seeing and drawing

Shape and volume

Materials: pencil, tortillon, chamois, erasers, and 90 lb (185 gsm) Fabriano Artistico hot-pressed paper.

While observing a head, a squash, or a pumpkin, represent the height, width, and depth of a form.

This drawing of a squash conveys a sense of volume.

Above: Drawing round objects teaches students to portray "weight" as well as form.

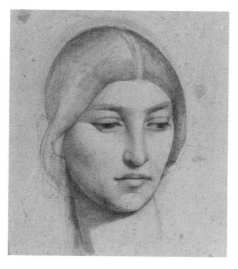

◄

Pierre Puvis de Chavannes
Study of a Woman's Head
*c.*1860–70
Pencil on buff paper
6 ¾ x 5 ¼ in (17.1 x 13.3 cm)
Sterling and Francine Clark Art Institute, Williamstown, Massachusetts

While emphasizing shape and volume, Puvis de Chavannes simplified and minimized the facial features to forms that suggest a classical ideal of perfection.

Exercises to encourage seeing and drawing

Value

Materials: charcoal, loose graphite, pencil, pen and ink, tortillon, and 90 lb (185 gsm) Arches hot-pressed paper.

While observing drapery, blend one value into another with graphite or charcoal and tortillon, or shade by hatching and crosshatching with pen and ink or pencil to show the gradation of tone from light to dark.

Drapery is an ideal subject for observing and learning to portray variations in value.

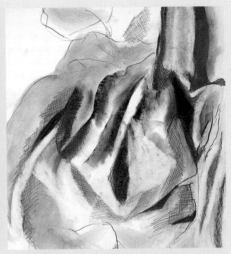

The illusion of folds can be created by smudging graphite or charcoal into the drawing.

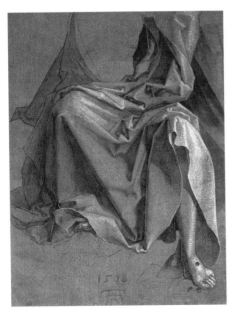

◄

Albrecht Dürer
Study of a Drapery
1508
Brush drawing on dark paper
with white highlights
10 x 7 ½ in (25.7 x 19.2 cm)
Louvre Museum, Paris

Dürer showed shape and volume by shading with hatching and crosshatching.

Exercises to encourage seeing and drawing

Line

Materials: various pencils, tortillon, erasers, and crayons (pastels, oil pastel, and litho crayon), and pen and ink.

You have already used various types of line such as doodling, contour, and gesture line. Experiment with other types of line such as cross-contour (a line that follows the eye across a form); calligraphic (free, rhythmic line that has the variety and flexibility of handwriting); implied, erased, and broken line (a line that stops and then continues again, allowing the eye to follow the unseen trajectory to complete the form); or blurred and smudged line, while sketching an everyday object such as a chair, vase, glass, box, egg, or paper bag. You could even sketch the human figure.

◀

Claes Oldenburg and Coosje van Bruggen
Soft Shuttlecocks, Falling, Number Two
1995
Graphite, charcoal, and pastel on paper
27 ¼ x 39 ¼ in (69.2 x 99.7 cm)
Whitney Museum of American Art,
New York

Oldenburg used broken, scribbled, erased, parallel, hatched, calligraphic, smudged, and blurred lines. In his own words: "I think drawing is making any kind of a mark that activates a space. My particular drawing depends on line. Line is what leads it on."[7]

Texture

Materials: conté crayon, pastels or other crayons, and Arches or Fabriano cold-pressed paper.

Explore the quality of the actual texture produced by your materials as you experiment with the use of conté crayon on a rough-surfaced paper. Draw an object or a scene in nature by isolating a segment with your viewfinder to present a view of simple forms.

▶

Georges Seurat
Study for Les Poseuses
c. 1886
Conté crayon on laid paper
11 ¾ x 8 ⅞ in (29.7 x 22.5 cm)
Metropolitan Museum of Art, New York

Conté crayon on rough paper produces a granular quality, as exemplified by Seurat's *Les Poseuses* ("The Models").

Exercises to encourage seeing and drawing
Spatial illusion
Materials: loose graphite, pencil, graphite sticks, graphite crayons, tortillon, chamois, erasers, large sheets of paper or large sketchbook, and dust mask.

For this exercise, build on the thumbnail-sketch exercise by making several large, quick sketches, and use line and tone to indicate the impression of three-dimensionality and depth while observing a scene in nature. Pour a shallow spoonful of loose graphite on a large sheet of paper and, using a chamois, spread out and rub in the graphite to provide a thin veil of middle-toned gray. Using a viewfinder to locate the scene, focus on the main features of the scene, not on the details, as you draw into the graphite with a pencil and erase away, smudge, and blur the graphite to produce light and value variations in forms.

▲
Rackstraw Downes
Portland, ME, The Million-Dollar Bridge
1983
Graphite on paper
19 x 50 ⅜ in (48.3 x 128 cm)
Whitney Museum of American Art,
New York

This was a study for a painting. The most distant elements are stated in light gray, increasing to darker values toward the center. The darks continue as they veer off to the left where shrubs and nautical gear engage the eye. Articulation of forms and brilliant light is defined, in high contrast to the darks, by leaving the white of the paper or by erasing back to it.

◄
Odilon Redon
Trees
c.1865–8
Graphite on blue-green paper
16 ¾ x 11 ⅝ in (42.5 x 29.5 cm)
Museum of Modern Art, New York

Redon's aesthetic combined an intense interest in observed reality and imaginati In *Trees*, we can see the evidence of his passion for the observation of nature which began in childhood with his deep appreciation of the remote landscape o the Médoc region of France.

Draw from nature/looking closely at the subject —
foreshortening and various points of view

Sketchbook exercise: leaf, branch, or other object from nature

Materials: pencil, sketchbook, tortillon, erasers, viewfinder, silver- or metal-point holder, light sandpaper, zinc-white watercolor to prepare one leaf of the sketchbook, or a gesso panel and brush.

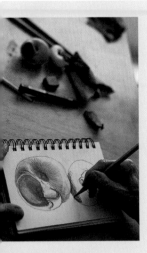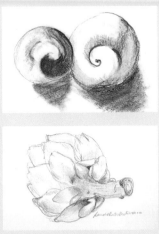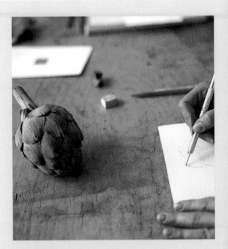

ving an object from above
low forces the eye to
 on what is, rather than
 is thought to be.

Tilting objects trains the
observer in the technique
of foreshortening.

Drawing with silverpoint on
prepared paper.

To draw from observation and visual analysis, as opposed to the *idea* of what you see, look closely and often at your subject. Draw a leaf or another object from nature, from above and below. To draw a foreshortened view, tilt the leaf so that one edge projects toward you and one edge projects back into space. From one point of view, draw the subject with silverpoint on paper prepared with zinc-white watercolor or on a gesso panel. For further exploration and to create a series of related works, draw the form in isolation and consider drawing it as it appears in a larger context. For example, draw the seed, the plant, and the field of plants.

◀

Joseph Stella

Mixed Flowers with Hydrangea

1919

Silverpoint and colored crayon on paper

14 ⅛ x 9 ½ in (35.9 x 24.1 cm)

Whitney Museum of American Art, New York

Silverpoint allowed Stella to render botanical subjects with clarity, precision, and delicacy. He prepared his ground by thinning zinc-white gouache to the consistency of light cream and applying it unevenly on the paper with a swift brush stroke. When he applied the silverpoint over colored pencil, he found that it took on a richer and deeper tonality. And when colored pencil was applied over silver, it obscured the stroke and softened the contrast.

After practicing this exercise several times, you can begin to choose what aspects of your visual observations of the subject best express your impression. You may wish to reduce the visual information to what you determine to be the most essential aspect of what you are seeing. See the following examples for ways that Ellsworth Kelly and Arshile Gorky decided to indicate what, for them, were the most important visual aspects.

▲
Ellsworth Kelly
Briar
1963
Graphite on paper
22 ⅜ x 28 ½ in (56.8 x 72.1 cm)
Whitney Museum of American Art,
New York

Kelly chose to use pure contour that suggested shape and volume, and to leave out any extraneous information and details.

▲
Arshile Gorky
Drawing
1946
Graphite and colored crayon on paper
19 ⁄16 x 25 ⁄16 in (48.4 x 63.7 cm)
Whitney Museum of American Art,
New York

Gorky drew forms in nature. During the process he transformed and abstracted the forms to express a psychological state of being.

Exercise: abstraction to figuration—layered sketch

Materials: various pencils, inks, brushes, pens, wax rubbing stick or any crayon, vellum, and various papers.

Build on the *continuous curved-line drawing; observational writing/creating a book* exercise (see p. 64) to further explore the creation of layered imagery.

• If you are in a museum, sketch a detail of a work of art or make a quick sketch of a person or people passing by.

• On a piece of vellum, sketch an abstract pattern or motif by using pre-existing shapes such as floor patterns, architectural motifs, stars, your hands, numbers, or letters. You can also create a rubbing* (also known as *frottage*) by using a wax rubbing stick or any crayon to produce a texture or design. Rub the stick on your vellum while it rests on a textured surface or design such as a mosaic floor, a coin, or an engraved stone surface.

• Cover the entire sheet.

• Overlay your abstract motif onto your figurative sketch.

• To visually connect your two sketches, erase, adjust, and emphasize similar shapes and forms in both of them.

*A rubbing is used as a quick recorder or visual memory marker of an experience. Besides vellum, *aqaba tableau* (a smooth, strong, lightweight paper suggested for use when making woodblock prints and monoprints) works well for creating rubbings. It is thin yet tough and resilient.

Exercise: a selection of historical methods and contemporary experimental techniques
Study
Materials: optional.

A study, a more carefully detailed representation than a sketch, is used to work out themes, ideas, techniques, and materials in an experimental way, or as an evaluation of suitability for a future project. It is often a detail or details of a projected work, such as a head, figure, or botanical or architectural motif.

Think of a theme or idea you would like to explore. Create a series of studies either to explore the idea through the materials and techniques you have chosen for your project or to explore your idea in a purely experimental way.

▲

Sandro Botticelli
Study for the Allegorical Figure
of Abundance
1475–82
Ink and wash over chalk on paper, tinted
pink, heightened with white
12 ⅜ x 10 in (31.5 x 25.5 cm)
British Museum, London

Botticelli studied several motifs in one drawing. The lines of the drapery run over the mass of the forms in the main figure to indicate volume, with cross-contour and contour lines depicting the bodily limbs as columns thrust forward in movement. The figure becomes a metaphor for creation, with line and drawing material working together to define fullness of form and the elements of light, wind, and air.

▲

Margaret Krug
Patrick, Monte, John, Helen
2004
Pencil on Fabriano Artistico paper
Each 6 x 5 ¾ in (15.2 x 14.6 cm)
Collection of the author

My intention was to make a series of studies of family and ancestors to explore their history and my own. I did not know some of the individuals, and I knew a little about others through fascinating, although vague, stories. In the best circumstances, I worked from life; more often, I worked from a single small, faded photograph. What often emerged was an image of an individual ancestor imbued with the memory of the characteristics of a current family member. Now I have an extensive number of these studies as part of an ongoing project.

Cartoon

Materials: heavy paper such as 140 lb (300 gsm) Fabriano Artistico hot-pressed, charcoal or pencil, and graphite or colored pencil or conté crayons.

A cartoon is a full-sized, detailed drawing on paper. When a cartoon is used for a fresco, it is transferred to the wall by squaring (the cartoon is ruled off in squares and the surface onto which the drawing is to be transferred is ruled off into the same number of squares); "pouncing" (a small bag filled with pigment is tapped over a cartoon with small holes punctured along its lines to duplicate a design on another surface); or incising (a thin piece of muslin, on which the cartoon has been traced, is placed face up on the fresh plaster; the lines are followed with a stylus or any pointed instrument to make an indentation on the surface). The cartoon serves as a guide for the artist's execution of the project.

Create a cartoon using charcoal, or graphite and pencil; alternatively, create a full-color cartoon using colored pencils or colored crayons such as conté crayons.

◄

Leonardo da Vinci
Cartoon for the Virgin and Child
with St. Anne and St. John the Baptist
c.1499–1500
Black and white chalk on brownish paper,
mounted on canvas on tinted paper
55 ¾ x 41 ¹⁵⁄₁₆ in (141.5 x 106.5 cm)
National Gallery, London

Transfer

Materials: pencil, pouncing wheel, paper for transfer (such as tracing paper, glassine, or tissue), and pigment.

A transfer is a secondary cartoon, known as a *spolvero,* which is traced in outline from the cartoon, so as to be pricked for pouncing in order to preserve the original cartoon. With a pencil, trace an outline of your cartoon onto a piece of tracing paper, glassine, or tissue paper. Pierce it with small holes by running a pouncing wheel over the lines. To provide a receptive surface for the pouncing wheel, place a piece of muslin under your transferred cartoon before you use the wheel.

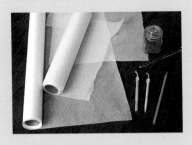

**Materials for
creating a *spolvero,*
or traced outline
of a cartoon.**

Sinopia

Sinopia is the name for an obsolete red earth pigment. During the Renaissance, as a preliminary guide, a full-scale sketch called a *sinopia* was directly executed with chalk pigmented with red earth pigment on the second-to-last mortar layer before the final lime plaster painting layer for a fresco was applied. The *spolvero* could also be transferred onto this mortar layer with a pouncing bag (pigment such as raw umber or graphite in a bag made of a square of muslin tied with a string) by laying the transfer over the fresh plaster surface and lightly pouncing or tapping the bag of pigment over the pierced lines to create a very faint dotted line on the plaster. Pigment that had been previously mixed into a paste with distilled water and then thinned with lime water was drawn over the faint line with a round squirrel or sable brush. Many sinopie have been uncovered in recent years because of modern art-conservation efforts. These underdrawings were often made with spontaneity and freedom.

rogio Lorenzetti
pia of the Annunciation
half of the fourteenth century
:o
Galgano, Monte Siepi Chapel,
ory of San Galgano (sec. XII), Chiusdino
a), Italy

s underdrawing for the *Annunciation*,
a few, fluid, calligraphic lines,
nzetti described life-size figures with
isite economy.

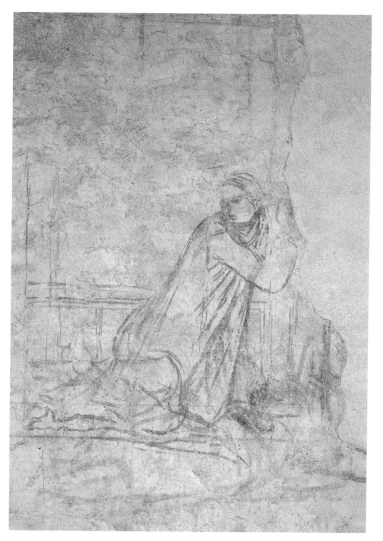

Exercise: additional experimental exercises
Installation

Materials: various pigments such as umber, *terre pozzuoli* (red earth), or graphite, string, cheesecloth or muslin, pouncing wheel, sketches, transfers, and paper such as 90 lb (185 gsm) hot-pressed; other materials for reworking such as pencils, erasers, tortillon, and chamois.

Pierce several of your drawings or transfers with a pouncing wheel and transfer to paper with the pouncing bag (filled with pigment) to create a series of works.

This can be the starting point of a process for creating an installation wall piece with as many components as you choose. Your chosen subject matter could be a single object, a motif, or a group of related objects; the components can merge and build into an installation wall piece to develop and construct over a period of several months. As you work, you may want to erase, smudge, incise, and draw back into your work. (See Chapter 8, p. 204, for an additional pounced image.)

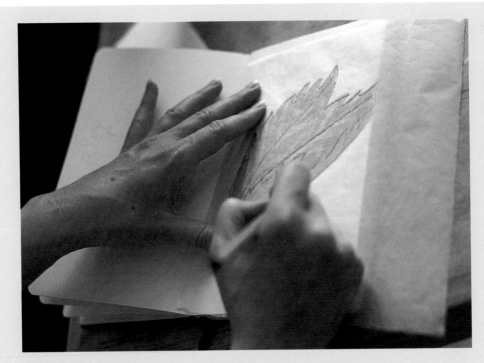

Tracing a sketch onto tracing paper to create a transfer/*spolvero*.

you have created the transfer/
vero, then pierce it with the
cing wheel. Then lay the
fer/*spolvero* onto the piece of
r and "pounce" it with the
cing bag filled with pigment,
ting in an image transferred
the paper.

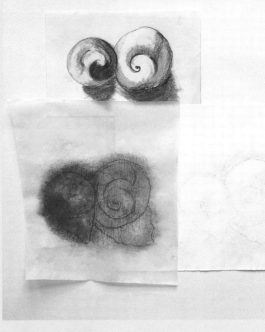

Sketch, transfer/*spolvero*,
and transferred image.

Black gouache drawings/silhouettes
Materials: small flat or round synthetic brush, black gouache paint, glass jars for distilled water, china plate for mixing paint with water, vellum or other paper.

Gouache is a water-thinned opaque paint that can be used for drawing or painting. Make your own gouache paint (see instructions for preparation in Chapter 5, p. 137) or purchase it in tubes.

The silhouette (a portrait, design, or image in profile in a single hue) was named after Etienne de Silhouette, the French minister of finance, in 1759.

To create a silhouette, light a candle and then place it next to the object you plan to draw so that a shadow of the object is cast either on your paper or on another surface. You could also allow the sunlight to project a shadow; then draw what you see with black gouache. However you choose to draw the silhouette, whether you outline the shadow you see and fill it in or you immediately draw a solid plane of color, you will notice that, unlike a contour line that has a three-dimensional quality, an outline and a silhouette read as flat and two-dimensional.

Making gouache paint.

Use gouache in creating silhouettes of objects.

Outline of silhouette.

Completed silhouette.

ra Walker

stress Demanded Swift and Dramatic
pathetic Reaction Which We Gave Her
00

paper and projection on wall
x 17 x 25 ft (3.6 x 5.1 x 7.6 m)
itney Museum of American Art,
w York

lker draws and cuts out black paper
houettes on the wall, turning them
o a panorama of American slavery-era
ages with a narrative twist. She uses
erhead projectors to cast colored light
to the space. The viewer's shadow is
o cast on the walls, mixing with
lker's silhouettes.

ise Bourgeois
itled
6

and gouache on paper
⅛ x 18 ⅜ in (61.3 x 46.7 cm)
itney Museum of American Art,
v York

rgeois has been engaged in an
oing exploration of the "house"
me in her drawing and sculpture.
er sculptures, some compartments
tain mirrors, providing a device for
ection both actual and metaphoric.
ompartmentalizing memory and
ositing various mnemonic devices in
h room, the house can operate as a
sitory or an evocation of memory.

4
INTRODUCTION TO PAINTING
MATERIALS AND PROCESSES

"The victories of artists who have preceded us are of interest to art history and not to the artist, be he painter or sculptor. Each one of those masters resolved the problem which his individuality had imposed on him, thus discharging his most noble duty."[8]

Giorgio Morandi

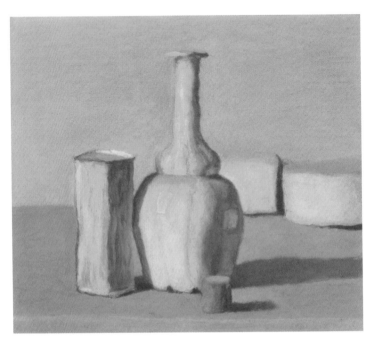

◄
Giorgio Morandi
Natura Morta
1959
Oil on linen
7 ⅞ x 13 ¾ in (20 x 35 cm)
Bayerische Staatsgemäldesammlungen, Collection of Modern Art at the Pinakoth● der Moderne Munich and Kunstdia–Arch● ARTOTHEK, Weilheim

For most of his career, Morandi painted two subjects: still lifes in his studio, and landscapes viewed from his studio wind● and the countryside outside the city. Thi● and spending his entire artistic career in● his native city of Bologna, Italy, allowed● him to engage in the constant search fo● and discovery of the space and extreme● subtle flux of light and color in his surroundings. His paintings manifest his● deep involvement with the application ● shimmering color to describe these conditions. His palette is in a narrow range, indicating the local hues. In *Natu● Morte*, he applied dry oil colors with tremulous brush strokes of subdued, creamy whites and tans, countered wit● cool grays and blue, a near-complemen● the yellow that imbues the picture.

◄
Giovanni Bellini
Pietà in a Landscape
1505
Oil on wood
25 ⅝ x 35 ½ in (65 x 90 cm)
Galleria dell'Accademia, Venice

In the early Italian Renaissance, Bellini was the first Venetian painter fully to develop the humanistic style. He introduced atmosphere without losing his fervent attachment to Christian subjects.

"Whether the painter is a hack or a master makes no difference to the 'address' of the painting. The difference is in what a painting delivers: in how closely the moment of its being looked at, as foreseen by the painter, corresponds to the interests of the actual moments of its being looked at later by other people, when the circumstances surrounding its production (patronage, fashion, ideology) have changed."[9]

John Berger

WHAT IS A PAINTING?

Painting can be defined as the application of paint to a surface, and, by its very materials and processes, employed to create the physical object. It can manifest a presence such as a king, a landscape, a color, or a word. It can also encapsulate the passage of time engaged through the process of its creation and present a complete, instantaneous, and composed visual harmony. The standard methods for permanent easel and wall painting are watercolor, encaustic, tempera, fresco, oil, and acrylic.

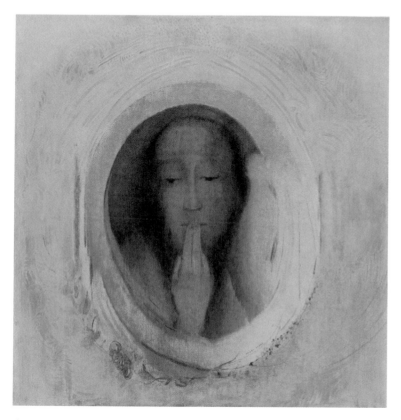

▲
Odilon Redon
Silence
c.1911
Oil on gesso on paper
21 ¼ x 21 ½ in (54 x 54.6 cm)
Lillie P. Bliss Collection,
The Museum of Modern Art, New York

"Materials have their own secrets to reveal: they have their own genius: it is
 through them that the oracle speaks."[10]

Odilon Redon

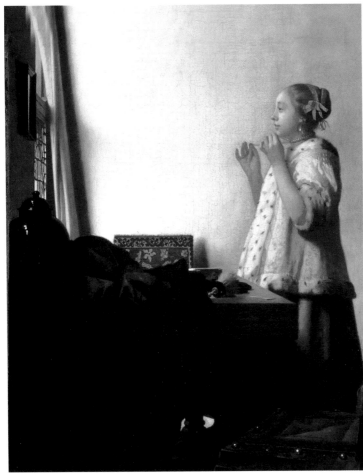

▲

Joan Mitchell
Clearing
1973
Oil on canvas
9 ft 2 ¼ in x 19 ft 8 in (2.8 x 5.9 m)
Whitney Museum of American Art,
New York

**This triptych introduces a developing
theme in the first panel. Similar forms
operate in three distinct episodes to crea
a narrative progression and movement
through time and space.** *Clearing*
**communicates the sense of elapsed time
and simultaneity that can be achieved in
a painting.**

▶

Pierre Bonnard
The Bath
1925
Oil on canvas
33 ⅞ x 47 ¼ in (86 x 120 cm)
© Tate 2007, London

◀

Jan Vermeer
Woman with a Pearl Necklace
c.1658
Oil on canvas
21 ⅗ x 17 ¾ in (55 x 45 cm)
Staatliche Museen, Berlin

"Here, reality is not subordinated to painting, indeed painting seems the handmaid of reality, though we feel it tending toward a procedure which, while not at the mercy of appearances, is not as yet in conflict with them."[11]

André Malraux on Jan Vermeer

"...all painting, irrespective of its epoch or tradition, interiorizes, brings inside, arranges as a home the visible..."[12]

John Berger

"I think I have found it. Certainly I had been carried away by color. I was almost unconsciously sacrificing form to it. But it is true that form exists and that one cannot arbitrarily and indefinitely reduce or transpose it; it's drawing, then, that I need to study... I draw constantly. And after drawing comes composition, which should form a balance."[13]

Pierre Bonnard

"To paint is to bring inside—doubly: into the inhabited space around the image and into the frame. The paradox of painting is that it invites the spectator into its room to look at the world beyond."[14]

John Berger

METHODS OF PAINTING

In the following chapters, I will introduce six standard painting methods—watercolor, encaustic, tempera, fresco, oil, and acrylic—and explain the techniques and processes for using the materials. An overview of the historical background of Western painting and contemporary applications will accompany these methods and techniques.

This will provide a foundation for how to paint in the twenty-first century and an insight into how painting has developed down the ages. If you are interested in any of the early or current methods and techniques, I have provided suggestions for continued research in Further Reading.

Since the history of Western art is extensive, I have chosen to focus on key moments in the development of a painting method instead of exploring it in a more comprehensive way.

Watercolor painting

Water-thinned painting is an ancient method that has been universally practiced in Western and Eastern painting. It is considered to be a drawing method as well as a painting technique, and is usually executed on paper. I will present a few historical and contemporary examples as I concentrate on the method consistently used throughout its history.

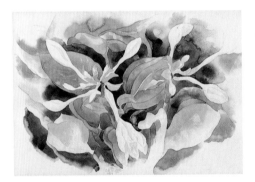

◄

Charles Demuth
August Lilies
1921
Watercolor on paper
12 ¹⁄₁₆ x 19 ⅛ in (30.6 x 48.6 cm)
Whitney Museum of American Art,
New York

In watercolor painting, no white paint is used to render hues lighter in value. The white of the paper is used to show the value gradations from light to dark.

Encaustic painting

For encaustic painting, I will concentrate on paintings created in the first to the fourth centuries AD, in the Fayum region of Egypt, and on how we are using these and similar methods to create contemporary encaustic paintings.

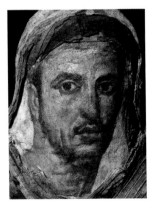

◄

A man
c. AD 25–75
Encaustic on linen
Height (mummy) 5 ft 7 in (1.7 m)
Ny Carlsberg Glyptotek, Copenhagen

The portrait appears to have been painted on a dark ground with brushes and a flat, spatula-type tool.

Egg tempera painting

I will examine egg tempera painting as it was practiced during the early Renaissance in Siena, 1278–1477.

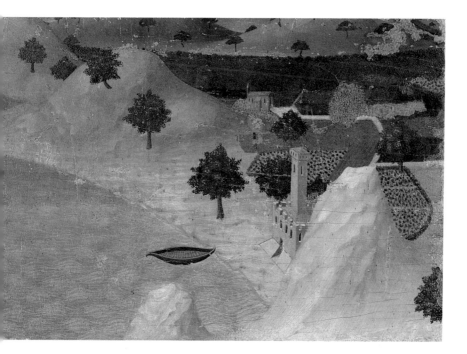

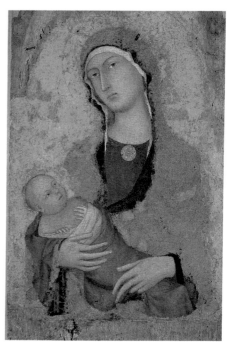

ibuted to Sassetta
le by a Lake
25
tempera on wood panel
3 in (23 x 33 cm)
acoteca Nazionale, Siena

le by a Lake and another painting
assetta, *City by the Sea*, have been
aracterized as the earliest purely
scape paintings in Western art.

▶

Simone Martini
Madonna and Child from Lucignano d'Arbia
1321
Egg tempera on wood panel
34 ⅝ x 20 in (88 x 51 cm)
Pinacoteca Nazionale, Siena

Fresco painting

Although fresco painting is no longer widely used, I will introduce it to foster an understanding of a medium that has had an important influence on the way we regard—and create—a pictorial space today. In the golden age of fresco painting in Italy, dating from the thirteenth to the sixteenth centuries (on which I will concentrate), artists created spaces that require a viewer to complete the work. Because of the scale of the work and its integration into the built environment, the viewer is encouraged to be a part of the story both physically and intellectually. In addition, in Fra Angelico's (c.1400–55) *Annunciation* and Piero della Francesca's (1410/20–92) *The Resurrection*, landscape details surrounding the portrayed scenes have an uncanny verisimilitude to the landscape outside of the spaces in which they were created. This condition is made possible, in part, by the artists' use of local earth pigments and their deep engagement with the visual world.

This confluence of art and life is a resonant theme that provides a connection to twentieth- and twenty-first-century art. Artists such as Sol LeWitt (see Chapter 8, p. 191) and Julie Mehretu (see Chapter 10, p. 246) create large-scale installation pieces tailored to a specific space, and which are cathedral-like in their impact. These works are installed according to the specific requirements of an exhibition, applied to the walls of galleries, and ultimately removed at the end of the exhibition. Sol LeWitt uses materials that produce similar effects to fresco, such as inks carefully selected for their hue and applied with sponges in layers to produce optical color mixtures.

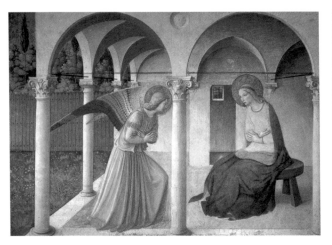

▲
Fra Angelico
Annunciation
After 1450
Fresco
7 ft 1 in x 10 ft 6 ⅜ in (2.1 x 3.2 m)
San Marco Convent, Florence

The *Annunciation*, created on a wall adjacent to the monks' cells at the San Marco Convent in Florence, greets viewers as they ascend to the second floor. The scale and location invite the viewer to enter the space.

▲
Piero della Francesca
The Resurrection
1463
Fresco
7 ft 4 ⅝ in x 6 ft 6 ¾ in (2.2 x 2 m)
Pinacoteca, Sansepolcro

The *Resurrection*, installed in a room of its own in Sansepolcro, Italy, seems to be an opening into another realm as tangible as the scene outside: the town in which Piero della Francesca lived for most of his life.

Oil painting

I will focus on the Venetian oil painting practice, which began in the fifteenth century, became widely used, and has endured into the present.

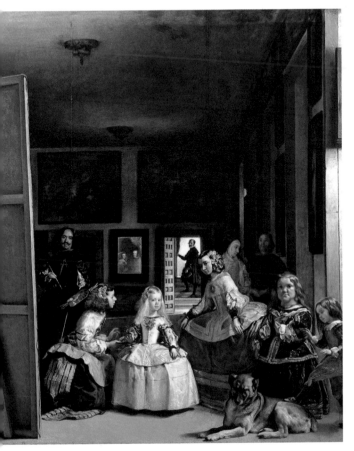

◄

Diego Velázquez
Las Meninas
1656–7
Oil on canvas
10 ft 5 ¼ in x 9 ft ⅝ in (3.1 x 2.7 m)
Prado Museum, Madrid

Velázquez's ambition was to obtain a fluid pictorial material in order to create a new aesthetic. He started with the Venetian method of painting, but then tried to escape formulaic strictures as his work evolved. For instance, he found that covering his canvas with a dark ground (a hallmark of the Venetian method) did not achieve the luminous effect he wanted. He began to use a white or near-white ground.

Las Meninas ("The Handmaids") is essentially a very large oil sketch, because of its loose, swift application of paint. On a hemp support, Velázquez laid a ground of lead white mixed with small amounts of ochers and black, and suspended in a solution of animal glue, probably with the addition of some drying oil. He applied the mixture with a painting spatula or palette knife, using very large, irregular strokes, creating an optical background of extraordinary luminosity.

He sketched out the essential lines of his composition on the ground. Mixing his pigments by hand with drying oils, he also occasionally, in light opaque pigments, mixed in an egg as a binder. With a limited range of colors, Velázquez used little more than the six shown on the palette he holds in the picture. Some pigments were ground coarsely, some very finely, and sometimes he would introduce larger particles of pigments in a mixture to reflect natural light.

In this painting, he scattered bits of coarsely-ground white, using the canvas weave and knots to produce pictorial and illusionistic effects. Notice the shadow on the right side of Infanta Margarita Maria's face, which has been created by a barely concealed patch of raw canvas. Velázquez combined sweeping applications of transparent colors with precise touches of pigment to define details, as exemplified by the precise, tiny red jar of water being handed to the Infanta, and the fluid execution of her sleeve. His goal was to capture fugitive, changing circumstances in permanent form.

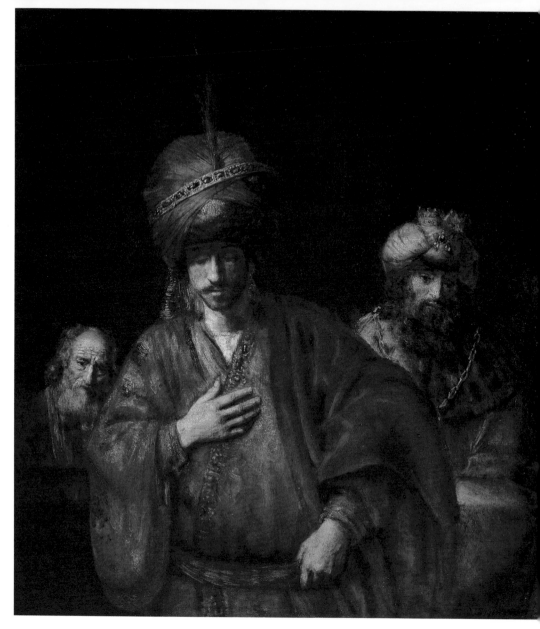

Rembrandt van Rijn
Haman Recognizes his Fate
(David and Uriah?)
c.1665
Oil on canvas
50 x 45 ⅝ in (127 x 116 cm)
The Hermitage, St. Petersburg

This painting asserts a strong physical presence, not through the definition of details, but by developing strong areas of light and shadow. The thick undulations of the white scumblings have been applied with excess and abandon, and glazed repeatedly with dark veils of color to achieve radiant warmth. Rembrandt dug into the painting with the end of his brush and palette knife to create an almost relieflike, sculptural surface. Although the facial features on the central figure contain very little detail, on seeing them in person one feels their palpable presence, in part because of the red pigment, juxtaposed with the relative coolness of dull green and umber pigments, rising like blood to the surface of the flesh.

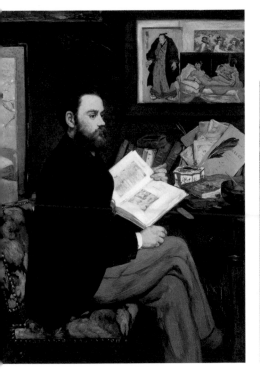

▲
Albert York
Twin Trees
c. 1963
Oil on canvas mounted on Masonite®
10 ⅞ x 10 ½ in (27.9 x 26.7 cm)
Private Collection, New York
Courtesy of Davis & Langdale Company,
New York

The loosely applied paint asserts its
material identity while it expresses
the physical palpability of the subject.
The viewer can identify elements of the
exposed Masonite® board used for a
support; it reads as a middle tone in the
value structure and as air in the subject
of the scene.

ard Manet
ait of Emile Zola

canvas
5 in (146 x 114 cm)
e d'Orsay, Paris

t's sketches reported modern life in
aris of the mid-nineteenth century,
e sought to retain that vitality in his
ings. Author Emile Zola is shown in
rn dress and surrounded by
utes that could be ascribed to
t's own endeavor to express his
ity: sources of inspiration such as a
ese print, a Goya etching after
quez, a copy of Zola's pamphlet on
t. Manet's language was one of vivid
ast and bold masses as he indulged in
incipal loyalty to the painterly aspect
craft. He advised looking for the
ghts and the deepest shadows when
dering the figure, and said that the
vould come naturally—which could
be very little.

Forrest Bess
Untitled (No. 31)
1951
Oil on canvas
8 x 10 in (20.3 x 25.4 cm)
Hirschl & Adler Modern, New York

"Painting has meant many things to me—once I thought the development
of a personal style was an end, but I have found a much greater purpose for
art that stems back to Cro-Magnon—and I believe is the truthful purpose of art.
The sign or symbol that emerges from the unconscious possesses the
greatest of therapeutic value in that, when integrated into consciousness, it
possesses the power to release pent-up tensions and actually bring about
a higher level of consciousness."[15]

Forrest Bess

Acrylic painting

Since acrylic and other synthetics used as a binder for pigments in painting are a relatively recent convention which emerged during the modern era, I will address the present and the recent past.

▲
Leon Golub
White Squad 1
1982
Synthetic polymer on canvas
10 ft x 15 ft 4 in (304.8 x 467.4 cm)
Whitney Museum of American Art,
New York

Golub's choice of hues aligns with the subject and content of *White Squad*: figures clothed in military greens imposed on a background stain of red. He applied paint to raw, unstretched canvas, which further accentuated the pathos of the subject.

Further methods

Within the chapters for most of the standard methods, I will explore alternate, experimental, or collateral techniques. For example, in the chapter on egg tempera painting, I will introduce casein tempera, an early technique used more in applied arts, craft, and domestic settings than for easel paintings. Following a period of in-depth study of fresco painting, I chose instead to use and teach casein painting, because although it is similar to fresco in terms of surface qualities and its ability to transport the individual qualities of pigments, it is much less cumbersome and more suitable to the needs of contemporary painters. I have also included casein painting and other techniques at the end of most chapters to promote an interest in further exploration and experimentation in the art of painting.

In this chapter, I will introduce you to the structure of the physical object: support, sizing, ground, and/or priming, paint or design layer, and varnish. I will also provide a brief overview of color. All this will serve to introduce the different terminology that applies to the standard methods explored in the text, the visual examples, and suggested exercises. I hope that artists and students will gain a deep intellectual and physical understanding of the roots of painting or a specific method through a hands-on, experiential exploration of the materials and processes.

Support

The most common supports are wood and canvas, but many artists also use paper, metal, stone, glass, cardboard, plastics, and synthetics. They even paint directly on existing walls, with lime-plaster wall being the traditional support and ground for fresco painting.

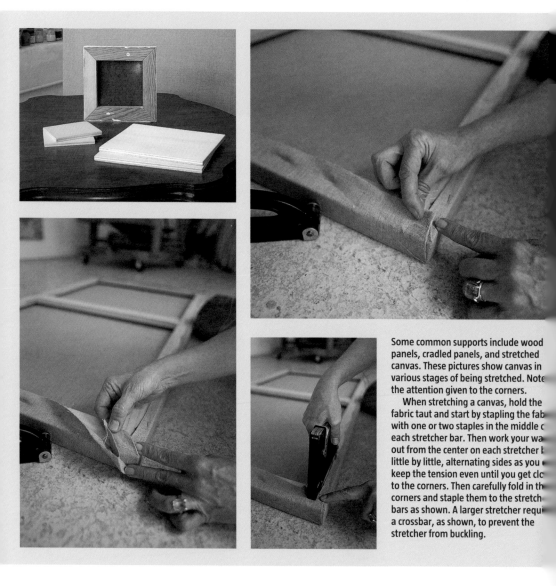

Some common supports include wood panels, cradled panels, and stretched canvas. These pictures show canvas in various stages of being stretched. Note the attention given to the corners.

When stretching a canvas, hold the fabric taut and start by stapling the fab with one or two staples in the middle c each stretcher bar. Then work your wa out from the center on each stretcher k little by little, alternating sides as you keep the tension even until you get clc to the corners. Then carefully fold in th corners and staple them to the stretch bars as shown. A larger stretcher requi a crossbar, as shown, to prevent the stretcher from buckling.

Ground

The ground and/or priming and preparatory layers are applied to the support, which acts as a receptive surface for the paint layer. An artist's preferred ground can be highly individual; however, sizing is generally applied as the first layer to all painting supports, and it can act as a ground on its own. Sizing is a very dilute solution of glue or resin applied to a surface to reduce its absorbency or porosity. The size will also shrink the stretched fabric support so that it will fit tightly on the stretcher. It is especially important for canvas if oil paint is to be applied, as direct contact with oils will cause the canvas fibers to become brittle and decay. Glue attracts moisture that can cause canvas to sag in more humid conditions. This can compromise the soundness of the paint film. You can use PVA (polymerized vinyl acetate) as a substitute for glue. It will protect the support and reduce its absorbency, but it will not shrink the fabric. Grounds can include gesso created from chalk and animal glue; a mixture of chalk, animal glue, and oil; or an acrylic gesso—to name but a few. To begin with, a particular ground is usually chosen to make the surface more receptive to a particular medium. I will suggest an appropriate ground for each method in the following chapters. By learning these basic methods, you can select from an almost infinite realm of minute adjustments in texture, absorbency, and hue to facilitate a desired effect.

ng and ground ingredients: rabbit-skin
e solution, rabbit-skin glue granules,
ogna chalk.

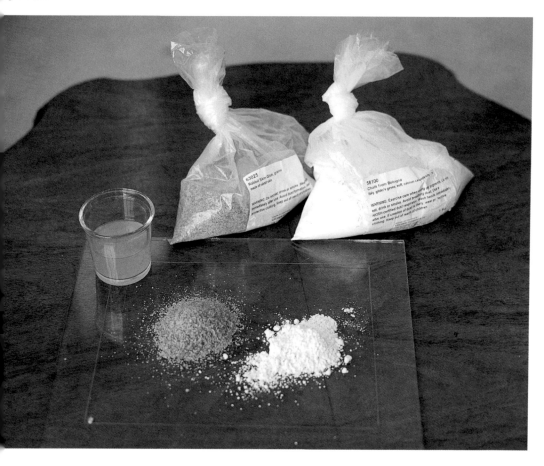

Paint layer

The paint layer is where artists' ideas come to be realized, and the preparation of materials can be a time when ideas are brewing as well as a time for becoming intimate with many of the physical aspects of the object and the materials. These can manifest the presence of an idea, a person, a landscape, an interior state, or the painting process itself, among many other phenomena. Preparing supports, grounds, and paint from scratch can provide an array of options otherwise not afforded, and it can allow for a variety of slight adjustments.

Paint layer: casein paint on casein gesso on wood.

From prehistory through to the present, paint has been defined simply as pigment—a range of colors in a finely powdered state (from inorganic, natural organic, and synthetic sources)—in conjunction with a binding medium (such as wax, egg, casein, oil, acrylic resin, or gum arabic) to hold the pigment and fix it to a support. The binding media affect the paint's handling and provide diverse effects. For instance, oil, acrylic, and wax bring out the depth and intensity of the pigments, imparting them with a different color quality than they have in the dry state, whereas casein and gum arabic have little visual effect on the pigment colors. Paint handling has varied greatly throughout the history of Western art, but there are only two significant periods when new paint media have created major breakthroughs in the art of painting: during the fifteenth and sixteenth centuries, when drying oils came into general use, and during the mid-twentieth century, when acrylic paints became widely available.

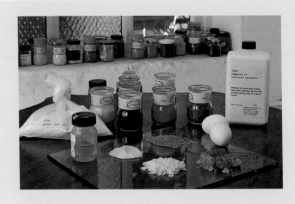

A selection of pigments, along with their various binders: acrylic emulsion, eggs, gum arabic, beeswax pellets, linseed oil, powdered casein, rabbit-skin glue granules.

The pigments and binding media are the paint or design layer, so I will be discussing direct painting and indirect painting in layers. Each chapter describes specific ways of approaching underpainting. All the layers of color/paint beneath the final paint layer are referred to as the underpainting. An underpainting can be as simple as an *imprimatura* layer, which is a translucent layer of pigment in a binder such as rabbit-skin glue or mineral spirit applied to a gesso ground. An underpainting could be a monochromatic painting called either: *verdaccio*, used in traditional egg tempera and fresco painting for outlining and modeling; *sinopia*, a full-scaled sketch or underdrawing for a fresco (see Chapter 3, p. 81); or *grisaille*, usually used for oil painting and executed in shades of gray, sometimes referred to as the "dead color."

"Impasto" is the texture created by the movement of the brush, which is usually regarded as paint applied in thick, heavy brushwork, but it can also refer to crisp, delicate textures found in smoother paint surfaces. Impasto should be applied sparingly, and dispersed throughout a painting with thinner passages of paint. Also be aware that a thick layer of impasto can crack more easily in oil painting than in acrylic painting.

rine Stettheimer

1

on canvas

⅛ x 26 ⅛ in (96.8 x 66.4 cm)

tney Museum of American Art, w York

impasto passages and ornately ed and painted frame facilitated theimer's surface excess and ar ornament, which corresponded merica's continuing involvement Art Nouveau in the 1920s and Os—a style that had evolved out of the ish Arts and Crafts movement of the Os, and in which plant and flower ifs abounded.

Varnish

The varnish is a protective layer that provides a uniform surface and modifies the appearance of the paint layer. If a varnish is used, oil and acrylic paintings require a clear, nonyellowing, elastic, and reversible varnish, whereas water-thinned, egg tempera, casein, and encaustic paintings can do without varnish. Indoor or outdoor frescos and other types of mural paintings are not usually varnished.

Types of varnish: mineral spirit-soluble acrylic varnish/gloss (MSA varnish) for acrylic paintings, dammar crystals soluble in turpentine, and prepared dammar varnish for oil paintings

Color

Within the text of individual chapters, I have included visual examples of various ways of applying color to show specific effects. Instead of color theory, I will offer "looking" and painting exercises so that you can master the practical use of color in painting. I will explain various tenets of color as they relate to a particular painting method or exercise, and I will encourage the learning of color experientially by suggesting the use of certain strategies to achieve particular effects.

◄

Josef Albers
Homage to the Square Ascending
1953
Oil on composition board
43 ½ x 43 ½ in (110.5 x 110.5 cm)
Whitney Museum of American Art, New York

Albers' *Homage to the Square Ascending* **exemplifies his lifelong exploration of color relationships. He was not interested in color theories or systems but in perception through direct observation.**

Lalchand
Leaf from the Shah Jahan Album
Verso: *c.* 1615; recto: *c.* 1540
Ink, colors and gold on paper
15 ¼ x 10 ⅟₁₆ in (38.7 x 25.6 cm)
Metropolitan Museum of Art, New York

Studying this work and other Balchand paintings from the *Shah Jahan Album* reveals how discordant color passages and harmonious color relationships within the same small pictorial space can bring about an exuberant vitality.

I will introduce *alla prima* painting, also known as *wet-into-wet* or *direct painting*, in the chapters on oil painting, watercolor painting, acrylic painting, and casein painting. Painting indirectly—covering the painting surface layer by layer—will be introduced in each chapter. A light opaque tone, usually white or near-white, can be painted over a darker one ("scumbling") to achieve a relatively cool, pearlescent effect. Alternatively, a thin layer of transparent color (glazing) can be painted over another color to create warmth. Glazing and scumbling can be alternated to create warm and cool effects, with a final glaze over underpainted scumbles creating a warm luminosity. I will also explain how to create optical mixtures of color by layering hues, the three primary hues or colors being red, yellow, and blue. If yellow and blue are layered, green is produced, which is one of the three secondary colors. Yellow and red can be layered to produce orange, another secondary color, and blue and red can be layered to create the secondary color violet or purple. The colors directly across from each other on the color wheel are known as complementary colors, and the colors next to each other are analogous colors.

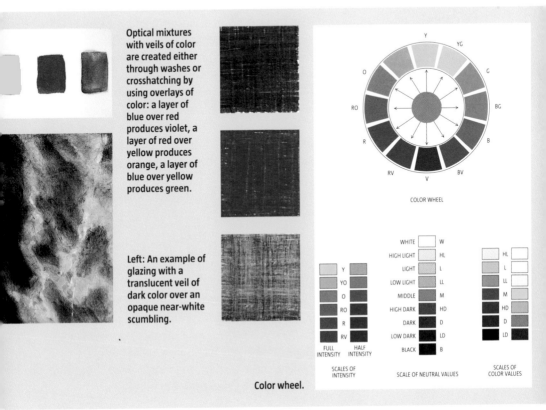

Optical mixtures with veils of color are created either through washes or crosshatching by using overlays of color: a layer of blue over red produces violet, a layer of red over yellow produces orange, a layer of blue over yellow produces green.

Left: An example of glazing with a translucent veil of dark color over an opaque near-white scumbling.

COLOR WHEEL

SCALES OF INTENSITY

FULL INTENSITY — HALF INTENSITY

Y, YO, O, RO, R, RV

SCALE OF NEUTRAL VALUES

WHITE — W
HIGH LIGHT — HL
LIGHT — L
LOW LIGHT — LL
MIDDLE — M
HIGH DARK — HD
DARK — D
LOW DARK — LD
BLACK — B

SCALES OF COLOR VALUES

HL, L, LL, M, HD, D, LD

Color wheel.

A brief overview of color characteristics

● Tones: are created by varying a color in its light and dark quality. Tints are light tones of color that are made by adding white or water to the original color. Shades are dark tones of color that are made by adding black to the original color.

● Hue: the quality by which we distinguish one color from another, such as red from yellow or blue-green from yellow-green, is called the hue. Hue is the name of the color, and the hue can be changed by adding some other color or colors: red-violet and blue-violet are hues of violet, and blue-green and yellow-green are hues of green. The hue is also affected by the amount of color used; in two different hues of red-orange, one may have more of the red quality than the other. Hues of a color may be "grayed down" by adding some of the third color. Red-orange is grayed by adding blue, and blue-green is grayed by adding red. Hues can be warm (red, yellow, and orange) or cool (blue, green, and violet); the former tend to move forward and the latter tend to recede.

● Value: the quality by which we distinguish a light color from a dark one, such as light blue from dark blue. It is also the term by which we indicate the amount of light or dark in a color. Yellow is light in value, while standard blue is of a darker value. Forms modeled from light to dark produce the illusion of three dimensions and illusionistic space. Adding white to a color lightens it, but renders it less intense.

● Intensity: the quality by which we distinguish a strong color from a weaker one—the brightness, strength, or purity of a color. It is illustrated by the difference between brilliancy and grayness, such as pure red and a red that has been grayed down by the addition of green, its complement. Red is bright but dark, whereas yellow is bright and light. Intensity of color can create the illusion of space; intense color advances, and as color intensity diminishes, space recedes.

Observing what happens between colors is essential when painting the illusions of light and space with color (see color wheel on p. 105). All painting is an interchange of warm and cool colors and dark and light values. Colors present themselves in relationship to one another and in changing conditions. When objects are closer to us, their colors appear more intense, warmer, and darker; details are prevalent and clear, and value contrasts are greater in the foreground. As they move farther away, objects become less intense, cooler, and lighter in color. Thus, the coolness and lighter value of hues is produced because of the effects of atmospheric perspective (see Chapter 1, pp. 18–19); thin, colorless vapor, interposed between the eye and the depth beyond, obscures color as distance increases.

"When people go to the ocean, they like to see it all day... There's nobody living who couldn't stand all afternoon in front of a waterfall. It's a simple experience, you become lighter in weight, you wouldn't want anything else. Anyone who can sit on a stone in a field awhile can see my painting. Nature is like parting a curtain, you go into it. I want to draw a certain response like this... Not a specific response but that quality of response from people when they leave themselves behind, often experienced in nature—an experience of simple joy... the simple, direct going into a field of vision as you would cross an empty beach to look at the ocean."[16]

Agnes Martin

THE PRACTICE OF PAINTING

In the late-medieval era, painting practice was highly codified. In *Il Libro dell'arte* ("The Craftsman's Handbook"), written at the end of the fourteenth century, Cennino Cennini recorded the standard techniques that painters learned through apprenticeships. His technical handbook documented the materials and processes for preparing the panel, gessoing, drawing, painting, and varnishing in the context of the artist's studio. The theories within *Il Libro dell'arte* were passed down into the nineteenth century and into the time when artists began to question and experiment with aesthetic issues. Contemporary artists continue to expand our notions of what a painting can be.

◄

Clyfford Still
Untitled
1957
Oil on canvas
9 ft 4 in x 12 ft 10 in (2.8 x 3.9 m)
Whitney Museum of American Art,
New York

In *Untitled*, Still applied thickly pigmented oil colors to a large canvas in order to evoke the vast space and rugged textures of the Great Plains of the United States, where he spent his childhood.

◄

Agnes Martin
This Rain
*c.*1960
Oil on canvas
70 x 70 in (177.8 x 177.8 cm)
Collection Emily Fisher Landau, New York

Painting is a vast subject: to examine specific paintings as historical documents is to begin to understand the subject and to begin to develop a language to explore the subject on your own as you make paintings. A painting may represent an historical event or condition, or it can be a historical event in itself.

I have included suggested exercises for each method to allow you to explore the techniques. In the encaustic and egg tempera chapters, there is a two-part exercise procedure to follow: 1) copy from a master painting image, and 2) create an original painting using the same technique. For acrylic, watercolor, oil painting, and the additional painting methods included in some chapters, I have suggested a few more free-form exercises for each technique. I have suggested the option of either copying a master painting or creating an original work for the exercise in the fresco chapter.

The suggested exercises provide a foundation for developing a personal style. Following the processes of a method while copying from an historical example can be an invaluable experience, enabling you to internalize a technique. When learning a language other than your native one, at a certain point, you begin to think and even dream in your second language, so the objective here is to allow the technique to become intuitive and automatic.

The following chapters will provide strategies to follow, but as you continue your practice, you will discover ways to diverge from a technique that will suit the demands of your individual vision. Unexpected surprises and even "mistakes" that are part of everyday studio activity can lead to valuable discoveries. As you gain an understanding of the materials and processes, you will see that each movement or combination of elements in a painting is a unique entity. Engaging in the process of painting is about finding out how to do it, and taking part in the continued fascination and effort of the artist to adapt this ancient art to the present. Always look at paintings and let the physical objects speak to you—look and then experiment in your own work.

"One can travel the world and see nothing. To achieve understanding, it is necessary not to see many things but to look hard at what you do see."[17]

Giorgio Morandi

Visual examples reveal how artists have used painting methods. Visits to museums and other related institutions should always be an essential part of the exploration of painting materials and processes. Images of paintings do not convey the finish, texture, or scale. It is even more meaningful to view paintings in the vicinity in which they were created to get a sense of the air, the light, and the space that the artists experienced.

"Remember that there are parts of what it most concerns you to know which I cannot describe to you; you must come with me and see for yourselves. The vision is for him who will see it."

Plotinus

m Hammershoi
man Sewing in an Interior
0
canvas
x 20 ½ in (54.6 x 52 cm)
e Collection

ior exemplifies Hammershoi's
ng investigation of the conditions
ace and light in the interiors of
partment in Copenhagen.

in Johnson Heade
buryport Meadows
6–81
canvas
x 22 in (26.7 x 55.9 cm)
Metropolitan Museum of Art, New York

de explored the subjects of the
ting—momentary color and light
r a passing shower—by employing
rrow range of hues, with grays
greens predominating, and restricted
e contrasts.

Watercolor is the perfect transition from drawing to painting, and from black and white to color. After studying drawing, I made the transition to painting by studying watercolor. Although it is not necessarily an easy method, watercolor allows for a great diversity in technique and style—from the point of a tiny brush delivering a minute amount of paint to create the smallest, most intricately detailed expression, to the deposit of broad, fluid masses of saturated color from a large, soft, full brush. I am fond of its luminosity, directness, color purity, and crispness. In addition, it is a convenient medium that enables the artist to capture an instant, and to record a mental conception or ephemeral mood in nature. As with drawing, the materials are lightweight, easy to store and transport, inexpensive, and available any time, anywhere.

◀

Charles Demuth
Study of Bee Balm
*c.*1923
Watercolor and graphite on paper
16 ½ x 11 ⅛ in (41.9 x 28.2 cm)
Whitney Museum of American Art, New York

 Like all the methods in this book, the manual dexterity and the mental competence behind the technique cannot be quickly acquired, but through daily practice you can gain satisfaction in the creative process and gratification in your finished works.

HISTORICAL BACKGROUND

Painting with pigment and water is a universal method dating back to antiquity. Watercolor is named for its diluent—water—instead of its binding medium, by which most other media (such as oil paint) are named. The other component of its name is "color," and in this technique it is the dilution of the pigments with water that determines the intensity of the colors. Two techniques can be used: glazing (indirect painting in layers) or a direct technique. Colors are applied relatively thinly, and the ground or another paint layer will show through all the colors. The ground, which is usually white, produces the necessary degrees of lightness in the painting. So, by leaving the white ground or paper untouched, pure-white areas are produced. The term "watercolor" is also used to name a work of art in that medium.

◄

The Master of the Monkey
Equestrian Portrait of Maharana Amar
Singh II of Udaipur
*c.*1710
Opaque watercolor and gold on paper
12 ³⁄₁₆ x 10 ½ in (31 x 26.7 cm)
Arthur M. Sackler Museum,
Harvard University Art Museums,
Cambridge, Massachusetts

Brushes, burnishing stones, pigments kept in clam shells, jars of water, and gum binding medium were used in this work. First, the paper was coated with white and sun-dried, then placed upside down on a flat stone and rubbed with a rock crystal or agate. Lighter pigments were used initially, and stronger colors were then added layer by layer and intermittently burnished. Drawing was based on the workshop's sketches of birds, beasts, trees, people, or gods; sometimes artists sketched from nature. They also used pieces of thin gazelle skin; these were placed on top of a pattern to be copied, outlined with a dark brush, then pricked. Powdered charcoal was rubbed through the pinholes to transfer the image.

Ancient Egyptians used watercolors to decorate their wooden sarcophagi and to illustrate their "books of the dead"—collections of chapters detailing magic spells and formulas. The books were commissioned by the deceased before their deaths, and they began to appear in Egyptian tombs around 1600 BC. Brushes made from rush stems were dipped in water and rubbed on cakes of ink and gum to decorate rolls of papyrus for the purpose of guiding the deceased through the afterlife on their journey into the underworld. Paper was invented in China around the first century AD, and by the ninth century the Chinese were painting with watercolor on paper, although they were painting with watercolor on silk before that. By the eleventh century, Indian miniaturists in the East and West were using opaque watercolor on palm leaves, and they used paper when it became available to them in the fourteenth century. Miniature painting was also practiced in Persia, where it was at its peak from the thirteenth to

the sixteenth centuries. Turkish painters used dry pigments combined with egg white and water during the golden age of Turkish miniature painting in the sixteenth century.

In the West, medieval illuminators of religious and secular manuscripts (from AD 1300 to 1500) used opaque watercolor and, when coloring drawings, engravings, woodcuts, and maps, they used transparent watercolors. German artist Lucas Cranach (1472–1553) painted in transparent and opaque watercolor, and sometimes in a combination of both.

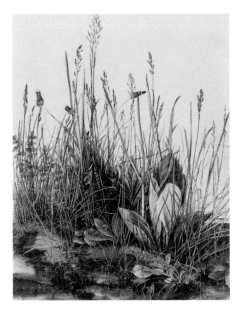

◄

Albrecht Dürer
The Large Turf
1503
Watercolor and gouache on paper
16 ⅛ x 12 ⅝ in (41 x 32 cm)
Graphic Collection, Albertina, Vienna

In 1490, Albrecht Dürer established the technique as the separate art form we know today with his watercolor landscapes, and later with his watercolors of animals and birds. Watercolors were used mainly for miniature painting in the sixteenth, seventeenth, and eighteenth centuries on cardboard or ivory, and sometimes on parchment and porcelain. Seventeenth-century Dutch artists painted landscapes in watercolor, but the technique was gradually subsumed by other painting techniques such as oil painting. From that time, it was regarded as a technique for amateurs until the nineteenth century, when it regained acceptance and was publicly exhibited in London in 1805, under the auspices of the Society of Painters in Watercolour.

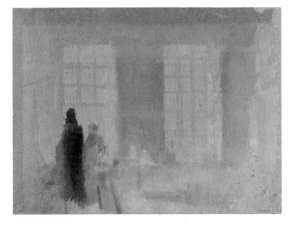

◄

Joseph Mallord William Turner
Interior at Petworth
c.1830
Watercolor and body color on blue paper
5 ½ x 7 ½ in (13.9 x 19 cm)
© Tate 2006, London

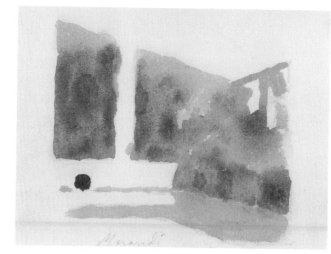

Morandi
Paessaggio
1957
Watercolor
6 ½ x 9 in (16.5 x 23 cm)
Private Collection, Bologna

During the late eighteenth and early nineteenth centuries, the modern technique of transparent watercolor painting was developed in England. Sepia or blue tints were superimposed on pen-and-ink drawings, which evolved into monochrome and then into a technique in which color was used with freedom and imagination. The contemporary use of fluid masses of color emerged out of this evolution. British artists who contributed to the beginnings of the techniques included William Blake (1757–1827) (see p. 51) and J.M.W. Turner (see p. 25, and opposite). American artists Edward Hopper (1882–1967) (see p. 136) and Charles Demuth (1883–1935) (see pp. 112, 131, 135) soon followed. Turner brought the watercolor technique to the forefront by masterfully exploiting its technical and artistic possibilities. He produced dense surface textures by combining gouache (opaque watercolor) with watercolor and fluid pencil markings, while manipulating the surface by scraping the color away with a sharp instrument to produce diaphanous light effects. French Romantic painters also confirmed the validity of watercolor as a fine-art technique with works by Théodore Géricault (1791–1824) and Eugène Delacroix (1798–1863).

Even though there is a wide range of pigments available, most artists often prefer to work with a basic set of about fifteen pigments. In fact, little has changed since Edward Norgate wrote *Miniatura or the Art of Limning* (1627–8). A friend of Charles I and the Earl of Arundel, Norgate established himself in seventeenth-century England as a musician, a herald, and a courtier. Widely circulated during his era, Norgate's treatise on the study of miniature painting is a guide to materials and techniques, and a record of the artistic knowledge and taste of King Charles's court. It presents in detail the methods of English miniaturists and the composition and preparation of pigments. Norgate provided the first proper list of watercolor pigments, recording the varieties of white, yellow, red, green, blue, brown, and black (twenty-four in all) which could be purchased in apothecaries' shops. The pigments, derived from natural materials, were ground by the artist and combined with gum arabic (derived from acacia) and "sugar candy"—made from a mixture of table sugar and water—so that they dried smoothly. Other writers refined Norgate's recipes and enlarged his range of pigments without altering the basic principles—and the process remains essentially the same today.

During the eighteenth century, small cakes of color began to be produced in England, and portable watercolor boxes incorporated these cakes. Tube colors containing additional glycerin as a plasticizer are now in widespread use as well. Contemporary artists use watercolor in much the same way as artists have throughout history; it is pure, simple, straightforward, but not necessarily an easy method.

PROPERTIES

With a matte finish, transparent watercolor is a resoluble medium that should be used thinly. The support and ground will show through the layers of color, and they are meant to be an intrinsic part of the value and color structure of the painting. The white or light surface of the paper (or other support to be used) serves as the lightening agent for the painting.

Unlike other painting media, transparent watercolor possesses a certain luminosity and lightness. Because of the transparency of the binder and because the pigments are so finely ground, the fibrous surface of the paper can hold the paint to the support and be more of a binder for the colors than the gum arabic. Gum arabic, the most transparent of all the painting binders, is a water-soluble gum exuded from incisions made in the bark of the acacia tree. For use, it is dissolved in hot water and, because the gum film can be brittle, a plasticizer such as glycerin should be added.

Watercolor is delicate and therefore requires more precision and patience than other media when it comes to making your own paint. So, to begin with, I recommend purchasing the finest ready-made paints, preferably color cakes or tubes that contain a paint formulated with honey or another humectant to retard drying and spoiling. Later on, I would suggest making your own color cakes rather than purchasing tubes or jars, which tend to dry out and sometimes spoil. Color cakes that you make by hand will last a long time without the threat of drying out. They are easily portable and are the most free, light, and readily used of all painting media.

Outline of technique
- Stretch watercolor paper on a drawing board and let it dry for four to twelve hours, or use a watercolor block or heavy paper.
- *Optional* Create a light pencil sketch on the watercolor paper.
- Paint indirectly or directly with watercolor paint.
- When your painting is dry, score with a utility or matt knife around the outer periphery of your painting and remove it from the board.

SUPPORTS AND GROUNDS

What you will need:

Paper
Drawing board
Natural sponge
Paper tape
Staple gun
Water
Utility knife, craft knife, scalpel, or pen knife
or
Watercolor block
or
Glue gesso (*gesso sottile*) ground panel (see Chapter 6, p. 142, for preparation instructions)

**Set-up used for stretching paper
and other supports and grounds.**

Usually the support and ground are the same in watercolor painting, and paper is the most commonly used support and ground. This is because, in transparent watercolor, the value structure of the painting is developed by the white color of the paper support, so a ground is unnecessary. Parchment, silk, vellum, and gesso panels have also been used, as well as thin ivory plaques for miniatures. You do need to have a fibrous, non-shiny surface to hold the paint on the support, so you should avoid glazed surfaces. You can also use a wood panel with a glue gesso ground, which provides a very white and absorbent surface for successfully developing a watercolor painting.

Watercolor paper

Watercolor papers should be handmade from 100 percent cotton or linen rag that has been sized during its manufacture to prevent colors from spreading and bleeding. (I personally prefer Fabriano watercolor paper from Italy.) The paper should be white to facilitate maximum brightness in transparent watercolor techniques. Fine papers come in three surfaces: rough, cold-pressed (medium finish), and hot-pressed (smooth finish). A rough or cold-pressed paper has a granular surface with hollows and projections, which provide an alternation of light and half-light. Pale colored paper can also be used, but a duller effect is produced.

Papers come in different weights, and paper weight is designated by numbers indicated in pounds; the lightest weight is 72 pounds (150 gsm), and a common weight— 140 pounds (300 gsm)—is twice as heavy. Lightweight watercolor paper under 280 pounds (600 gsm) should be stretched on a rigid drawing board to prevent buckling and wrinkling. Heavyweight paper, from 280 to 400 pounds (600 to 850 gsm), is preferred for its convenience because it does not need stretching, but it is more expensive. In addition to the advantage of not needing to be stretched, the heavier-grade papers are also able to withstand scraping with a knife, scrubbing, and other vigorous manipulations used in watercolor techniques. You can also use a watercolor block—sheets of paper held together in a block with adhesive around the edges. When you have finished a painting, insert a knife or scalpel into the adhesive between the sheets, and run the blade around the edge to remove the top sheet. On some watercolor blocks there is an edge without adhesive for easy insertion.

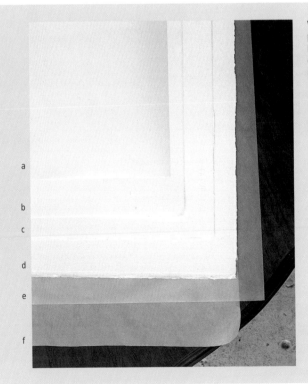

Various papers suitable for watercolor painting: a) Fabriano hot-pressed, off-white, b) Fabriano 90 lb (185 gsm) cold-pressed, off-white, c) Fabriano 140 lb (300 gsm) hot-pressed, bright white, d) Fabriano 300 lb (640 gsm) cold-pressed, bright white, e) vellum, and f) silk (not paper).

The watermark indicates the right side of the paper, but the other side is just as viable for use.

a

b

c

d

e

f

...ching watercolor paper: With a ...ral sponge, dampen the paper ...ally on both sides or, if possible, soak ...aper in a tub of water for fifteen to ...ty minutes. Lay the dampened paper ...e drawing board, flatten it out, and ...it down with dampened water-...le brown-paper glue tape, ...apping a quarter-inch of the paper's ...e. Press the tape down securely. In ...tion, some artists staple the tape ...n with a staple gun. Dry the paper ...ontally. When you are finished with ...ainting, cut it free around the outer ...hery of the painting with a blade. ...other way to stretch paper is to use ...staples to hold the paper in order to ...erve the deckle edge. You can staple ...aper down and carefully remove the ...es when you are finished with the ...ting. It will take between four to ...ve hours to dry before use.

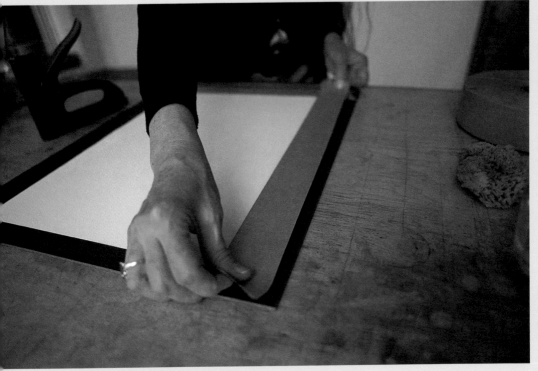

119

PIGMENTS AND BINDER

What you will need:

Color box: commercially prepared watercolor set
Color concentrates or dry pigments with a drop of wetting agent if necessary—oxgall or
 alcohol—mixed with distilled water to a creamy consistency
Sandblasted glass slab
Gum arabic
Distilled water
Double boiler
Glycerin as a plasticizer to improve flexibility, brushability, and solubility
Honey as a humectant to delay drying out of color cakes or tubes
Drop of clove oil to prevent mold, which can come about due to the use of glycerin (optional)
Paint pans: small plastic containers for finished handmade paints or small enameled metal
 watercolor palette with indentations
Cheesecloth or tea strainer
Soap
Various palette knives, paint knives, and a paint scraper
Glass wand
Glass muller
Measuring spoons or cup
Carborundum® (silicon carbide, an industrial abrasive)

Preparing watercolor paint

Watercolor paint can be made by hand, but the preparation requires patience and
precision. The dry pigments must be ground to a very fine consistency in order to obtain
the non-gritty paint washes necessary for watercolor painting. The use of commercially
prepared color concentrates streamlines the process because the pigments are finely
ground. The right strength binder for each pigment is essential so that the paint will not
harden or become insoluble in tubes or paint pans. To start, I would suggest making only
one or two of your own colors just to obtain unusual colors that are not available
commercially. You may enjoy the process, while not getting bogged down in preparing
colors for a method that is essentially less cumbersome than all other painting methods.

It is good practice to start with a minimum of colors, such as naturally transparent
pigments. Indian yellow, Prussian blue, manganese blue, quinacridone red and violet,
viridian green, and indigo work well in the watercolor medium. Naples yellow and lead
white are both lead-based, so they should be used with great care in dry form. Vermilion,
which contains mercuric sulfide, can darken in watercolor.

Other pigment suggestions for use in watercolor: Hansa yellow, Mars yellow, yellow
ocher, raw sienna, burnt sienna, *terre pozzuoli*, burnt umber Cyprus, Italian raw umber,
Italian green earth, Verona green earth, chrome oxide green, priderit yellow, irgazine
orange, irgazine scarlet, alizarin crimson (light red), cerulean blue, ultramarine blue (very
dark), ivory black, lampblack, iron oxide black, and zinc white (used to mix with other
pigments to create tints, not instead of the white surface of the paper to produce
highlights or light values).

Using a glass muller on a glass slab with a sandblasted surface, grind dry pigments very finely with distilled water to a thick, creamy paste. Add a drop of wetting agent such as oxgall to tame unruly pigments that resist being mixed with water. You will need to work quickly, because the water will soon evaporate; you should then be left with your own pigment paste or handmade color concentrate. As long as you put the pigment paste in a lidded jar with a half-inch layer of distilled water on top to keep it moist, you can keep pigment pastes on hand indefinitely. Take a bit of the pigment paste from the jar and add to the gum arabic solution when you choose.

Pigments, tools, and binder:

Outer circle: honey, oxgall (dispersion aid/wetting agent), color concentrates, color box, handmade color cakes in paint pans in color box, measuring cup, distilled water, olive oil soap, and glycerin.

Inner circle: tea strainer, palette knives and paint spatula, glass wands, pigments, Carborundum®, glass muller, and gum arabic crystals.

'ading a glass surface
h Carborundum®:
a glass slab with a
ette knife mix 1 teaspoon
Carborumdum® and
ough water to make a
se solution. Abrade in a
ular motion for about ten
nutes until you have a
dblasted surface.

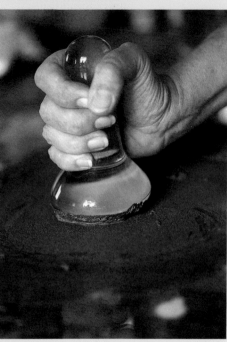

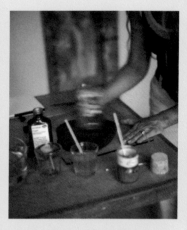

Grind dry pigments with distilled water and a drop of wetting agent, if necessary.

121

Exercise: watercolor paint recipe

Binder: make only enough gum arabic solution for one working session, since the solution will easily spoil.

- Crush one part gum arabic crystals with a hammer in a cloth.
- Heat two parts distilled water to boiling in a double boiler.
- Combine gum arabic crystals with the hot distilled water in a clean jar, then stir, and let it dissolve, which could take one to two days.
- Strain the solution through cheesecloth or a small strainer such as a tea strainer into a clean jar.
- Add a half-part glycerin or less—add a bit more if you are preparing small color cakes.
- Add a half-part or less of honey (I prefer to add a small amount of honey while I am grinding the paint).

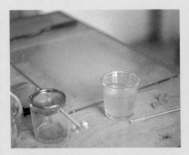 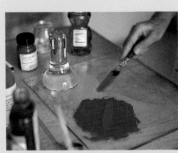 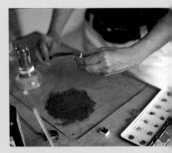

Strained gum arabic binder, glass slab with sandblasted surface.

Watercolor paint—pigment paste combined with gum arabic binder.

Preparing a color cake by putting paint into a paint pan.

Paints: to begin, mix one part binder with one part pigment paste or color concentrate. You will find that small adjustments in the ratio may need to be made with individual pigments.

- On a glass slab, use a painting knife or palette knife to rub the prepared pigment pastes or color concentrates into a smooth paste with the gum arabic binder.
- With the glass muller, grind the paste into a very smooth liquid—work quickly, or the water will evaporate.
- Add distilled water (not more binder) to prevent the mixture from drying up and becoming difficult to work with.
- Pour the mixture into a paint pan—the mixture will harden into a small cake.
- Dilute with distilled water for use.
- Clean all your tools with soap and water before preparing the next color.

All this said, if you do make your own watercolor it is best to use commercially produced color concentrates that you then mix with a gum arabic solution, combined with glycerin as a plasticizer and a small amount of honey as a humectant.

Commercially prepared watercolor paint comes in paint pans and tubes. Tube colors can be less expensive, but become hard and unusable more rapidly. Some tube colors have honey added as an ingredient, which can extend the length of time that they will stay in a liquid state.

METHOD

What you will need:

Two or three round red sable brushes: small, medium, and large
One large, full, soft mop: squirrel, badger, or camel
Three flat brushes
Synthetic brushes
Sable brush (00) for detail work
Olive oil soap to clean brushes after each work session
Porcelain palette with indentations
Enameled pan or china plate
Glass or plastic jars: one for rinsing brushes and one for distilled water
Glass wands
Glass dropper (pipette)
Utility knife, craft knife, scalpel, or pen knife
Clean rags and blotters or tissue paper
Natural sponge

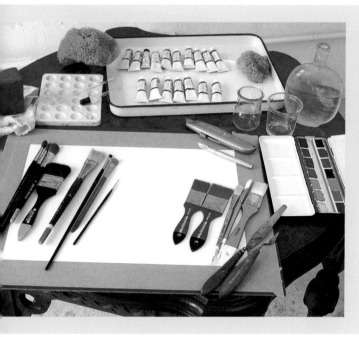

Tools and materials used for watercolor painting (clockwise from the top): enamel pan for mixing colors with distilled water, watercolor paint in tubes, natural sponges, distilled water, glass jars for water to clean brushes and to mix washes, utility knife, matte knife, color box, palette knives, soft flat synthetic wash brushes, stretched paper, 000 sable brush, flat sable brush, flat synthetic brush, flat white sable brush, squirrel wash brush, large and medium round red sable brushes, soft cotton rags and olive oil soap, porcelain palette with indentations, glass wand, pipette.

Brushes

It is absolutely essential to have the appropriate brushes; you can successfully execute an entire watercolor painting with one good large brush, but almost nothing can be accomplished with several shabby brushes. Brushes are categorized by shape: round, flat, bright (flat but stubbier), and filbert (oval). Brushes are numbered according to size, but the sizes vary with individual manufacturers. Possessing all the desirable qualities for watercolor painting, red sable brushes produce a fine point, they are soft and springy, and they hold a substantial amount of color. Red sable brushes are expensive, though, but as you should only need two or three—small, medium, and large—it may be worth the investment. They should be uniformly round and sharply pointed, and if you only purchase two, medium and large will be the most useful to have. You should have a large squirrel, badger, or camel brush for laying washes over large areas such as skies and background, as well as for quick, bold sketching.

Flat, square-pointed sable brushes are important for specific needs such as representing buildings and other squarish forms. A single stroke can represent a window shade or one plane of a skyscraper. Three flats in various sizes, from an eighth of an inch to one inch wide, are also useful to have.

I use a few very fine, soft synthetic wash brushes as well. They can keep their shape and spring for longer periods of time and can be slightly less expensive.

While using brushes, do not let them rest in a rinsing jar, as the hairs will bend and the handles will swell and cause the ferrule—the cylindrical device that holds the paintbrush hairs together—to expand and become loose. A brush with a loose handle and bent hairs is obviously difficult to use. Brushes should be thoroughly cleaned with mild soap and water after each work session. They should be stored and transported flat in a non-airtight box or, if possible, in a small bamboo mat in which the brushes are rolled one after another. If you store your brushes for a long period, pack them with mothballs for longevity.

APPLYING THE PAINT

Watercolor paint is most often applied with free, loose, linear strokes and broad transparent washes. The grain and whiteness of the paper provide brilliance to the complete work.

Washes

A watercolor wash is a liquid composed of water, in which color brushed from cakes of pigment is suspended and distributed evenly across a surface. Washes may be either flat or graded. Graded washes can go from light to dark, from dark to light, or from one color to another. One of the most pleasant and important skills to learn in watercolor is laying a wash. It will serve you well in other methods, too. It can take many hours of practice to master laying a wash, especially over a large area or an area with an irregular contour.

A great way to practice and also learn about all of your colors is to lay a wash for each color, and to layer the colors in combination with each other. Each pigment has unique characteristics. As you experiment with each one, you will learn that some colors are much easier to handle in the form of washes than others. Some colors do not layer well; some do not layer well in combination; and some have more granular pigments that settle faster. Washes should be continuously stirred because of the settling factor.

A wash can be layered with another wash to create a new color by optical mixture. For example, you can layer yellow over red to optically produce orange. A similar approach to drawing with graphite, volumetric forms are developed by laying a wash using the white of the paper and tints in various degrees of saturated color in a dynamic relation, in order to develop the value structure.

A valuable exercise when you begin the watercolor method is to make free-form test sheets to play with the colors. On a china plate or mixing tray, mix each color in your color box with the adjacent color; then apply the mixed colors to a test sheet and practice laying a wash (see instructions on pp. 127–8). Layer colors in optical mixtures and be sure to let the first wash of color dry before proceeding with the second wash. To tone down brilliant colors or colors that appear too garish in a composition, you can create broken tones. Experiment with this by adding a small amount of a color's complement or near-complement, or by letting warm and cool hues drop from your brush to mingle or flow together. Mix strong saturated colors to produce broken tones and nuances that can eventually reduce to gray and finally black. The blacks you create in this manner will harmonize more closely with your overall color composition. Experiment by creating simple forms such as cubes, spheres, and cylinders with color washes.

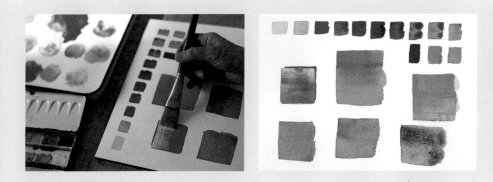

Making a free-form test sheet: At the center of this sample test sheet is a simple single-color wash. Along the top are examples of mixing each color in the color box with the one next to it, combining as you go in a large enamel pan (clean your brush with water after each application of color on your test sheet). At center right is an optical mixture, where a yellow wash has first dried and then a blue wash laid over it. Center left is an optical mixture of yellow over red, while along the bottom are three washes of broken tones, where colors are combined by laying a wash over another before it is completely dry.

For a more structured exploration use these suggested test exercises.
Experiment on your own by stretching a fairly large piece of watercolor paper or use
a watercolor block for each of the following exercises.

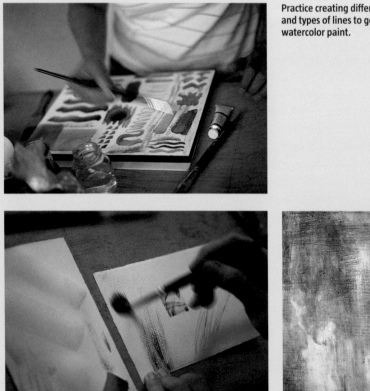

Practice creating different line widths and types of lines to get the feel of watercolor paint.

The "broken" line of dry brushwork is excellent for creating texture.

Exercise: line work

1 sheet of paper

To begin, create various types of lines from a thin hairline to an inch or more thick. You can use a medium or large round red sable brush which will make fine to thick lines. Make graded, broken, wavy, dotted, and doodle lines, and dabs and stipples.

Exercise: dry brush

When paint begins to run out of liquid, the brush will be somewhat dry, and it will produce ragged, broken brushstrokes. On rough paper, this type of brushstroke will create a textural passage—useful in representing foliage, coarse cloth, tree bark, and many other related surfaces.

Exercise: wash work—one sheet of paper

Lay a flat wash
Lay a graded wash
Lay a superimposed wash

Mix enough color to cover the entire working area. Tilt the surface of the painting at about a five-inch diagonal so that the wash will flow gently, but not run down the plane. Lightly outline the area in pencil; then wet the area with clear distilled water, brushed exactly within the lines. When it is no longer shiny, but still damp, start the wash. Load your brush with liquid color and shake the brush a bit to release surplus paint and to prevent the brush from dripping onto your paper. Begin at the top of the plane you wish to cover, and lay a quick horizontal line of color. Dip your brush as often as necessary to form a wet puddle.

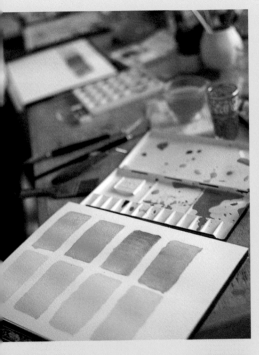

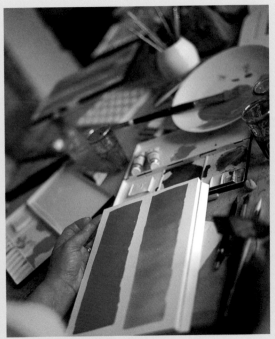

Top left: Laying a flat wash.
Top right: Laying a graded wash.
Left: Laying a superimposed wash.

When you have a puddle formed all the way across the top of the area, re-dip your brush and start again at the left to draw the floating liquid down the plane by making consecutive lines, parallel to the first, all the way down the specific area. You will need to dip your brush as often as necessary to maintain an adequate puddle all the way down the plane to be covered. The upper areas will begin to dry as you go down, but do not go back into them as they begin to set. As you approach the bottom of the area, take up any surplus paint by drying your brush slightly by touching it to a rag, and then take up any surplus paint with the dry brush, using a light touch, in order not to lift too much paint on the lower edge of the wash. This takes practice.

Graded wash

You can work from light to dark or from dark to light. To work from dark to light, begin with a color mixed with water in a more saturated solution. Then reduce the saturation as you go down the area by progressively adding the necessary amount of water to dilute the color as you go. Some artists consider it easier to mix several cups of wash ahead of time, each a little lighter than the previous one. If you wish to work from light to dark, you can reverse this by starting with the lightest wash, then shift to the next, and so on. You can also make a wash from one color to another in this manner.

Superimposed grades

With a quick, light touch, lay a wash of one color and wait for it to dry thoroughly before adding the next. With some pigments beautiful tones can be built, while other pigments will not respond well to superimpositions.

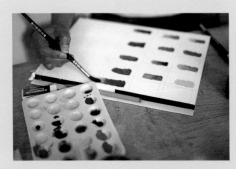

Creating a test sheet of washes of each color helps build skill as well as providing a reference sheet for color saturation.

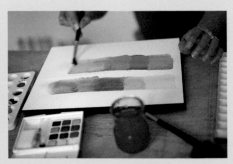

Create optical mixtures with superimposed washes of colors.

● Test sheet of washes of each color

With a pencil, lightly outline as many small rectangles as you have colors. Fill each rectangle with a graded wash. Group your reds, yellows, blues, greens, and browns on your test sheet. Use this test sheet to build your skill at laying washes. Keep it as a permanent reference to view your colors in full saturation and diluted to see how transparent some colors are, how relatively opaque others are, and to see the granularity of your colors.

- Test sheet of superimposed washes of colors

Make a test sheet to see how each pigment works in optical mixtures. To start, superimpose the colors adjacent to each other in your color box, and then, over time, superimpose as many different combinations as you can see are possible. Reverse the superimpositions, such as layering yellow ocher over ultramarine blue, and then reverse the layering on the next test. You can produce new hues and develop various textures because of the individual qualities of each pigment. You may find that when you layer several colors a muddy effect will result, because the lower applications are dissolved. However, not all colors work well with superimposition. Some colors are naturally more opaque and can hide another color.

You will discover that watercolor work should be as fresh and direct as possible, and that the colors used for initial washes should be only those that are resistant to later overpainting. On the same test sheet, or a new one if needed, apply small parallel bands of all your colors. Let them dry and then quickly run a wet brush straight across the middle of the bands. Notice how some colors immediately lift and others are almost impervious to the water. The colors that do not dissolve or dissolve very little will be the best choices for a foundational wash. For the purpose of removal, some colors dye the paper so that they cannot be removed easily, and other pigments can be wet with water and blotted with a tissue right off the paper.

Exercise: indirect painting

You can create a line study in pencil to be built up slowly with pale washes in order to develop a value structure and depth of color.

Create an indirect painting: A portion of a pressed leaf was isolated by a viewfinder, and then it was lightly sketched to enlarge the composition to fit the painting surface. The view was painted in layers of color while closely looking at the subject.

This is the initial underpainting of the city view framed by the studio's fire-escape door. While still looking carefully at the view, the painting was completed by establishing the local colors with superimposed washes.

Exercise: direct painting or *alla prima* painting

With no preliminary drawing and broad strokes, you can create a quick, fresh response to what you are looking at or to a fleeting idea, impulse, or memory. However, do not paint too thickly, or the paint may crack. Passages can be revisited and refined at a later stage.

Create a direct painting—painting wet-into-wet from nature: Broken colors were created by color complements and near-complements combining while wet.

With watercolor, as with some of the methods that follow—such as oil and acrylic painting—the direct and indirect methods can be combined. For example, you can create a very loose, pale sketch in pencil, instead of a full study, as a subtle guide for a very free, loose, *plein air* (open-air) painting sketch. You may lay down a color and wait for it to dry before laying down another color for an optical mixture. In another passage in the same painting, lay down a color; then, without waiting, you may lay another color directly into the wet wash. Direct and indirect painting techniques can come together in watercolor without fail, if you are working and using whatever is necessary.

◄

Paul Cézanne
Foliage
1895
Watercolor and pencil on paper
17 ⅝ x 22 ⅜ in (44.8 x 56.8 cm)
Museum of Modern Art, New York

GENERAL TECHNICAL SUGGESTIONS

Paint as directly as you can, and then paint indirectly when you notice that the colors could mingle and become muddy. Lay the light tints first, then the darker washes, darkest tones next, and finally the accents. Do not complete one area at a time. Keep the whole painting going so you will be able to adjust values more accurately. One of the most important aspects in watercolor is to keep it fresh and spontaneous, so do not go over an area more often than it is necessary, and do not try to show every detail and slight gradation of tone. Suggest and indicate instead of overworking in a fussy manner, catching the life and spirit of the subject in a light, unlabored way. Always use a test sheet to apply colors before use on the painting, which will help ensure the freshness of the final piece.

While the watercolor paint is still fluid, to bring in the light (provided by the whiteness of the paper) you can make corrections or remove paint by blotting with a sponge, blotter, or tissue. Although traces of color will still remain, you can lighten areas of dried paint by lightly scrubbing them with a sponge dampened with water and squeezed, then by blotting the areas with a tissue. You should not roughen the paper surface with these manipulations.

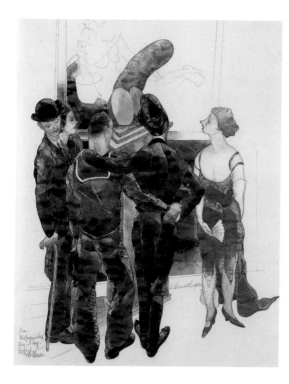

◄

Charles Demuth
Distinguished Air
1930
Watercolor on paper
16 ³⁄₁₆ x 12 ⅛ in (41.1 x 30.8 cm)
Whitney Museum of American Art,
New York

To bring in light and volume to the forms and to obtain discreet tones, Charles Demuth blotted out color with a blotter or sponge. This can be accomplished while the paint is still damp with a blotter or sponge, or when the painting is dry with a damp sponge.

With heavy papers, small highlights can be scraped out with a very sharp utility knife, craft knife, scalpel, or pen knife. If you plan ahead, you can also use small pieces of masking tape, masking fluids, or rubber cement to preserve areas of light. When your painting is dry, remove the masking by peeling or rubbing it with a clean, dry cloth.

As with drawing, be aware that in a delicate method such as watercolor, when you touch the paper, your hands will release oil that will change the way that the materials on the paper will respond. The oil can absorb material and create a more saturated color, a deeper value, or a blemish.

Exercise: creating paintings from a photograph

In preparation for creating a painting, it is important to get used to the way the paints handle and focus on a value structure, so I suggest starting with monochrome painting, which uses just one hue. Select a simple, pleasant, and well-composed black-and-white photograph. To simplify, use a simple viewfinder (made by measuring a 1 by 1¼-inch [2.5 x 3 cm] rectangle on a piece of card and then cutting out the rectangle with a knife; see Chapter 3, p. 68) to select and isolate a portion of the photograph. You may want to make a preliminary 1 by 1¼-inch thumbnail sketch (see Chapter 3, p. 68). Block out the main proportions with a medium pencil, and place the thumbnail sketch and the photograph directly in front of you in a vertical position. On your painting block or stretched paper, lightly sketch your subject. Make your final sketch larger than the photographic image. Choose a gray-blue, blue, sepia, green earth, red earth, or umber hue. Analyze the subject: look for the direction of the light and important textures, and squint your eyes to simplify the value variations. Now begin to paint, remembering to lay the light tints first, followed by the darker washes, the darkest tones, and finally the accents. Work over the entire area of the painting and not only on one area at a time.

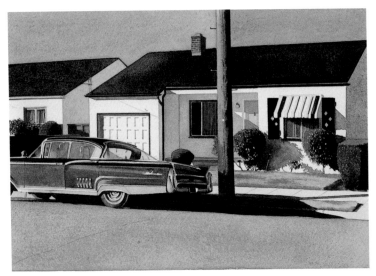

◄

Robert Bechtle
Mercury
1974
Watercolor on paper
10 x 14 ¾ in (25.4 x 37.5cm)
Whitney Museum of American Art,
New York

You could carry this exercise a step further by copying a master painting or a portion of a master painting while employing the same process. Choose a painting in this chapter or a watercolor painting in Chapter 1 or Chapter 2. Select the whole piece or a portion on which to focus. Make a thumbnail sketch and then a final sketch on watercolor paper. Then proceed with painting in the way that is most natural for you: in washes, dabs, mingling, or drawing with the end of your brush. You may want to work on two or three portions of paintings by different artists, so as not to get hung up on one artist's style and methods. Then quickly progress with creating and experimenting in your own work.

After selecting your subject photograph, frame a portion of it with a viewfinder. On your paper, lightly sketch the image, making it larger than that framed by the viewfinder. Now begin to paint, remembering to lay the light tints first, followed by the darker washes, the darkest tones, and finally the accents. Use test sheets to test colors before laying them on the painting surface. Work over the entire area of the painting and not just on one area at a time.

Care and protection of watercolor painting

A watercolor painting should not be varnished, as varnish would be difficult to remove when necessary and it could compromise a delicately nuanced painting surface. To protect the watercolor, store it away or hang it in a glazed frame, and always store and transport it flat, because the gum arabic binder is not flexible.

Exercise: creating *plein air* paintings

Travel exercise: *plein air* watercolor painting—direct, open-air painting in the ambience of light and atmosphere.

Take a small watercolor kit, a small flask of distilled water, two to four brushes, two small plastic or glass cups, pencil, eraser, a small sponge, and a 9 x 12-inch (23 x 30.5 cm) or postcard-sized watercolor block, or postcard-sized single sheets, with you wherever you go. I take postcard- or credit card-sized gesso panels with me when I travel. To immerse yourself more deeply into your surroundings, look a little longer and harder to record a scene with paint rather than with film or a digital camera. Create a memento, record moments; work quickly to record a fleeting scene out of a train, plane, or car window. Then work more slowly to record the changing light.

Left:
Open-air painting allows you to record images in watercolor directly from their natural setting.

Right:
Portable watercolor materials: brushes and bamboo mat for transport, color box and small sponge, small water bottle, postcard-sized cold-pressed watercolor paper, pipette, small wood gesso panels, pencil and kneaded eraser, small glass cups, small color box, and portable watercolor paper block.

Above:
Credit card-sized watercolor painting. Note the colors used: ultramarine, cerulean blue, yellow, red, the white of the gesso ground itself, and zinc white.

Exercise: creating paintings from nature and color observation

Look closely when working in nature and with material from nature, as nature will inform you about color and you will learn what colors need to be layered. For instance, spend time looking at a rose petal. If it is pink, you will want to lay down a pink that most closely approximates the pink that you see. Use your test sheet to see how accurately you can produce the pink. If the rose-petal pink is less saturated than the one you have put down, you can take up color with a damp sponge and then add more water to the pink next time, so that the paper will lighten the hue. Start again, this time by looking even closer at the rose petal. You may see yellow or greenish yellow at the inner edge of the petal where it was connected to the rest of the flower. That can indicate that you will need to lay down a

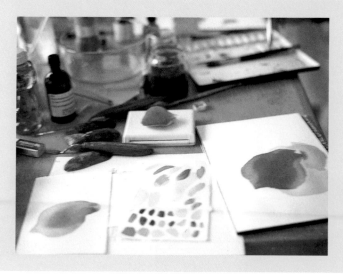

pale yellow under the entire form before you lay down the pink. The yellow will enrich the pink and it may render it closer to what you are seeing. Wait for the yellow to dry and then lay down the pink; then lay a little more of the yellow on the exposed edge of the petal, to bring it closer to what you are seeing in the real edge of the flower. Again, look closely. You may see some cool veins of color on top of the pink hue. To indicate the blue veins of color, try laying down a few very faint indigo lines with a tiny, thin brush. With this watercolor exercise you have documented the material existence of a flower petal that will perish within a few hours. As you engage in this and other related observational exercises while painting in nature, you will begin to notice subtle interchanges of color automatically. You will also learn to indicate phenomena, such as the cool veins of color, in a less literal way by representing them with a hint of the appropriate color in a wash. (Note—colors used for the rose-petal exercise: red, yellow, indigo.)

◄

Charles Demuth
Trees and Tower, Bermuda
c.1916–17
Watercolor and graphite on paper
7 ¹⁵/₁₆ x 10 ⅛ in (20.2 x 25.7 cm)
Whitney Museum of American Art, New York

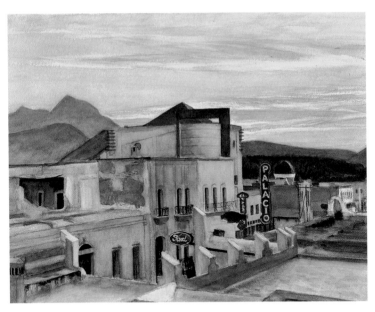

◄

Edward Hopper
El Palacio
1946
Watercolor on paper
22 ⅜ x 30 ¾ in (56.8 x 78.1 cm)
Whitney Museum of American of Art,
New York

On his first trip to Mexico, Edward
Hopper created watercolors of the
local architecture in Saltillo, a small
city in the north. Hopper's life coincided
with the rise of the film industry, which
fostered his lifelong fascination with film
and film houses. *El Palacio* is a carefully
planned watercolor of a scene of a movie
theater he frequented, which was across
the street from where he stayed. He
carefully reflected the light and the
colors of the earth in the architecture
and the landscape, and recorded the
presence of corporate American culture
and the confluence of cultures.

▲

Georgia O'Keeffe
Morning Sky
1916
Watercolor on paper
8 ⅞ x 12 in (22.5 x 30.5 cm)
Whitney Museum of American Art,
New York

ANOTHER WATERCOLOR METHOD

Opaque watercolor

Watercolor mixed with white pigments renders it opaque. Opaque watercolor, usually referred to as *gouache* and sometimes referred to as *body color*, is resoluble, is used more thickly than transparent watercolor, and is matte. A ground is not necessary because the combined opacity and matte finish produces paint with a body effect that will mask the underlayers.

The binder and pigments are the same as for transparent watercolor, but with the addition of precipitated chalk, titanium, zinc-, or china-white pigment, the paints are rendered opaque. The paints can be handmade with more ease because it is not necessary to grind the pigments so finely.

Using basically the same recipe as for preparing watercolor, add up to one part precipitated chalk or white pigment to one part pigment, as well as slightly less plasticizer (glycerin). It is necessary to limit the amount of plasticizer so that the color will retain its opacity and will not go dull. Use a paint knife or palette knife to rub the pigment and chalk into a smooth paste with the binder. Each pigment will require a slightly different amount of binder, but begin with the ratio of one part pigment to one part binder. Grind the mixture into a smooth liquid with the glass muller on the glass slab. Gouache paint should be more of a liquid than a paste, and for this reason, it cannot be put into paint pans. Fill small glass jars with the liquid paint and cap them tightly. Clean all tools before preparing the next color.

You can use the same paper or a glue-gessoed panel for support and ground. Although the same brushes may be used, you may want to use bristle or synthetic brushes so that the paint can be applied more thickly.

The method can be the same as for transparent watercolor, but the paint can be built up to a thicker film. Since the transparent watercolor and gouache paints are approximately equal in strength, they can be applied on top of each other in any order, without the danger of creating an unsound paint surface. Be aware that gouache dries lighter in value than it appears when it is wet.

Commercially prepared gouache comes in tubes only because of the necessity to limit the amount of plasticizer.

◀

Amy Cutler
Pine Fresh Scent
2004
Gouache on paper
8 x 10 in (20.3 x 25.4 cm)
Whitney Museum of American Art,
New York

6
ENCAUSTIC PAINTING

In order to follow the chronology of the development of painting, I'm now focusing on an ancient method known as "encaustic painting." You can skip to oil painting or another method at any time.

The earliest surviving examples of encaustic painting are portraits on small wooden panels, dating from the first to the fourth centuries AD, which were created by Roman and Greek artists living in the Fayum region of Egypt. These wooden panels were attached to mummy cases of the deceased. Since the beginning of the nineteenth century, over six hundred such portraits have been excavated, suggesting that this was the most prominent encaustic painting movement in history.

Many are painted directly on ungessoed panels (see *Portrait of a Woman Called Eirene*, opposite). Wax colors were heated on a metal palette set over a metal drum filled with glowing charcoal. Molten colors were applied with warm brushes and metal tools such as a palette knife, and fine modeling work was done with heated bronze tools. A brazier filled with charcoal was then used to fuse the surface upon completion.

The practice of using encaustic for the painting of icons of holy figures continued until the sixth and seventh centuries in North Africa and throughout the Byzantine Empire, after which it was replaced for the most part by egg tempera. These icons continued to be produced with encaustic in Russia and other parts of the Eastern Orthodox world well into the nineteenth century. Encaustic painting was superseded in the West by the practice of egg tempera, fresco, and then oil painting. A revival of encaustic was sparked in the mid-eighteenth century by French antiquarian Comte de Caylus (1692–1765), who took issue with earlier translations of Pliny's *Natural History* which, for the most part, were translated without interpretation; Pliny the Elder (AD 23–79) documented the Hellenistic painting tradition, specifically that perfected by the fourth-century BC painter Apelles. Caylus hired the artist Joseph-Marie Vien (1716–1809) to experiment with the wax medium. Vien painted a small head of Minerva on panel in encaustic that was exhibited at the Académie Royale des Inscriptions in 1754. The encaustic revival, inspired in part by the interest in antiquity that began with discoveries made in Italy at Herculaneum and Pompeii of fragments of ancient wall paintings, continued through the nineteenth century in France and Italy.

Properties

The word "encaustic" derives from the Greek *enkaustikos*, meaning "to burn in." Dry pigments mixed with molten wax and then painted directly onto a support are burnt in at the completion of the painting to fuse and consolidate the surface. In the traditional method, it is not regarded as an encaustic if the final thermal treatment is omitted. Once hardened, the surface can be polished to a dull sheen with a soft cloth. Encaustic reaches its permanent state in a minute or two, and can then last 2,000 years, to be repaired or reworked at any time by melting and scraping.

An encaustic painting is durable, retains its body, is impervious to water, and, because it contains wax, does not yellow or oxidize. At different stages in history, however, the addition of various substances sometimes has led to an impairment in the fine qualities of wax. It has become a common practice, for example, to add more than a small amount of oil, which can cause encaustic to yellow. Also, the addition of turpentine or mineral spirits can limit the crystalline quality that can occur when the encaustic surface is polished.

Jasper Johns
Three Flags
1958
Encaustic on canvas
30 ⅞ x 45 ½ x 5 in (78.4 x 115.6 x 12.7 cm)
Whitney Museum of American Art,
New York

In a small sketch on the back of an envelope, Jasper Johns recorded the image of a large American flag he saw himself painting in a dream. He chose encaustic for the painting, as it simply had to cool, and then you could paint another layer.

▶

er Johns
ch for Three Flags
3
coal on paper
x 9 ⁷⁄₁₆ in (10.6 x 23.9 cm)
tney Museum of American Art,
York

Portrait of a Woman Called Eirene
c.AD 37–50
Encaustic on wood panel
14 ½ x 8 ⅝ in (37 x 22 cm)
Ancient Art Collection,
Württembergisches Landesmuseum,
Stuttgart

The optical effects it produces have attracted artists of all eras. In the twentieth and twenty-first centuries, the technique has been used by artists such as George Rouault (1871–1956), Diego Rivera (1886–1957), and especially Jasper Johns (b. 1930), who has said of encaustic: "The combination of this new medium—well, actually it's old-fashioned—coincided with this idea that everything was right then. What it did was immediately record what you did. I liked that quality. It drips so far and stops. Each discrete movement remains discrete."[18]

Outline of technique
- Prepare the surface of the support: panel or canvas.
- (Optional) Lay down an *imprimatura*: a thin layer or veil of color made with distemper.
- Create a sketch directly on the panel with charcoal, or transfer your sketch.
- Underpaint with distemper.
- Paint with molten colors on the panel or canvas.
- Manipulate with a heat source such as infrared bulb while painting.
- Model with heated metal tools.
- Finish with touches of distemper.
- Fuse surface with an infrared bulb, heat lamp, or heat gun.
- Polish.

Preparing the rabbit-skin glue solution and the gesso

What you will need:
Rabbit-skin glue granules
Water
Double boiler
Small wood panel or stretched canvas
Bologna chalk
Soft, wide, flat varnish brush
Fine sandpaper

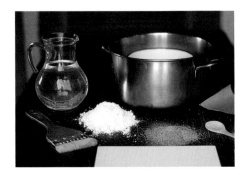

Encaustic paint can be applied to a wooden panel or to canvas stretched over a wooden support. The Fayum encaustics have only rarely been found to have a gesso ground. However, the wood or linen on which they were painted was seldom left bare, and most have been shown to have a distemper (glue and dry pigment) underpainting. I suggest that the wood or canvas be prepared with one coat of rabbit-skin glue solution and then that two or three thin coats of traditional glue gesso (*gesso sottile*) be applied. Traditional glue gesso is absorbent and will provide a receptive ground for a thin distemper underpainting.

Glue recipe: Soak one part rabbit-skin glue granules in fifteen parts water for one hour until it swells. Warm the glue to form a translucent solution. Do not boil, as boiling may compromise the adhesive properties. Test the glue with two fingers. If your fingers stick together, the glue has been properly mixed and it is ready to use.

Glue gesso recipe: Add one part Bologna chalk to one part warm glue solution (see Glue recipe, above). Add the chalk slowly without stirring. Allow the chalk to be absorbed into the glue solution for thirty minutes. Stir slowly to avoid air bubbles and combine the chalk with the glue solution before applying to the panel.

It is easiest to apply glue and gesso to the panel or canvas if the solutions are slightly warm. To maintain a warm solution in cooler temperatures, keep the vessel immersed in another container of warm water while you are using the glue or gesso solution.

If you are using a wood panel, lightly sand it with fine sandpaper and clean it with a soft rag. Using a soft, wide, flat varnish brush, apply a thin coat of warm glue to the front, sides, and back of the panel or canvas to seal it, equalize tension, and prevent warping.

Let it dry for four hours. With the same brush, apply a thin coat of warm gesso to all sides of the panel or canvas. With a circular motion, quickly and vigorously rub the gesso solution onto the front of the panel with your hand while the gesso is wet.

Before adding the second coat, let it dry to the touch. Apply this coat quickly and smoothly in one direction. Let it dry to the touch, then add a third coat, perpendicular to the last. Aim to add at least three thin coats of gesso. Make sure that you apply these multiple coats of gesso to the surface on the same day to ensure adhesion and prevent flaking.

Let the surface dry overnight. It is not necessary to have a completely smooth surface for encaustic painting. When dry, the surface of a wood panel will be slightly rough due to surface irregularities, and because the wood grain will rise when liquid solutions are applied. If you prefer a smooth surface, however, lightly smooth the surface with fine sandpaper after the gesso has been applied.

The surface of a canvas is intrinsically rough and, again, you can sand the surface to obtain smoothness. However, with canvas, this can only be done after at least four coats of gesso have been applied to canvas that has been stretched over a wooden panel. As I do not recommend applying more than two coats of *gesso sottile* (glue gesso) to canvas that has been stretched over stretcher bars, I suggest using half-chalk gesso, which includes some oil to provide flexibility (see Chapter 8, p. 217, for instructions on how to prepare half-chalk gesso). This is because glue gesso is fragile and can crack on flexible surfaces such as canvas. If you prefer the rough surface, apply rabbit-skin glue to protect the canvas, and if you would like to have a more substantial and receptive ground, apply one thin coat of *gesso sottile*.

are the rabbit-skin glue tion (test to see if two ers stick together).

Brush on the rabbit-skin glue solution.

Prepare glue gesso by letting chalk slowly drop into solution.

first coat of gesso on el in a circular motion.

Brush on the gesso.

Apply multiple layers of gesso.

Dry the panels.

PIGMENTS AND BINDER

Preparing the pigments

What you will need:
Rabbit-skin glue solution for distemper
Porcelain palette with indentations
Bleached beeswax (pellets if possible)
Metal palette with indentations, at least 8 inches (20.3 cm) in diameter
Hot plate with temperature adjustment
Dry pigments
Small spoons
Glass wand
Glass dropper (pipette)
Palette knife
Linseed stand oil or sun-thickened linseed oil
Dammar crystals
Sheet of iron or stainless steel

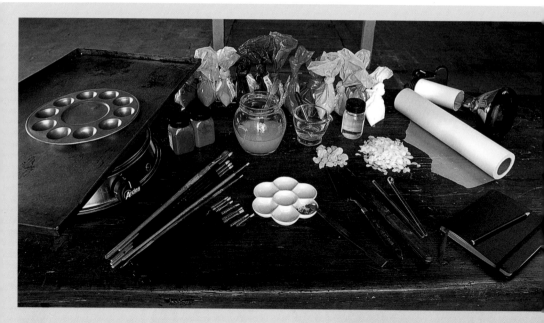

Tools and materials for encaustic painting (clockwise from top): dry pigments, infrared heat bulb and fixture, tracing paper, sketchbook and pencil, small spoons, glass wand, glass dropper, palette knife and other metal tools, bristle, synthetic, and sable brushes, porcelain palette, rabbit-skin glue solution, rabbit-skin glue granules, beeswax pellets, dammar crystals, linseed stand oil, distilled water, hot plate with temperature adjustment, sheet of iron or stainless steel, metal palette with indentations.

Dental tools: spatula-type.

Tools and brushes

What you will need:
Infrared heat bulb and fixture
Heat gun
Bristle brushes for encaustic painting and synthetic or sable brushes which can be
 used for distemper painting
Palette knife
Sketchbook
Pencil
Tracing paper
Charcoal

The Fayum portraits are very simple in their color harmonies and composition, offering examples of the portrait conventions established in the early Hellenistic tradition. In this chapter, I will present the technique used by the Fayum painters—as shown in *A Woman, Early Antonine* (see p. 146)—and suggest using their limited palette of four colors for portrait areas: white, yellow ocher, red earth, and black—the Greek primary colors in antiquity. Additional colors can be used, such as blue, green, and purple for clothing and decorative elements. The backgrounds in these portraits are frequently gray, which can be produced with black and white, and small amounts of the other two colors, to allow a warm or cool inflection. In his *Natural History*, Pliny the Elder mentions the use of black soot to produce a range of warm and cool grays. It was obtained from various substances, such as the brownish soot produced from burning ivory or bluish soot produced from burning the dregs of wine. Vine black, indigo, and raw umber could be substituted for these colors if needed.

Start with a distemper underpainting. Preparing distemper is simple and straightforward. It requires dry pigments and the rabbit-skin glue solution described in the glue recipe on p. 142. With a glass wand, thoroughly grind each pigment in an individual indentation of your porcelain palette. To produce a color from two or more hues, dry powders should be mixed and ground together before any type of binder is added. After mixing and grinding, add a drop or two of distilled water with a pipette. Grind the pigment and water again to make a paste. With a small spoon, add an equal or greater amount of rabbit-skin glue binder and grind again to make a liquid color. If you are in a cold studio, the colors will become gelatinous. When my studio is cold, I keep my palette on a small warmer usually used for a teacup. You can also put your palette in a shallow bath of hot water to liquefy the colors.

Thoroughly grind each color with a glass wand in an individual indentation of the small metal palette for encaustic painting. Electrically heated metal palettes to put under the small metal palette are available commercially. A heated palette can also be improvised by placing a sheet of iron or stainless steel (with legs for best results) over a hot plate with temperature adjustment, or by using an inexpensive electric skillet. The small metal palette with indentations can then be placed on top.

When you are ready to paint with encaustic, add several pellets of bleached beeswax to each color and then turn on the heat. I recommend using a greater amount of

beeswax than color as you begin. The amount of beeswax can be varied according to need. Use the maximum amount of wax for the most transparent glazes and the minimum amount for a thick, coarse impasto. Place your palette on the metal sheet on top of the hot plate, warm the pigments until they are liquefied, then stir them with a palette knife until well mixed. Pigments and molten bleached beeswax as the binder are kept at around 200°F/93.3°C while painting.

Do not allow the wax to smoke, as wax vapors can be harmful. Encaustic is, however, one of the least toxic of artists' paint because it does not require the use of highly flammable solvents.

Encaustic paint can be thinned by adding a bit of oil or additional wax, or by slightly increasing the temperature of the paint. You can add one part sun-thickened linseed oil to ten parts molten beeswax (remove from heat when adding) for a slightly thinner, more flexible paint. The linseed oil will cause the paint to yellow, however. You can crush one or two pellets of dammar resin and add to each quarter-cup of molten beeswax to achieve a harder, more crystalline painted surface. When you add these substances to the wax, you will need to add the wax mixtures to the pigment in molten, liquid form.

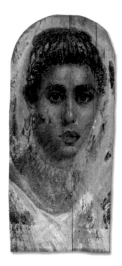

▶

A Woman, Early Antonine
c.AD 138–161
Encaustic on wood panel
14 ⅞ x 6 ⅔ in (38 x 17 cm)
British Museum, London

Although the majority of the examples of Fayum portraits are less than life-sized, they can appear to be life-sized due to the distance from which we view paintings at a museum. Given that notion, the artists may have been at that same distance from their subjects while creating the paintings.

METHOD

Beginning the distemper underpainting

Exercise: preparing and applying the distemper underpainting

What you will need:
Pigment prepared with rabbit-skin glue binder
Small cup
Extra rabbit-skin glue solution
Glass wand
Glass dropper (pipette)
Bristle, synthetic, or sable brushes
Distilled water
Charcoal

Imprimatura layer (optional)

The *imprimatura* can be applied in one very thin coat. When it is dry, the color will appear lighter. Additional coats can always be added to achieve a darker *imprimatura* layer if desired. While the brilliant white gesso shows through, providing a light source from within the painting, the earthen *imprimatura* brings depth and a warm counterpoint. Place a pea-sized amount of pigment such as green earth or raw umber in a small cup, add a few drops of distilled water, and grind the pigment with a glass wand. Add approximately fifteen parts of rabbit-skin glue solution and grind again to produce a liquid color. Apply a thin veil of color with a large, soft-bristle brush to the surface of the panel.

When the *imprimatura* is dry, make a rough sketch directly on your gessoed panel with charcoal, or transfer a sketch—see p. 153, the self-portrait example below, Chapter 3, p. 80, or Chapter 7, p. 163, for an explanation of a transfer method.

The distemper underpainting is applied from dark to light. For specific portrait areas, the underpainting can be made in broad strokes in different colors with bristle brushes or with synthetic or sable brushes, because the distemper will not cause damage to brushes. The underpainting for the flesh should be green earth, which can be made by adding a small amount of black to yellow ocher, or you can use a green earth pigment. You can begin to model the contours at this stage by diluting the green earth with a bit more water and glue solution. The underpainting for hair is a blackish-gray flat helmet. For the background, a neutral cool gray, produced by mixing small amounts of black and yellow ocher with white, can produce relative warmth in the flesh tone, which will be applied later. The warm flesh tone can be intensified because it is offset by the cool gray background. Choose another neutral color for the underpainting of the garment area. Cool and warm hues, rather than dark and light tones, are used to make objects appear to recede or advance. The cool grays of the background recede as the warm tones of the flesh advance.

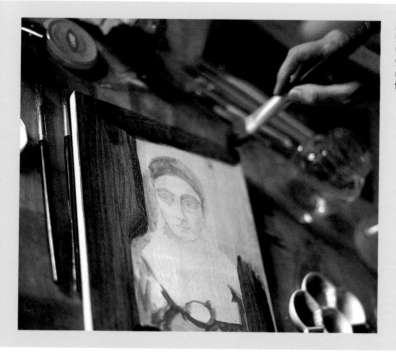

A distemper *imprimatura* layer was applied before a sketch was transferred onto the wooden panel. A distemper underpainting is being applied from dark to light.

Beginning the encaustic: painting with molten wax

Exercise: painting and burning-in

What you will need:

Prepared pigments in a small metal palette with indentations

Infrared heat bulb and fixture

Heat gun

Bristle brushes

Palette knife and other metal tools

Apply the local colors—the true colors you see in ordinary daylight—of the background and garments first to direct and maintain the relative warmth of the flesh tones. Use a single brush for each color, or one brush for dark colors and one for light. Bristle brushes in small pointed, flat, and round and medium flat and round are sufficient. Sable and synthetic brushes will not hold up with the use of wax. Clean the brushes before using another color by placing them briefly on your metal palette and immediately cleaning with a towel.

While molten, paint is applied quickly and directly to the panel or canvas with a brush or palette knife, or other metal tool that has a wooden handle so the heated metal will not come into direct contact with your hand. I have found that dental tools (the spatula type) are perfect for applying and manipulating encaustic paint; the metal tip conducts and holds heat longer than the palette knife while the handle stays cool. Paint strokes will set almost immediately. Colors can be applied in small strokes and then warmed with the heat lamp to blend and fuse. Alternatively, your panel or canvas surface can be kept warm by holding a lamp with your free hand or clipping it to an adjacent structure to facilitate more fluidity in paint. A heat gun allows for an easier focus on details. Black and dark, translucent colors melt faster than opaque white or light hues, so depending on the desired effects, you may want to wait to use dark, sheer colors until you are nearly finished painting. By painting with lighter, opaque hues, you can blend and fuse as you go along; then, the final burning-in should fuse the dark, translucent colors relatively quickly, while gently warming the whites and light, opaque colors to consolidate the entire painting.

As you continue to apply the paint, notice if the background colors have a cool inflection. If so, the warmth of the flesh tones can appear intensified because of the contrast of warm and cool hues. A warm inflection in the background colors can make the flesh tones appear cooler and more subdued. These phenomena exist because colors change their appearance in response to the colors they are placed next to. If red is placed next to orange, it will appear relatively cool in response to the warmth of the orange. If red is placed next to blue, it will appear warm in response to the coolness of the blue.

The eyebrows and hair are stated with force. Over the flat, blackish-gray of the helmet of hair, shadows can be painted in black and highlights can be painted in a gray that is slightly lighter than the middle tone of the helmet. The three tones can be varied according to the hair color. Strands or curls can be painted individually on top of the helmet to break up the outline, while leaving a bit of the gray underpainting around the hairline as a shadow, providing a natural look. The flesh tones are laid over the green-earth underpainting. The flesh is composed of a combination of the four colors mentioned above—white, yellow ocher, red earth, and black—in varying proportions, according to the complexion of the individual. For instance, there is more red and black in dark skin tones, and in the very darkest tone there may be just black with a trace of red, yellow, and white. In the very lightest tone there may be white, yellow ocher, and a trace of red and

black. Red earth can be used on lips, cheeks, and wherever a blush is needed.

Finally, put a minute amount of pure black in areas such as the nostrils, the corner of the eye, and the interior edge of the lips. Define bright points of light with controlled impasto in white or near-white. Decorative details can be delicately defined and facial features sharpened with the very slightest touch of distemper paint before the final burning-in.

The final burning-in is achieved by laying the painting flat and passing the heat source—an infrared heat bulb, a household iron, or a heat gun—over the surface carefully and at a distance of four to six inches (ten to fifteen cm) above. This will allow the

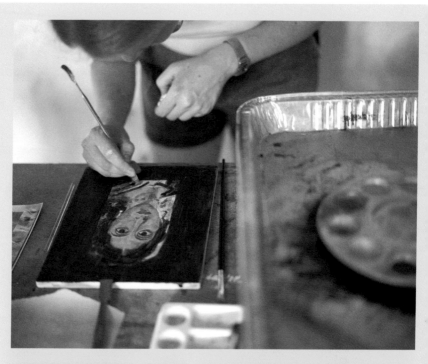

nting with molten wax.

t:
ng pigments by burning-in
k areas).

ight:
ning details with
mper.

pigments to fuse, but not to melt completely and run off. Be aware that sheer, dark pigments melt more quickly than opaque white or pigments of a light hue.

After burning-in to fuse colors and consolidate the surface, wait for a day and then polish the surface to a soft, dull sheen with a cotton cloth. The surface can be polished intermittently (once every few months) to remove dust and renew the soft sheen.

I have found that the materials and processes of encaustic painting provide challenges that take the work out of my control, and allow a framework for scruffy, painterly surfaces. A more careful application of details can be combined with these surfaces: creating, for example, a tension between delicate refinement in facial features and a reckless energy in the garments and background. Descriptive content can coexist with the tactile paint surface by applying lustrous points of controlled impasto.

Encaustic painting needs a lot of practice and experimentation to see how the materials and processes can best suit your needs and goals as an artist. It is well worth the struggle that encaustic materials and processes impose, as the rewards are great and the possibilities are limitless.

TECHNIQUE

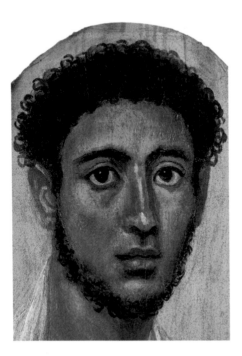

◀

Anonymous
Portrait of a Man, from Hawara (detail)
C. AD 117–138
Encaustic on wood panel
14 ⅝ x 7 ¾ in (37 x 20 cm)
Antikensammlung, Munich

Portrait of a Man, from Hawara may have been funerary, not done from life. Observe how the artist achieved liveliness. Notice how the relatively warm flesh color advances as the cooler background recedes. The highlights stand out against the deep hue of the flesh. There is transient, incident light hovering and flickering across the face to depict a fleeting moment. Squint your eyes to discern the relative darkness and strong, clearly directed incidental light. The shadows, such as those cast by the nose and lower lip, are abrupt and are not blended with the flesh tone or the lights. The modeling of the flesh as it curves back from a frontal plane of the cheek toward the ear is painted in a more subtle gradation. To create a natural look, the curls of the hair have been individually painted over the barely visible helmet of gray underpainting. There is a swift, rough brushwork visible in the garments.

bara Ellmann
ehand History
)4

aaustic on wooden panel
x 24 in (60.9 x 60.9 cm)
ection of the artist

nann mounted watercolor paper on a
oden panel, covering it with a layer of
swax. She used a manufactured
aaustic paint combining beeswax,
ment, and dammar resin, which she
lied with brushes and a heated stylus
l. Masking tape helped create sharp
es, and dental tools and a razor blade
re used to carve and incise. Each layer
s fused with a heat gun, and finally the
el was buffed with a soft cotton rag to
sh the surface.

da Benglis
vel Agent
6/77–8

nented beeswax and gesso on Masonite®
4 x 6 ¾ x 5 ½ in (82.1 x 17.2 x 14 cm)
tney Museum of American Art,
v York

da Benglis's interest in the tactile
cess of making her own paint led her to
d Ralph Mayer's Materials and
hods. On finding that encaustic was
ed in alchemy (the beginnings of
ting), she purchased wax from a
lesale lipstick company and combined
th dammar resin crystals and dry
ments. Drawn to the mutability of wax,
anslucency, and its brilliant color, she
tinued to experiment with encaustic for
next ten years.

▲
Jasper Johns
Double White Map
1965
Encaustic and collage on canvas
90 x 70 in (228.6 x 177.8 cm)
Whitney Museum of American Art,
New York

The stacked canvases each show the
contiguous U.S. and portions of Canada
and Mexico. Johns produced a range of
softly translucent whites, off-whites, and
beiges with encaustic paint. Collaged
fabric and paper, such as newspaper
advertisements and pages from a
detective story, show through the painted
surface. The red, white, and blue trim of
airmail envelopes is visible on areas
outside of the U.S.

Exercise

Part 1: Copy a Fayum portrait on a wooden panel

Choose one of the encaustic Fayum portraits. Now is the time to apply an *imprimatura* if you choose. With a piece of charcoal, create a sketch directly on your gessoed panel or canvas, or make a sketch with pencil or charcoal in your sketchbook, equal in size to your painting surface. Copy or transfer your sketch onto your panel and then begin your encaustic painting by creating a distemper underpainting and continue through the entire process described on page 148.

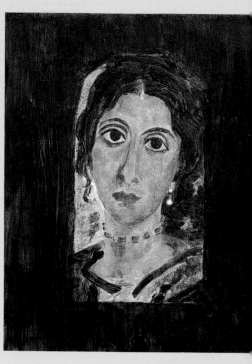

Above:
Copying a portrait in distemper.

Right:
Finished piece.

Part 2: Make an original painting using the same method

Create a self-portrait, a portrait of another person or a pet, or paint a landscape. If you choose to make a portrait, place yourself, your friend, or pet in front of a neutral background. Make a few quick thumbnail sketches (see Chapter 3, p. 68, for an explanation of the thumbnail sketch). Choose your favorite sketch and make a larger drawing from it, equal in size to your painting surface. Transfer your sketch to your panel or canvas. Use your sketches and close observations of your subject to inform your choices in color, form, and composition. After you have completed your distemper underpainting, continue the encaustic process described above, while paying close attention to the local colors and the incidental light.

creating an encaustic landscape, I created a graphite sketch the same size as the wooden panel I intended to paint on, which was 6 ¾ x 8 ¾ inches (17.1 x 22.2). I used this as a reference when I began the distemper underpainting on the panel. I then continued by painting with pigments dissolved in molten beeswax. I the distemper exposed on the diagonal shape representing a dock on the right side of the painting, because I wanted to have ry, nonreflective surface in this area to set and provide a contrast to the area resenting water.

reating my own encaustic self-portrait, o started by creating a pencil sketch in etchbook while looking closely at my rored reflection.

Then I traced the sketch using glassine tracing paper and a pencil. I rubbed a pea-sized amount of raw umber dry pigment onto the back of the tracing, then placed it right-side up on top of my painting surface. I taped it down and drew over the lines with pencil to transfer the sketch in raw umber to the painting surface.

I produced a distemper underpainting and full encaustic painting, then melted it down, scraped it off, sanded, and painted back in with distemper. There is a residue of wax, while the wood grain is exposed, which supports the underpainting and subsequent painting.

SOME ALTERNATE TECHNIQUES

Encaustic painting lends itself to use in experimental, free-form, improvisational applications. Encaustic painting can be combined in various ways with most painting and drawing techniques. You can "encausticate" (apply wax to the surface) any painting or drawing by pouring molten wax on the surface, or by placing beeswax pellets on the surface and heating the surface with an infrared heat lamp to liquefy the wax. You can then paint back into the surface with whatever media you are using, such as oil or casein, and then fuse it with a heat source to consolidate the surface.

▲

Joan Nelson
Untitled (#279)
1990
Oil and wax on wood
6 x 12 in (15.2 x 30.5 cm)
Robert Miller Gallery, New York

A white ground that has been heavily coated with a layer of pure beeswax can be delicately painted with oil paint. Because of the beeswax coating, the oil paint can appear to be floating on the surface as it disperses somewhat into the wax ground. When fused, it can create soft, atmospheric effects. The white ground is allowed to show through as a substitute for white paint.

You can melt wax pellets on the surface of graphite drawings on paper or gesso panel to varnish, preserve, and protect the surface. Drawings or other ephemera can be embedded into the surface of a painting or drawing by applying wax to the surface over the material. Wax can be inscribed with a sharp instrument, creating lines as delicate as those of pencil, and then oil paint can be rubbed in and wiped down. The toned ground will diffuse irregularly into the wax as the paint sinks into the lines to darken and define them.

e Marden
ve IV
5
nd wax on canvas
 panels,* each 72 x 108 in
*.9 x 274.3 cm)
mon R. Guggenheim Museum,
York

e Marden mixed oil paint with a
lium of beeswax and turpentine,
 warm on a hot plate. Oil is the
ary binder, not wax. He applied
r after layer with a brush, reworking
 with a painting spatula and knife.
layers were not fused with a heat
ce, so as the wax cooled, it produced
t, mellow translucency.

7
EGG TEMPERA PAINTING

The earliest records of egg tempera painting come from Greece and from the Fayum region of Egypt in the first century AD, where, like encaustic, Greek painters used the technique for mummy portraits in a practice that continued until the fourth century. From the fifth to fourteenth centuries, during the Byzantine and medieval periods, devotional paintings or icons were made in egg tempera.

In Italy, between the twelfth and fifteenth centuries, it developed into the refined and standardized method that we know today. It served the needs of early Renaissance painters such as Giotto di Bondone (1267–1337), Duccio di Buoninsegna (c.1255/60–1315/18), Cimabue (1240–1302), and Simone Martini (c.1284–1344), whose extended narrative cycles involving religious themes benefited by this precise linear style to convey ideas and religious concepts rather than naturalistic appearances. The glowing surface was obtained by many translucent, superimposed layers of paint, which were composed of discrete brushstrokes that dried almost immediately, preventing blending. The fine network of hatched lines served to blend colors optically when viewed from a distance during religious services. A culmination of technical mastery was achieved by Fra Angelico (c. 1400–55). Starting in the early fifteenth century, drying oils came into use. These oils, usually linseed, walnut, and poppy, dry to a solid film with prolonged exposure to air, and the underpaintings came to be glazed with pigments ground in oil or egg-oil emulsions.

In the course of the next 200 years, oil-mixed pigments gradually eroded the popularity of egg tempera, and after 1600 oil paints were used almost exclusively. One reason for this was that the human being became the central focus during the fifteenth century, shifting the subjects of painting from religious to more secular themes. As oil paint does not dry immediately like egg tempera, it lends itself to the seamless blending of colors needed to achieve a more naturalistic depiction of subjects with a secular humanistic theme.

A revival of egg tempera began at the end of the nineteenth century and the beginning of the twentieth century in England, Germany, and the United States. Artists began to study the translations of Cennino Cennini's late fourteenth-century treatise Il Libro dell' arte ("The Craftsman's Handbook") as they began to be published in the nineteenth century. Ready-made materials for egg tempera also became available, but egg tempera painters preferred (and continue to prefer) to make their own paint. Twentieth- and twenty-first-century painters, including Paul Cadmus (1904–99), Andrew Wyeth (b. 1917), Ben Shahn (1898–1969), Jacob Lawrence (1917–2000), Altoon Sultan (b. 1948), Rebecca Shore (b. 1956), and Jim Lutes (b. 1955), have continued to use egg tempera, as do contemporary icon painters.

▶

Giovanni di Paolo
St. John the Baptist Retiring to the Dese
c.1454
Egg tempera on poplar wood panel
12 x 19 ¾ in (30.5 x 49 cm)
National Gallery, London

This panel shows one of four scenes surviving from the predella (the long, lowermost section of an altarpiece whi may contain a series of small paintings relating to the main panel or panels ab it) of a large *Madonna and Saints* that r have been painted for the church of Sa Agostino in Siena.

PROPERTIES

The binder is egg yolk: a simple natural, oil-in-water emulsion. Egg tempera thinned with distilled water dries quickly and becomes quite water-resistant. Tap water contains metals and salts that can leave the binder ineffective by separating the pigment from the egg emulsion. Egg tempera is painted thinly with repeated brushstrokes, visible as many small hatches on the finished surface. Mistakes can be corrected by gently wiping the area with a damp cloth and repainting it.

When the egg tempera is first completed, the surface is delicate and fragile and it takes a year for the surface to cure. As it cures, the paint film becomes richer, deeper, water-resistant, and remarkably tough and durable. If the colors have been properly mixed, the paintings do not develop defects during centuries of aging. The cured egg tempera can be burnished with a soft cotton cloth to bring out the natural sheen, harden the surface, and make it more water-resistant. Varnishing can compromise the beauty, clarity, purity, and complexity of the veils of color, as well as the soft sheen of the surface.

Outline of technique
- Prepare the surface of the panel.
- Prepare the colors and the egg binder.
- Create the cartoon.
- Transfer the cartoon.
- Make an ink water drawing.
- Begin the egg tempera: prepare the *verdaccio*,
then execute the *verdaccio* underpainting.
- Underpaint local colors and then paint the local colors.

SUPPORT AND GROUND

Preparing a panel with traditional gesso

What you will need:
Rabbit-skin glue granules
Water
Double boiler
Wood panel
Bologna chalk
Soft, wide varnish brush
Fine sandpaper
Cheesecloth or muslin

Sand the glue gesso panel.

Dampen the muslin or cheesecloth and squeeze it out until almost dry.

Burnish the panel with a slightly damp folded cloth pad.

The traditional ground for egg tempera is gesso—a combination of animal glue and chalk—applied to a wood panel. I suggest a small, cabinet-grade poplar or birch plywood panel; you can progress to a larger panel later. To prevent warping, the latter should be "cradled" (attaching a framework to the reverse of the panel; see Chapter 4, p. 100).

Glue recipe: Soak one part rabbit-skin glue granules in fifteen parts water for one hour until it swells. Warm the glue to form a translucent solution. Do not boil.

Gesso recipe: Add one part Bologna chalk to one part warm glue solution. Add the chalk slowly, without stirring, allowing the chalk to be absorbed into the glue solution for thirty minutes. Stir slowly to avoid air bubbles and combine the chalk with the glue solution before applying to the panel.

It is easiest to apply glue and gesso to the panel if the solutions are slightly warm. Keep the vessel with glue or gesso solution in a bath of warm water while you are using it.

Lightly sand your panel with fine sandpaper and clean it with a soft rag. Using a soft, wide, flat varnish brush, apply a thin coat of warm glue to the front, sides, and back to seal it, equalize tension, and prevent warping. Let it dry for four hours. With the same brush, apply to both sides a thin coat of warm gesso, and then with a circular motion, quickly and vigorously rub the front while the gesso is wet. Let it dry to the touch. Apply the second coat in one direction, and then four to ten coats, each applied perpendicular to the last. Put a few thin, rough coats on the back of the panel at the same time to prevent warping. Let it dry overnight. Lightly sand the front of the panel with fine sandpaper until it is smooth. Using a brisk, circular motion burnish the panel to an eggshell finish with a folded pad of very slightly damp cheesecloth or muslin. If the pad is too wet, it will remove the gesso.

PIGMENTS AND BINDER

What you will need:

A fresh egg
Distilled water
Sewing needle
Large bowl
Small glass jar
Glass dropper (pipette)
Glass wand
Paper towels
Dry pigments
Oxgall
Small glass spoons
Porcelain palette with indentations

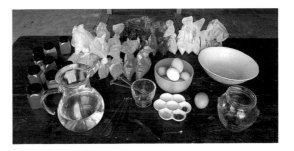

Renaissance egg tempera painters used a range of colors from earth, mineral, and organic sources to artificially prepared colors. My favorite pigments for egg tempera, which adhere closely to the traditional palette, are *terre pozzuoli* (red earth), yellow ocher, raw sienna, burnt sienna, Italian green earth, Italian raw umber, burnt umber Cyprus, Verona green earth, priderit yellow, irgazine orange, irgazine scarlet, alizarin crimson (light red), cerulean blue, manganese blue, chrome oxide green, indigo, ultramarine blue (very dark), ultramarine violet (medium), Naples yellow, cadmium red, cadmium yellow, iron oxide black, titanium white, and vermilion.

Preparing the binder

To prepare the egg binder, break an egg over a basin. Pour the egg yolk out into the palm of your hand. Let the white of the egg fall as you pass the yolk from palm to palm, while drying your free hand with a paper towel as you go. When the yolk is somewhat dry, grab the delicate skin with two fingers and pierce it with a needle, letting the yellow liquid flow into a clean glass jar. Discard the skin; then add an equal amount of distilled water to the egg and mix with a glass wand. The binder is ready for use.

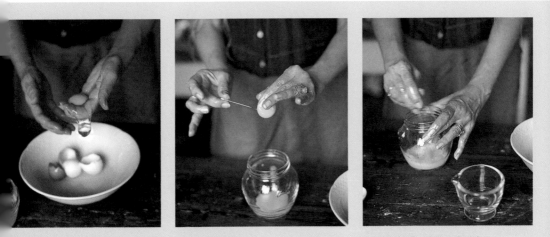

the egg over a basin. Pierce the yolk and let it flow into a clean jar.

Preparing the pigments

Using a mortar and glass palette with a sandblasted surface (see Chapter 5, p. 121), many painters grind larger amounts of pigment and water into pastes and place them in glass jars covered with 1 inch (2.5 cm) of distilled water on top of the paste for storage. I prefer to grind a small amount of each pigment with distilled water each day. No matter which way you choose, the pigments must be ground finely—like water, according to Cennino Cennini. You can use a glass wand and a porcelain palette with indentations. Grind each pigment with distilled water into a paste in an individual indentation of the palette. Use distilled water to prevent deposits from contaminating the colors. If you are mixing pigments (such as yellow and blue to produce green) to make a new color, grind the powders together *before* you add water and egg binder to ensure that they are well combined. Some pigments are very fine and fly around, making them difficult to combine with water. Add a drop of oxgall to tame the pigments for grinding. Add an equal or greater amount of egg mixture to each pigment paste and grind it well. While painting, I frequently add a drop of distilled water, with a glass dropper, to keep the pigments fluid. Mix only the colors and the amount you need for one session. The egg binder does not store well and should be made fresh for each session.

METHOD

A traditional egg tempera painting is created by building up layer upon layer of rhythmic line work. To determine the composition, a cartoon is created, traced onto tracing paper, and then transferred to the gesso panel.

The design is outlined and very lightly shaded with "ink water" made from waterproof ink and distilled water. As in a drawing, the initial work is done with a network of fine interlocking, crosshatched, and parallel lines, which can help to describe form. A traditional egg tempera painting has a substructure of rhythmic line work. The application of the egg tempera paint starts with the *verdaccio* underpainting; this is where the substructure of the painting begins, with the rhythmic line work that is similar to a drawing made with pencil. Then there is usually an additional underpainting for the individual areas of local color before the final local colors are reached.

Each time you dip your brush, you must squeeze out any excess liquid with two fingers until it is almost dry in order to avoid blotches. The paint dries to a translucent film almost immediately. As veils of color accumulate on your panel, the surface becomes "fat" or slightly glossy. At this time, you can begin to lay down broader washes of color with an almost dry brush. Each layer subtly changes the previous color, and the colors are blended optically. For example, a pale red earth under a cool pale blue gives a warm glow to the blue. Subsequent layers of paint should be applied with a bit more distilled water. If more egg is present in subsequent layers, the paint surface is susceptible to cracking.

While painting, mistakes can be corrected by gently wiping the area with a damp cloth and repainting it.

Cartoon

A cartoon is a full-scale drawing used in the transfer of a design to a painting. With a graphite pencil, complete a full-scale monochrome or tonal drawing, equal in size to your proposed painting.

Transfer

What you will need:

Tracing paper
Dry umber pigment
Cotton or muslin
Tape
Soft graphite pencil

Trace your cartoon on a piece of tracing paper. To transfer your tracing to the panel prepared with gesso ground, take a very small amount of dry umber pigment and rub it on the back of the tracing paper with a piece of soft cotton or muslin. Lay the tracing face up on the panel and tape it down on four sides. With a soft graphite pencil, go over the lines, pressing lightly onto the panel. Check the transfer by turning back a corner of the tracing to see whether the lines are marking. If not, rub more pigment on the back of the tracing and begin again. When the tracing paper is removed, the whole design will be pale but clearly marked on the gesso. Dust away any excess pigment with a soft, clean, dry brush.

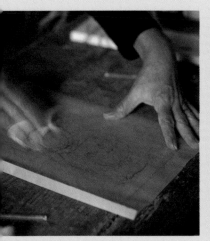

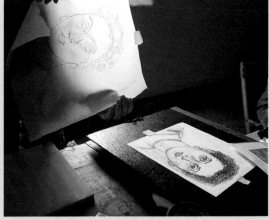

ing umber pigment on the back of
acing.

Sketch/cartoon and tracing
with pigment.

Ink water drawing on panel

Porcelain palette or inkwell
Glass dropper (pipette)
Inkwell
Distilled water
Waterproof ink
Pointed sable brush (00)
Soft, flat sable brush (size 1 or 2)

Fill one of the indentations of your porcelain palette with distilled water. Put a drop of waterproof ink into the water to make ink water. Go over the lines on your panel with a 00 pointed sable brush dipped in the ink water. After dipping your brush into the ink, always squeeze out your brush with two fingers before going over a line on your panel to avoid blotches. With a flat brush, wash in the main shadows, and always squeeze out your brush to keep it as dry as possible. Refer to your detailed cartoon to help you to establish major value relationships. The ink water lines and value sketch should be faint when completed.

Materials for ink water drawing.

Preparing the ink water.

Going over a line with ink water—sho
the proper density.

Pale silverpoint drawings were used to set the design for painting on panels in the early Renaissance. You could draw over your transfer with silverpoint if you prefer. See Chapter 2, p. 48, and Chapter 3, p. 77, for an explanation and examples of silverpoint.

BEGINNING THE EGG TEMPERA

Preparing the verdaccio

What you will need:

Dry pigments: yellow ocher, zinc white, iron oxide black, *terre pozzuoli* (red earth)
Distilled water
Small bowl
Prepared egg binder
Fine sable brushes:
 00 pointed brush for line work
 1–4 flat, round, and filbert for washes
Glass wand, glass dropper, small glass spoons, porcelain palette with indentations
Jars for water
Palette knife
Cheesecloth, muslin
Paper towels

Egg tempera, as with all painting methods, is an interchange of warm and cool colors and dark and light values. The *verdaccio* underpainting provides relative dark warmth to the cool, white gesso ground that shows through the underpainting, providing an internal light source. In addition to the warmth, the *verdaccio* further establishes the values and forms that were begun with the ink water drawing.

Verdaccio

The *verdaccio* is a monochrome underpainting. Mix dry pigments to make a green-brown neutral tint. Mix six parts yellow ocher with two parts white, one part black, and less than one part of red earth in a small bowl or jar and grind until the pigment is very fine. Make a large enough quantity for the *verdaccio* underpainting and to reserve for use in completing details throughout the painting.

The *verdaccio* should be applied in three value gradations. To make three gradations, put a small amount of the *verdaccio* into three segments of your palette. Leave one segment alone, add a small amount of white pigment to the second segment, and add a bit more white to the third. Another way of making three gradations is to use the first mixture as the darkest and make the second and third progressively more dilute with the egg and distilled water binder. I also use one dilution of the *verdaccio* and build a value structure by hatching and crosshatching, as in a pencil or silverpoint drawing; the denser the hatching and crosshatching, the darker the value.

Thoroughly grind the pigments, add distilled water to make a paste, and then grind them again. Add an equal or greater amount of the egg binder to make a liquid color.

When painting the *verdaccio*, refer to your detailed cartoon to help you to determine the values from light to dark. Use a soft, blunt brush dipped in the liquid pigment and then squeezed with two fingers until almost dry. Start by painting the middle tone all over the surface to be covered, then pick out the lights and shadows with the other two shades. Model the surface fairly solidly with the three tints of the *verdaccio*. If there are areas in the painting which are to be flesh color, or to depict sky, leave the white gesso showing until

Left: Materials for the *verdaccio*.

Right: Mixing the dry pigment for the *verdaccio* (yellow och zinc white, iron oxide black, *terre pozzuoli*).

you begin the process of painting the flesh or the sky. At this stage in the painting you will be using only the three gradations of the *verdaccio*, which do not include the darkest darks (such as black or near-black) or the lightest lights (such as white or near-white). The painting should appear to have a more narrow value range than when it is complete. Most colors will require a second underpainting over the *verdaccio* before the final color is reached, as discussed under the drapery section, below. The *verdaccio* and subsequent underpainting will remain slightly visible through the final coats.

The completed *verdaccio*.

Local color

This section on local color will serve to introduce you to ways in which to execute a traditional egg tempera painting by explaining how to go about painting some specific areas. After years of teaching the egg tempera method, I have found that students and artists have benefited by learning these techniques while engaging in specific exercises. It has allowed them to gain a hands-on understanding of the method and provided them with the means and a variety of options for applying the techniques to fulfill their own artistic aims. For each of the local color segments below, it is suggested to superimpose multiple layers of fine hatched and crosshatched brushstrokes or veils of color to achieve a final effect. Following these suggestions and then using them as a model for further exploration can increase your understanding of color interaction and allow you to make your own discoveries regarding the practice of painting in general. Learning these techniques will also enable you to know more about what you are seeing while viewing an egg tempera painting.

Paint the backgrounds and draperies before the flesh to make it easier to establish the correct values of the flesh tones. If the background is relatively cool, the flesh tones will appear warm; conversely, if the background is warm, it will promote a cool inflection in the flesh tones, which may then require a flesh tone to be adjusted with the addition of a larger amount of a warmer hue, such as yellow ocher or red earth.

Mix three gradations of color and then work systematically from one tint to the next (dark to light), ensuring that you clean your brush with water between each change. To refine further within the three gradations you can make two more tints within each gradation so that you are working with nine tints in all. The darkest will be pure color and the lightest will be white. Most colors require a second underpainting over the *verdaccio* before the final color is reached. The underpainting will remain slightly visible through the final coats.

Brushstrokes

Look carefully at the line work in Simone Martini's *St. Luke the Evangelist*. Why do you think he chose to shift the direction and form of the lines? Which colors did he use in combination to create an overall flesh color? To create the flesh, which color do you think he put down first? Which colors did he lay down subsequently?

▶

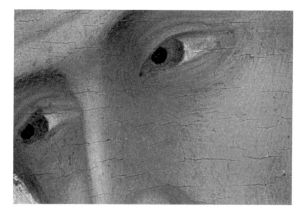

Simone Martini
St. Luke the Evangelist (detail)
*c.*1330
Egg tempera on wood panel
26 ⁹⁄₁₆ x 19 in (67.5 x 48.3 cm)
The J. Paul Getty Museum, Los Angeles

Simone Martini used fine hatched (parallel) and crosshatched lines to define the form of the skull, following the dictates of the form with curved lines around the fold of the eye and defining the apple shape of the cheek. He used parallel diagonal lines down the sharp ridge of the nose, and crosshatching in areas such as between the eye and the bridge of the nose to create deeply shaded areas.

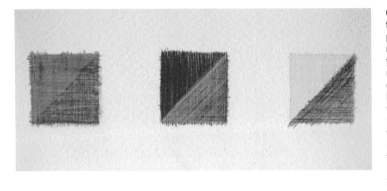

Crosshatched brushstrokes i three examples of layered planes of color (from left to right): Optical mixture: Azo yellow cross-hatched over manganese blue to create green. Scumble: ultramarin blue mixed with titanium white to make it opaque is used as a scumble over vermilion; it brings a cool inflection. Glaze: the dark, translucent pigment indigo is crosshatched over Naples yellow to create a glaze; the glaze brings warmth.

Sky

Underpaint with red earth or vermilion mixed with white. I often lay down a loose wash of Naples yellow to warm the panel and create light at the horizon before I lay down the red earth as a second underpainting. When dry, lay a flat wash overall with a blue tint made from ultramarine blue, or manganese blue and white. Repeat several times until the warm underpainting is well covered, and the sky is the color you wish for the darkest tone. Take lighter shades of the same color and continue gradating with them and lightening the horizon and other areas. Clouds and tints of yellow, orange, or pink can be added. Use a flat brush and maintain a loose wrist to convey delicately the subtle gradations of light.

Underpainting sky.

Landscape and foliage

Over the *verdaccio*, underpaint tree trunks and other elements of dark-green foliage (such as grass) with dark, solid colors such as black or indigo mixed with burnt umber. Greens tend to look weak unless underpainted solidly. The tree trunk should be laid in with pure black, and a mixture of black and red earth or burnt umber should be used as a second underpainting under foliage. Leaves and other foliage can then be painted with dark green. Add black to keep green strong where necessary. The light on leaves can be painted with lighter green and the highlights put in with yellow-green or pure yellow. Darks can be strengthened by glazing with dark green or black afterwards. Add a little red earth and deep yellow ocher to all greens to avoid coldness or weakness. Observe closely Sassetta's *City by the Sea* for landscape and foliage—specifically the trees.

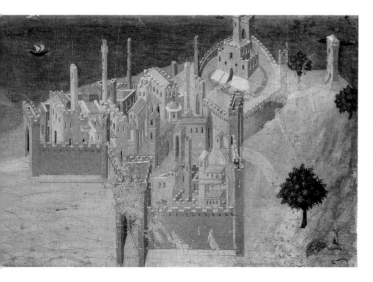

Attributed to Sassetta
City by the Sea
*c.*1425
Egg tempera on wood panel
9 x 13 in (23 x 33 cm)
Pinacoteca Nazionale, Siena

This small panel, together with its companion piece, *Castle by a Lake* (Chapter 4, p. 93) has been considered to be the earliest "pure landscape" painting in all Western art.

Drapery

Cennino Cennini recommended to start painting drapery from the darks to the lights, and then to work back again from the lights to the darks. Dark blues can be underpainted with a mixture of black and red earth. Make three shades using more black to make them darker. For light blues, underpaint with red earth mixed with white, and then mix three tints. For crimsons, the underpaint should be painted in three tones of black and white with the deepest shadows in pure black and the highlights in white. The final crimson should be a thin glaze or stain of pure color. These suggestions for how to go about underpainting drapery can also apply to other areas. Experimentation can lead to other discoveries.

For the foliage and landscape in this image I started by applying a loose layer of the *verdaccio* mixed with a generous portion of the egg binder on the ground for the foliage, then I painted another loose layer of red earth. Next, I painted in near-blacks made from umber mixed with indigo before combining them with the egg binder as an additional underpainting for the foliage. I made dark green by mixing Indian yellow and indigo before combining them with the egg binder. Then I applied bright, clear colors for the flowers and the greens and yellows of the highlights of the foliage.

In this underpainting for a blue drapery, I also started with the *verdaccio* under-painting, but in three values, made by using the *verdaccio* full strength for the darkest value, adding water to create the next value, and a little more water to create the lightest value. This step reminds me of drawing with pencil to create a value structure. For the next layer of underpainting I used black and two additional shades of red earth made by mixing black with red earth and then using pure red earth for the lightest hue.

Hair

Lay a wash of *verdaccio* or raw umber all over the area for the hair as the initial underpainting. Mix a middle tint the color of the hair and sweep over the surface with a soft, flat, dry brush. Use a darker tint of the same color for shadows. Use a light shade for picking out the lights with a 00 pointed brush. Pick out the lightest lights with white. Touch and retouch until a sufficient "fatness" or richness of surface has been achieved.

Painting hair.

Flesh

The flesh is the last step. Mix a tint of *terre verte* (green earth) with a bit of white and grind together with the egg binder. Lay this tint with a very soft flat brush in two flat washes, one on top of the other, all over the flesh. Care should be taken to avoid brushmarks and to make an even coat of color. This layer will enrich the warm flesh tones with cool gray half-tones. Model the contours with the *verdaccio*. Shade lightly with the same flat brush, going over the area several times, gradually reinforcing them where necessary until the surface is sufficiently modeled. With a 00 pointed brush, strengthen the outlines with dark umber.

Put in the red or *rosetta* referred to by Cennini. This is separate from the flesh color. Mix vermilion with an equal part or less of white, and grind together with the egg binder. Dilute with water and lay down as a thin glaze all over the flesh. Put more of the same color on the lips, cheeks, the interior edge of the eye and nostrils, and other areas where a warm glow is needed.

Mix a flesh tint of ocher, vermilion, and white. Use very little vermilion so that the flesh does not appear too red. Make three gradations by adding more white. Start with the lightest shade, follow with the middle tone and finish with the darkest. Cover the surface several times as you carefully adjust to the subtle interchange of tones. This flesh tint is a suggestion that can be altered in many ways to accommodate darker and lighter flesh tones. Finally, put a minute amount of pure black in areas such as the nostrils and the corner of the eye.

Top left:
The *terre verte* underpainting.

Top right:
Rythmic crosshatched line work for modeling with the *verdaccio*.

Bottom left:
The *rosetta*.

Bottom right:
The finished flesh tints.

TECHNIQUES

Observe the consistencies in the paintings created in the early Renaissance by Fra Angelico and Duccio di Buoninsegna and compare them with the twentieth-century paintings by Paul Cadmus and Jacob Lawrence. What differences do you notice?

◄

Fra Angelico
Healing of Deacon Justinian
1438–43
Egg tempera on wood panel
14 ½ x 17 ¾ in (37 x 45 cm)
Museo di San Marco, Florence

This panel from the predella of the San Marco altarpiece shows great subtlety in the observation and depiction of light from a variety of sources. Light from the left window provides a soft glow to the scene, while more sharply illuminating the drapery. Light comes from the door as well as from a third source on the left, outside the picture, producing a broad, diagonal sweep across the right wall. The light is the directing factor for the eye picking out closely observed still-life motifs—the container hanging from a nail on the bed, the glass and decanter, the slippers, and the three-legged stool.

◄

Duccio di Buoninsegna
Maestà (two details)
1308
Egg tempera on wood panel
Museo dell'Opera Metropolitana, Siena

The massive 14 ft (4.3 m) depiction of the Madonna is composed of fluidly executed small hatched brushstrokes providing delicately integrated transitions between forms. The pale, violet robe on the child has tiny four-pointed gold stars that were created by scratching through the layers of paint to reveal a ground layer of gold. The gown of St. Agnes possesses a super-real quality dependent upon a fusion in the eye of a mass of small, precisely controlled touches in the relief and patterning of the textile.

▲

Jacob Lawrence
War Series, Victory
1947
Egg tempera on board
20 x 16 in (50.8 x 40.6 cm)
Whitney Museum of American Art,
New York

A year after his discharge from the U.S. Coast Guard in 1945, Lawrence produced his fourteen-panel *War Series*, of which this is one, that records the experience of the African American contingent in the armed forces during World War II. The series is created in a sound manner that will allow these works to convey the story for centuries to come.

▲

Paul Cadmus
The Bath
1951
Egg tempera on wood panel
14 x 16 in (35.6 x 40.6 cm)
Whitney Museum of American Art,
New York

Cadmus combined depictions of contemporary culture with his interest in the classical conception of the human figure inspired by Italian Renaissance interpretations. The fine network of intricate line work is barely visible even at a close distance. He spent up to a year creating one egg tempera painting. Look carefully at the two individual figures and their flesh tones in *The Bath*. Notice how Cadmus used the traditional method of creating flesh color to make adjustments for individual flesh tones. For example, look at the colors and/or steps that he minimized, accentuated, or altered.

Exercise, Part 1: copy a master egg tempera painting on panel

Choose a segment of one of the early Renaissance paintings or an entire work such as those illustrated in this chapter. With a graphite pencil, make a full-scale cartoon equal in size to your panel; transfer your sketch to your gessoed panel. Make an ink water drawing on your panel. Begin your painting with the *verdaccio* and continue through the entire process described above.

Copying a master egg tempera painting on panel.

Exercise, Part 2: make an original painting using the same method

Using colored pencils, make a full-scale cartoon in nature or of an interior. To avoid overload of information and to keep it simple, choose an object or a small detail in nature or from an interior, such as a portion of a tree with foliage revealing pieces of the sky. Make a few small thumbnail sketches (see Chapter 3, p.68, for an explanation of the thumbnail sketch), choose your favorite, and enlarge it to begin your full-scale cartoon. Look for the relationship between colors. For example, notice the interchange between warm and cool—between a fiery orange-red barn and a cool, watery blue-gray sky. Look for value relationships such as how objects closer to you appear darker and more intense, and how objects farther away become cooler, lighter, and less intense. When you complete your cartoon, let the work and your close observations inform you as you make an original painting using the same method described above.

◀

Rebecca Shore
2006 # 1
2006
Egg tempera on panel
14 x 11 in (35.5 x 27.9 cm)
Courtesy of the artist

Shore starts her paintings with a background of several layers of egg tempera wash applied to a traditional gesso surface. These layers are applied in a variety of ways: large or small brush, with varying degrees of flow to the paint. She often exploits the translucency of certain pigments to layer paint so that you see previous layers through subsequent ones. To depict invented "objects," she may begin with studies made from the decorative arts or from directly-observed natural forms.

CASEIN TEMPERA

Although an ancient technique, casein was the preferred method of twentieth-century French painter Balthus (1908–2001) for its freshness of color, nontoxicity, and similarity in appearance to fresco. Casein is a quick, economic pigment binder, which can be used to show how pigments behave. Pigments suspended in casein maintain their true individual qualities of translucence, opacity, brilliance, or softness. The casein binder is a powder derived from the dried curds of skimmed milk dissolved in distilled water, with an addition of a small amount of borax as an emulsifier. It dries water-resistant and can be used in thin washes or opaquely. Some sources suggest mixing drying oil with casein, but I would not recommend it, because the resulting paint will turn yellow or brown. Casein gesso can be made with casein binder and Bologna chalk, and then it is applied to a wood panel as a painting surface.

▲
Balthus
La Phalène
1959–60
Casein and tempera on cloth
63 ¾ x 54 ¾ in (162 x 139 cm)
Private Collection

Moving to Rome to serve as director of the French Academy brought Balthus into contact with the Italian Renaissance art that had inspired him as a youth, such as the fresco cycles of Piero della Francesca, Masolino, and Masaccio. After this, he worked exclusively with casein tempera, applying it often in many layers over many years. His aim was to have the resulting matte surface convey the impression of a fresco.

▼
Margaret Krug
Henry, Colorado
2005
Casein, shellac, beeswax on casein gesso panel
7 x 5 in (17.7 x 12.7 cm)
Collection of the author

After applying several layers of color, I laid down shellac to bring warmth, a bit of shine, and to enrich the colors. I then painted back into some area to create a soft matte surface as a counterpoint.

Support and ground

Preparing a panel with casein gesso

What you will need:
Casein powder
Borax
Large bowls
Distilled water
Wood panel
Bologna chalk
Soft, wide varnish brush
Fine sandpaper
Small kitchen scale to weigh casein powder

With a casein gesso ground, the wood-panel support is treated in a similar way as when using traditional glue gesso ground. The panel should be sanded and sized with diluted casein solution on both sides to ensure even torque. Then apply at least three coats of casein gesso to both sides of the panel. Stir the gesso frequently because the chalk tends to settle, and let each coat dry to the touch before applying another coat. Casein gesso dries more slowly than traditional gesso, and it is easier to apply than traditional gesso, as it does not form bubbles or ridges. You will not need to sand between coats, nor will you need to buff your panel as it will not produce a shell-like glow. However, it does produce a beautiful chalky, dry appearance. To prevent the gesso from lifting off, let your panel cure overnight before a final light sanding.

Binder recipe
- Soak 2.5 oz (70.8 g)of casein powder in 9 fl oz (255 ml) of distilled water for twelve hours.
- Dissolve 1 oz (28.3 g) of borax in 9 fl oz (255 ml) hot distilled water.
- Stir the hot borax solution into the soaked casein solution.
- Stir again after another five minutes.
- Let the mixture stand for one hour to one day, until it is completely dissolved.
- Add six cups of distilled water for use.

Casein binder.

Casein binder spoils, but if you keep it in the refrigerator it will last for about three weeks. You should let it warm to room temperature before you use it.

Casein gesso recipe
- Slowly add one part casein solution to one part Bologna chalk. The mixture can be strained through two layers of cheesecloth or a tea strainer. I have found this unnecessary when I use Bologna chalk instead of other chalks.
- For a brighter surface you can remove a small portion of the Bologna chalk and substitute an equal amount of titanium-white pigment. Mix the powders thoroughly before adding them to the casein solution.

Casein gesso solution.

Pigments and binder

What you will need:

Casein binder
Glass wand and small spoons
Dry pigments and distilled water
Porcelain palette with indentations

Mix the pigments with distilled water into a paste, add an equal amount of casein binder to the paste, then thin with water. You can test your paint by applying it on a piece of cardboard. If it rubs off after an hour, you need more binder, and if it cracks, you need less binder. Reduce the binder content by adding pigment and water.

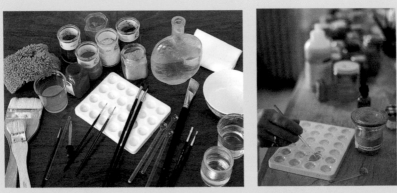

Pigments, binder, brushes, and other tools. Making casein paint.

Method

What you will need:

Dry pigments
Distilled water
Small bowl
Casein binder
Glass wand, glass dropper, small glass spoons, and porcelain palette with indentations
Brushes:
> Soft wide brushes: 3-inch (7.6 cm) and 1- or 2-inch (2.5 or 5 cm) hog hair—made in China, two or three in total
> Small and medium inexpensive bristle brushes and small synthetic and medium flat synthetic brushes
> Very fine pointed sable brushes (00) and very fine synthetic brushes (Casein is hard on brushes, so wash them immediately after use with soap and water.)

Jars for water and casein solution
Palette knife
Cheesecloth, muslin
Paper towels
Sponge

Technique

Indirect painting in layers and painting directly (wet-into-wet)
Casein paint will remain damp a bit longer than other temperas and acrylics, so you can paint wet-into-wet effectively. When the paint dries to the touch you can layer colors relatively quickly, if you have a light touch and do not scrub with your brush. Cracking may occur if the previous layer is not completely dry, but this has been desirable to artists for the crackling effects. Using a similar strategy, color can be pulled up with a bit of the casein solution or distilled water to bring in the light of the gesso ground. Depending on weather conditions, the paint layer should dry completely overnight, and it will be waterproof in about a week. You can make corrections using a damp sponge to erase while the paint is still damp.

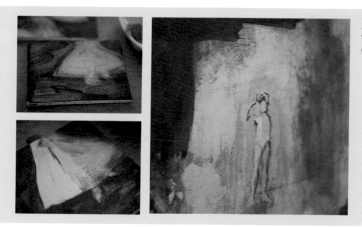

Applying casein paint in layers to achieve interesting surface effects.

Casein paint is versatile and lends itself to experimentation. It can be applied thinly and in relatively thick, opaque layers, but not too thickly or it will crack.

One way to experiment with the final paint layer is to apply a layer of clear melted beeswax or shellac. To create a varied surface you can paint back into the shellac. If you choose to paint into the beeswax, you can melt the surface with a heat source to consolidate it. The shellac will give a warm, crackled surface, whereas the wax will impart a dull sheen; both substances will bring out the colors.

This casein painting has a final coat of beeswax that brings out the subtle color steps and variations while it provides a soft sheen.

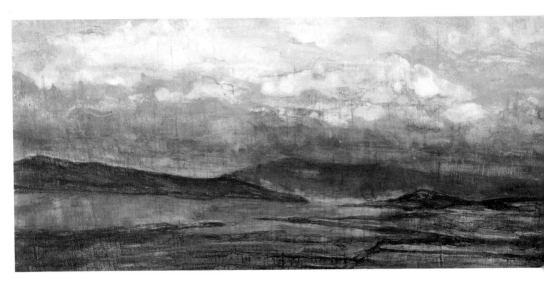

▲

Margaret Krug
Dingle Peninsula
2002
Casein on wood panel
4 x 11 ½ in (10.1 x 29.2 cm)
Collection of Randolph Hannah

I created this hue-bias composition by
first discerning the all-over hue of the ar
I was intending to represent. I painted
indirectly with layers of colors using colc
complements to create broken tones wh
needed. After layering colors to underpa
the sky, I painted directly wet-into-wet t
letting colors pool together. I was paint
a place I was visiting, but I let my reflect
on J.M. Synge's observational writings
the exact same place from a century ea
influence my interpretation.

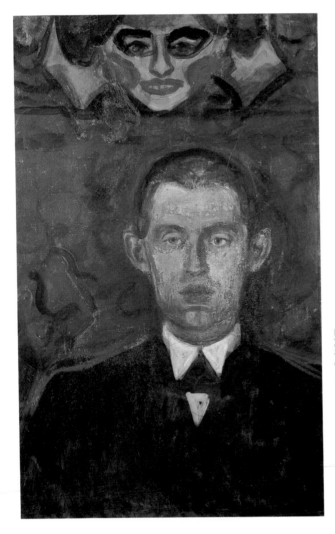

◄

Edvard Munch
Self-Portrait Beneath a Woman's Mask
c.1893
Mixed media on wood panel
27 ½ x 17 ½ in (70 x 44.5 cm)
Munch Museum, Oslo, Norway

Munch employed various unusual means
to manipulate the surface of his paintings,
including leaving them out in the rain. For
this self-portrait, he used paint containing
casein and he created the brown, blistered
patches on the forehead and cheeks by
scraping away the paint to reveal the
wood of the panel.

Exercises

Exercise: copy from a master painting or a fragment of a master painting

Because of surface similarities in casein paint and fresco, I would suggest looking at a fresco or fresco fragment. See Chapter 8 for an image of a fresco or fresco fragment, such as *La Villa di Livia e la Pittura di Giardino* (detail), p. 207.

Exercise: color study; memory of a landscape; hue bias using complementary and analogous colors

Create a painting with a hue bias, employing the practice of using an all-over dominant color to provide pictorial unity. To produce a variety of color interactions and provide visual interest, use color complements in smaller passages. You can also layer the color complement or mix a small amount of the color complement with the color to create a broken color (grayed version) of the dominant color for appropriate passages, such as where shadows occur or if a color appears too garish. You can mix or layer analogous colors—those colors adjacent on the color wheel—to create subtle shifts or steps and inflections.

Do you have a memory of an experience in nature?
Do you have a favorite poem or essay that brings to mind an image of a landscape?

Pick the all-over dominant color in your image of nature or remembered landscape, and create a sketch from memory. Use color complements such as green and red, or yellow and purple, or blue and orange—colors opposite on the color wheel—to intensify and create balance in your hue-bias composition. Use analogous colors to create subtle variations. Observe *Dingle Peninsula* for an example of a hue-bias compostion.

Far left: Copying from an mage of a Pompeian fresco fragment.

Bottom left: Drawing over a tracing rubbed with pigment to transfer a sketch.

Left: Closely observing a sketch while beginning a hue-bias composition; and removing color with casein solution to bring in the light from the white gesso panel.

DISTEMPER

Distemper has been used throughout the centuries. It was used in combination with encaustic in ancient Egypt for the Fayum mummy portraits, and during the Renaissance in the north by Dieric Bouts (c.1415–75). The method is fully described in Chapter 6 as the technique for underpainting an encaustic work, but distemper painting is a method unto itself. I am fond of distemper for its fluidity, ease of application, delicacy, and simplicity of production.

◄

Dieric Bouts
The Annunciation (detail)
c.1450/55
Distemper on linen
89.1 x 29.4 cm (35 ⁷⁄₁₆ x 29 ⅜ in)
J. Paul Getty Museum, Los Angeles

Support and ground

Preparing a panel or canvas with traditional gesso
What you will need:
Traditional gesso (recipe on p. 160)
Rabbit-skin glue solution (recipe on p. 142)
Double boiler
Distilled water
Canvas and stretcher bars or wood panel
Soft, wide varnish brush
Fine sandpaper

Stretch canvas over stretcher bars as shown in Chapter 4, p. 100, or use a wood panel. Apply rabbit-skin glue solution to the canvas or panel. Let the surface dry for four hours. Then, if you are using canvas, apply one thin layer of gesso. If you apply more layers, they could crack on the flexible surface. I prefer to work on canvas that has been sized with the glue solution alone to protect the surface and to make it taut and a bit less porous. If you choose to work on a wood panel, prepare it in the same way you would for an egg tempera painting (see p. 160).

Pigments and binder

What you will need:

Rabbit-skin glue solution (recipe on p. 142)
Distilled water
Glass wand
Dry pigments
Small spoons
Porcelain palette with indentations
Small bowls

Mix the pigments with the distilled water into a paste. Add an equal amount of the rabbit-skin glue solution as a binder to the paste. Thin it with water.

◄

Margaret Krug
No Sweet Bird Did Follow
2002
Distemper on linen
60 x 25 in (152.4 x 63.5 cm)
Collection of the artist

I combined broad washes of color, applied with a soft, wide brush, with fine details, applied with small brushes, for the decorative details and to define figural elements. This work was alternately painted on the easel and on the floor. When I worked on the floor, I let the liquid distemper run and pool on its own to create a more atmospheric effect. I laid in areas of shellac to isolate layers and to create warmth and a bit of shine as a counterpoint to the matte effect of the distemper.

Method

What you will need:

Dry pigments
Distilled water
Small bowls
Rabbit-skin glue solution binder
Glass wand, glass dropper, small glass spoons, porcelain palette with indentations
Small tea- or coffee-cup warmer
Brushes:

> Soft wide brushes: 3-inch (7.6 cm) and 1- or 2-inch (2.4 or 5 cm) hog hair—made in China, two or three in total
>
> Small and medium inexpensive bristle brushes and small and medium flat synthetic brushes
>
> Very fine pointed sable (00) brush and very fine synthetic brushes

Jars for water and rabbit-skin glue solution
Palette knife
Muslin or cotton rags
Paper towels
Sponge

Technique

Distemper is made with dry pigments dispersed in warm animal glue, and it must be kept warm while you are using it. I leave my porcelain palette on a small teacup warmer while I am working. If using larger quantities for washes, I put the cup containing the paint mixture on the warmer to maintain its fluidity while I am using it. Distemper dries quickly to a matte surface. When a layer is dry, another color can be layered effectively, if you avoid scrubbing with the brush. Distemper lends itself to covering broader areas than egg tempera. Loose veils of color can be combined with delicate precise detail. It can be applied thinly on canvas or more substantially on wood panel.

Exercise

On a gesso panel, create a small portrait, still life, or an all-over abstract pattern by choosing an element to repeat from a botanical, architectural, or other decorative motif, or invent a form to repeat. With a 1-inch (2.5 cm) brush, lay washes of color similar to those of watercolor (see Chapter 5, p. 124) for the background. For the portrait or small details in the landscape or the decorative pattern, use a small brush for hatching and crosshatching as described for egg tempera painting (see p. 165).

Look for the dominate hue in the scene, portrait, or, if you are creating an abstract pattern, choose a dominate hue. To create a color scheme, choose two additional analogous colors (colors next to each other on the color wheel). Play with the three colors as you paint, creating broken colors by adding color complements to the colors in places where shadows occur, or to provide subtle interchanges enhancing visual interest.

When you are finished, let the painting dry for a day. Melt a layer of beeswax on top by laying beeswax pellets all over the surface and then heating it with an infrared heat lamp to melt and disperse the wax evenly. Wait for an hour, then buff the surface with a cotton rag to produce a soft sheen. Observe Fra Angelico's *Healing of Deacon Justinian* (see p. 171), for small still-life passages to provide ideas for this exercise. Duccio's *Maestà* (see p. 172) could provide additional ideas for decorative textile patterns for this exercise.

garet Krug
boji
4
emper on linen
54 in (38.1 x 137.1 cm)
ection of the artist

8
FRESCO PAINTING

HISTORICAL BACKGROUND

It can be said that a connection exists between a place and the forms and colors that develop there. In turn, the forms and colors chosen by the artist can reflect the culture and nature of an area. In *fresco*, Italian for "fresh," pigments are absorbed into the wet wall by a capillary action, and they become an integral part of the wall's surface. Raw pigments mixed with water were rubbed directly into the rock surfaces of cave walls in the oldest

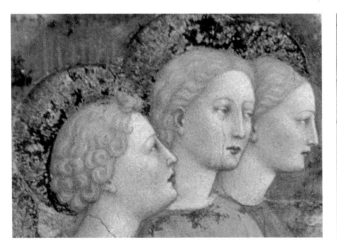

▲
Masolino
Baptism of Christ (detail)
1435
Fresco
145 ½ x 89 ⅜ in (372 x 227 cm)
Baptistry, Castiglione Olona, Italy

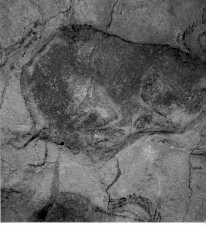

▲
Wounded Bison
*c.*15,000–10,000 BC
Paleolithic cave painting
Altamira, Spain

The almost life-size animal was first drawn in a fine outline with a sharp flint, then modeled in colors made from charcoal and red, yellow, and brown ocher. The massive volume of the upper body is accentuated by the undulations of the rock wall.

◄
Fra Bartolomeo
St. Mary Magdalene (detail)
*c.*1506
Fresco on flat tile
18 x 13 in (47 x 35 cm)
San Marco Convent, Florence

This fresco records Fra Bartolomeo's interest in light effects and transparence, facilitated by the fresco technique.

known prehistoric paintings and drawings. The pigments were bound to the wall by a thin layer of limestone that resulted from the interaction of the water and the rock surface, which makes these paintings true frescos. The natural contours of the rock may have initiated the first impulse to create the drawings, and they suggest the undulations of forms depicted in the subjects. Their expressiveness as works of art is indivisible from the union with their place—an intrinsic value and identifier of fresco throughout the centuries.

rogio Lorenzetti
Well-Governed City (detail)
—40
co
: 3 in x 46 ft (7.7 x 14.02 m)
della Pace, Palazzo Pubblico, Siena

rld of harmony was depicted on
wall of the Sala della Pace ("Hall
eace"), sometimes called the "Hall
e Nine;" the "Nine" were elected
t as governors and defenders of the
mune of Siena. They defended the
e against the domination of any small
s or group. The fresco portrays ideal
litions of city life, rural life, and the
ities of work and leisure to be
ltained by the Nine.

◄

Late Minoan I
Head of a Woman ("La Parisienne")
(fragment)
c.1500 BC
Fresco
Height (approx) 10 in (25.4 cm)
Archaeological Museum, Heraklion, Greece

The Minoan palette consisted of earth colors (natural mineral colors) and included lime white, slate black, red from native oxides, Egyptian blue from copper oxides cut with marble dust, green earth, and green made from blue, black, and yellow ocher.

Fresco was used in most of the early Mediterranean civilizations, such as that of the eastern Mediterranean Minoan in Crete (*c.*1700–1380 BC) and throughout the entire history of art in Europe, although less used in northern Europe because the damp climate caused the plaster to crumble. Fresco paintings in India, such as those in cave temples at Ajanta, date from 200 BC. In Italy, frescos had been created consistently since Roman times. Beginning in the Italian Renaissance, the works of the masters Giotto (*c.*1267/75–1337), Masaccio (1401–28), Fra Angelico, Piero della Francesca, Michelangelo, and Raphael exemplified the classical and traditional techniques of *buon* (true) fresco in Italy, the most

▲
Perugino
The Crucifixion (detail)
1494–6
Fresco
15 ft 8 in x 26 ft 6 in (4.8 x 8.1 m)
Church of Santa Maria Maddalena
dei Pazzi , Florence

Brilliant, high-key color is emblematic of *buon* fresco due to the pigments sinking into the white lime, or having been mixed ahead of time into the lime to create light gradations.

▲
Giotto
Nativity
1304–05
Fresco
6 ft 6 ½ in x 5 ft 10 ⅘ in (2 x 1.8 m)
Capella degli Scrovegni, Padua

For the Madonna's robe, Giotto preferred to apply the expensive pigment lapis lazuli *a secco* (dry) to maintain the depth of blue. If laid into the wet plaster, the blue could have quickly turned black in reaction to the lime plaster. To further contribute to the intensity of the blue, a reddish brown underpainting was laid into the wet plaster, while areas of the plaster were left untouched to create highlights before applying a solid coat of lapis lazuli on the dried plaster. Notice that the lapis lazuli has mostly flaked away over the years to reveal the red underpainting.

extensive application of which was between 1300 and 1500. *Buon* fresco is composed of several layers of lime mortar or plaster, the last of which is the *intonaco* (painting coat) of wet plaster applied in sections called *giornate* (the singular is *giornata*: literally "a day's work"), on which pigments are applied wet. When the *intonaco* begins to dry and no longer accepts the liquid pigments, it is time to stop and scrape away the excess plaster. The next day a new *giornata* is carefully laid to match the plaster surface. Although a difficult technique, it was pursued and valued for an extended length of time for its brightness, clarity, luminosity, and durability.

...to
...eting at the Golden Gate
...4–06
...co
...6 ½ in x 5 ft 10 ½ in (2 x 1.8 m)
...ella degli Scrovegni, Padua

...ting at the Golden Gate is part of a
...e fresco cycle in the Capella degli
...ovegni in Padua, that includes the
...y of the apocryphal New Testament
...racters Joachim and Anna. Giotto
...ited a dynamic space through which
...viewer can experience the story by
...ing through real space and time in
...er to view the entire piece.

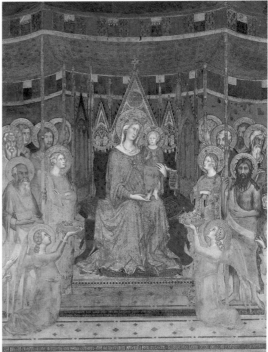

▲

Simone Martini
Maestà (detail)
1315
Fresco
25 ft x 31 ft 9 in (7.6 x 9.7 m)
Palazzo Pubblico, Siena

Over a full-scale brush drawing (*sinopia*) on the brown coat of plaster (*arriccio*), the final image was painted quickly, patch by patch, on the smooth *intonaco* layer of lime plaster. Simone Martini finalized his fresco with *a secco* work throughout, using small brushes to create details he would have been unable to execute quickly on a large fresco before it dried. The ruinous condition of the fresco may be due in part to this.

▲

Paolo Uccello
Flood and Waters Subsiding
1447–8
Fresco
7 ft x 16 ft 8 ¾ in (2.15 x 5.1 m)
Green Cloister, Church of Santa Maria
Novella, Florence

Flood and Waters Subsiding, a lunette, is a near-life-size depiction of the story of Noah's ark. Because of the scale, level of presentation, and, at the time of its creation, revolutionary use of linear perspective, the viewer is allowed to feel as if it were possible to enter the scene.

The concept of the painter as a mere artisan began to change toward the middle of the fifteenth century. Artists needed to work faster as painting became a subtle and elevated art. Painters with new-found prestige were receiving commissions for which they had to work fast to maintain the pace. The less-sound *a secco* (dry) technique began to be practiced; this had previously been reserved for the application of smaller passages of expensive color or in larger areas by painters such as Simone Martini (who preferred to work with small brushes in a more intricate manner). In contrast to the more complicated *buon* fresco technique, *a secco* fresco was speedier and it involved painting dry on the *intonaco*, the painting coat of lime plaster. After the *intonaco* surface had been roughened a bit, egg yolk was used to create a tempera paint to fix the colors onto the surface of the wall for *a secco* work. *A secco* egg tempera and oil painting on the *intonaco* met the needs of a new age of painters, no longer anonymous workers but ones who could be considered individual geniuses. However, because the plaster could not absorb the pigments and unite with them, complete *a secco* paintings and *a secco* additions to fresco were fragile. Due to flaking, they deteriorated quickly. When Michelangelo went to paint the *Last Judgment* (1508–12) in the Sistine Chapel, a layer of *intonaco* had already been

spread and left to dry on the wall for him to paint *a secco* with oil paints. In opposition to the *a secco* painting trend, he had it removed in order to paint the scene in true fresco.

A labor-intensive technique, requiring a crew for large-scale works, *buon* fresco is generally considered unsuitable to the more singular way in which painters tend to work today. Nevertheless, *buon* fresco is essential in the discussion of the history and properties of painting, and through that, an understanding of where we are today. Mural paintings are still commissioned for public spaces, but they are usually executed with synthetic compounds or with oil paint applied on top of existing walls or in newly constructed buildings. Artists such as Sol LeWitt are inspired by the history of *buon* fresco painting. LeWitt has been particularly interested in the fresco cycles of Piero della Francesca. To create what he calls "wall drawings," LeWitt works out designs on paper ahead of time and then writes detailed instructions and thorough lists of materials. A crew of artists executes the wall drawings in specific spaces and exhibitions. The materials, processes, and format he uses produce similar effects to fresco. The large-scale works, which can occupy multiple walls, provide a physical environment for the viewer. He selects translucent inks, to be applied in layers with sponges. The inks provide dry, matte hues, which can be layered to produce new colors through optical mixture. In most instances, when exhibitions conclude, the wall drawings are completely destroyed and disposed of by demolishing or scraping the walls on which they were drawn. What remains are the instructions, which will allow the works to be created at other times and places in the future.

The fresco technique was virtually extinct by the eighteenth century, but it was revived in the nineteenth century by a group of artists known as the Nazarenes, based in Vienna. Removing themselves from contemporary trends, the Nazarenes returned to the style of the painters of the early Renaissance, imitating old forms rather than referring to nature or inventing new forms. The most important of the Nazarenes were Friedrich Overbeck (1789–1869) and Peter von Cornelius (1783–1867). The Mexican muralists Diego Rivera (1886–1957) and José Clemente Orozco (1883–1949) brought the *buon* fresco medium into prominence in the twentieth century.

eWitt
Drawing #808 and
Drawing #444
5
r ink wash on white wall
tney Museum of American Art,
York

◄

Diego Rivera
The Exploiters
1926
Fresco
Universidad Autónoma de Chapingo
Chapel, Chapingo

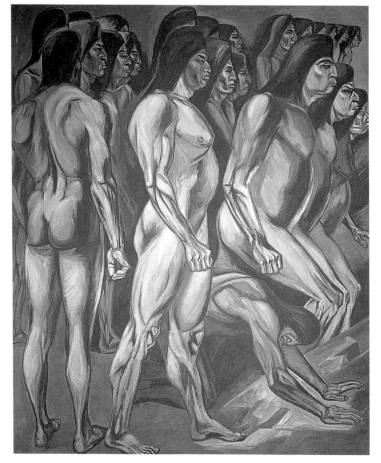

◄

José Clemente Orozco
The Epic of American Civilization:
(Panel 21) Modern Migration of the Spirit
(detail)
1932–4
Fresco
10 ft x 10 ft 6 in (3 x 3.2 m)
Commissioned by the trustees of
Dartmouth College, Hanover, New
Hampshire

True or *buon* frescos (to distinguish them from other fresco techniques) are painted *into*, not onto, the surface. This is the technique that we will demonstrate in this book. The earliest frescos in prehistory were created by rubbing raw pigments by hand into the rock walls of caves without a skin of plaster.

Permanent lime-proof pigments, dispersed in distilled water, are painted on freshly laid lime plaster at a point when the surface is wet enough, but not too wet, to combine its moisture with the water containing the pigment. The color changes as the plaster dries and grows lighter in value. Pigments are absorbed into the wet wall and become an integral part of the surface of the wall. The fresco color palette is limited but beautiful in its natural harmony. Many pigments are not stable in fresco because they cannot withstand the alkaline action of the lime in "live" plaster. The most brilliant colors tend to be the most unstable. In the past, blue, such as manganese blue, had to be laid *a secco* on top of a red earth painted into the lime plaster. That changed in the nineteenth century after lime-proof cobalt blue was discovered and began to be industrially manufactured. The most permanent colors for *buon* fresco are cobalt blue (which is absolutely lightfast and waterproof) and the earth pigments, extracted from natural clays, including browns, grays, red earths, greens, yellows, and vine black. Colors painted *a secco* are not susceptible to the action of "live" lime plaster. The fresco surface is matte, and the color retains its pure, brilliant luminosity. The technique was favored in the Mediterranean climate of Italy, in part because, if applied to interior surfaces, true fresco is one of the most permanent painting techniques in dry climates, and ages with ultimate grace. In the damp climates of northern Europe the plaster would quickly crumble.

Fresco most appropriately aligns to monumental styles. The gesture of the drawing needed and employed is large, whereas on a small panel, the gesture can seem somewhat miniaturized and less effective. Because the artist has to work fast, it is a process that encourages boldness of application.

I would suggest going to see any fresco you can find. There are many frescos in existence in China, India, the Near East, Africa, and throughout Europe and Mexico. In the United States, the Federal Arts Project (1935–43) commissioned frescos in public buildings. In an undisturbed historical setting, an original fresco can be viewed in the harmonious union of painting and architecture. The painting is one with the wall, and can reflect both the life of the fresco and the context and life of the space it occupies. A flood or consistently burning candles during vigils can simultaneously compromise and reflect the life of the work and place. To observe a fresco first hand at close proximity, the surface and scent can reveal the physical fact of flood or fire. To see a fresco *in situ,* where it can reveal its full meaning—its scale and very presence having an impact on the body—is perhaps the only way to experience a fresco fully.

Fresco is the least accommodating medium in the history of painting. Not only is it labor-intensive but any shortcomings are magnified by the smoothness of the *intonaco* (painting coat of plaster), which highlights every stroke, good or bad. To facilitate the quick application of pigment into patches of wet lime plaster (*giornate*), a crew of professional plasterers is required to prepare and apply the mortar layers so as not to expend the artist's energy, which would divert the artist from executing the painting in a precise manner. Assistants are also essential, as they can mix colors ahead of time and aid in the preparation of the cartoon transfer, among other tasks, to complete a large-scale fresco.

Outline of technique
- Preparing portable panel support with galvanized steel mesh or burlap.
- Application of lime plaster mortar layers.
- Preparing pigment pastes.
- Application of *intonaco* (painting coat).
- Preparing cartoon and transfer.
- Transferring cartoon to wet lime plaster
- Painting into wet lime plaster with pigment pastes.
- *A secco* corrections or additions, if needed.

The technique to be demonstrated here is *buon* fresco on portable panel, because their use can be excellent practice for those unfamiliar with a challenging technique. Then, if there is an interest in pursuing a larger project, please find sources listed in Further Reading that provide detailed explanations for executing fresco on walls.

Buon fresco painting was executed directly into wet plaster, so an artist's hand and mind needed to be quick and sure. The painter had to have the full scheme conceived in detail before work began. A preparatory drawing called a *sinopia* (see Chapter 3, p. 81; the material made from a reddish brown chalk mixed in limewater) was drawn directly on the *arriccio*, a brown coat or underpainting coat of plaster. It was used by early artists as a guide for each *giornata,* or section of work completed in a day. Because the *intonaco* was laid section by section on top of the drawing, the *sinopia* disappeared as the painting progressed. The *sinopia* recorded the relatively canonical form on the preliminary surface, so that the essential lines of the buried drawing could be rapidly retraced on the *intonaco*, and the part quickly painted by the artist. If the *intonaco* was laid thinly, a faint image of the *sinopia* remained to guide the artist. If not, the artist could quickly draw the outline from memory. Any excess *intonaco* was chipped away before the next day's plaster was applied. Later, as forms became less conventional and more individual, artists used cartoons to transfer their designs by pouncing (see Chapter 3, p. 80) or incising. On occasion, the dotted pounce line or incised lines have remained visible here and there, revealing the process. An artist may have chosen to make a *quadrettatura*: a small drawing divided into a grid and enlarged in proportion to the full-scale size of a cartoon.

A secco was a technique used to paint on dry lime plaster wall with tempera paint such as casein or egg. It has a dry matte surface resembling the effect of fresco but without the brilliance or purity, and it is a surface coating so it is much less permanent. *A secco* is also referred to as the "touching up" that takes place at a later time on a dry fresco when tempera colors are used to make small corrections or finishing touches. In addition, it was used for applying colors, such as genuine ultramarine blue, which would have reacted with the live lime and turn black or dull with time.

inopia

(right)
solino
ure of a Saint
4
opia
10 ½ in x 1 ft 6 ½ in (240 x 47 cm)
urch of Sant'Agostino, Empoli, Italy

ept for a few traces of shading, the
re is executed without retouches by
ar, definite outline alone.

(far right)
lo Schiavo
donna and Child Enthroned
7–1478
opia
2 in x 7 ft 9 ¼ in (280 x 237 cm)
rch of Santissimi Apostoli, Florence

sinopia is a characteristic example of
method of construction, drawn in the
plaster *arriccio*, in which the central
ical line (as well as the other vertical
horizontal lines of the framework)
cated by snapping a cord soaked in
d color.

rtoon

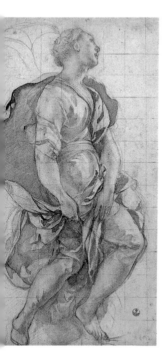

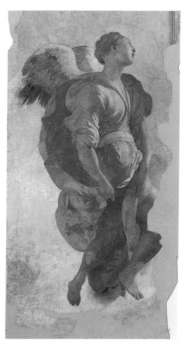

◀ (far left)
Jacopo da Pontormo
Cartoon of the Angel of the Annunciation
1527–8
12 ft x 5 ft 6 ⅛ in (3.6 x 1.6 m)
Drawing, squared for transfer
Uffizi Gallery, Florence

◀ (left)
Jacopo da Pontormo
The Angel and Virgin of the
Annunciation (detail)
c.1527–8
Fresco
12 ft x 5 ft 6 ⅛ in (3.6 x 1.6 m)
Capponi Chapel, Santa Felicità, Florence

Since drawing was not regarded as an
art form until much later, studies and
cartoons created by the fresco artists that
were not destroyed during the transfer
process, or discarded afterwards,
represent some of the few remaining
examples of early drawings. The careful
drawing in the cartoon, created by
Pontormo, helped facilitate the grace
and delicacy of the final work.

SUPPORTS, GROUND, AND BINDER

A large-scale fresco is executed on a wall or a number of walls for a fresco cycle. Most contemporary fresco is, however, completed on single portable panels. Panel supports include wooden panel, unglazed clay tile, fiberboard, and other inflexible surfaces.

◄

Yvonne Jacquette
Skowhegan Dam with
Green-roofed Building
1988
Fresco on panel
16 x 24 ⅞ in (40.6 x 63 cm)
Courtesy of the artist

Out of a necessity to make smaller paintings for a while, Jacquette decided to paint small frescos. This image, which she painted in one day, was taken from a detail of one of her large oil paintings. The fresco took on a completely different character to that of the comparatively opaque quality of the oil painting. The liquid pigment was stroked on in thin layers until the proper density was achieved. The fact that fresco dries light can be an attribute because the "ripening" of the *intonaco* brings in light.

The ground and the binder are the same in fresco, since the pigments are absorbed into and are incorporated with the ground.

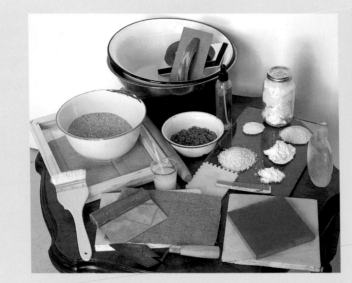

Tools of the fresco trade: trowel, lime plaster, metal and plastic comb, burlap, plywood and other rigid panels, casein glue, marble meal, marble dust, crushed unglazed clay tiles, river sand, metal, rubber, and wood floats, large bowls, mortarboard (glass palette), atomizer, metal pastry cutter with wooden handle, wooden strainer, large bristle brush, milk of lime water.

Preparing portable panel support and application of lime plaster

What you will need:

Birch plywood panel or other rigid support, approximately 1 inch (2.5 cm) thick

Clean galvanized steel mesh screen and wire cutters, and small nails
 or tacks or heavy, rough burlap equal in size to the panel

Casein glue: one part commercially prepared casein glue base and one to two parts
 distilled water (see Chapter 7, p. 75, for handmade casein preparation
 instructions; the casein glue for this purpose must be stronger than
 for a painting solution)

One large bristle brush or a wide, soft-bristle plasterer's brush

Trowel: must be balanced so that when you set it down the point tilts up

Painting knife trowel

Aged pit lime

Milk of lime water

Coarse marble chips/marble meal, crushed unglazed clay tiles, or crushed brick
 (the size of split peas), thoroughly washed, strained, and left to dry

Coarse river sand: thoroughly rinsed, drained to remove any debris, and left to dry

Wooden strainer

Marble dust or fine river sand

Metal pastry cutter with wooden handle

Wooden and rubber float for smoothing the *intonaco* (painting coat)

Metal float for polishing the mortar or glass or wooden roller

Large bowls or buckets

Mortarboard, hawk, or large glass palette to hold the mortar

Clean water

Water atomizer

The preparation and the mortar layers are the most time-consuming aspects of the technique. The actual painting process in fresco can be fast and relatively simple. The wall or portable panel must be clean. If necessary it should also be degreased with denatured alcohol and then left to stand for three hours. The surface must also be absorbent and toothy to provide a key for the plaster. The structure must not contain any impurities that could leach out and discolor the painting.

There are several methods used to encourage bonding of the successive layers of mortar. A clean mesh screen of galvanized steel can be nailed—or rough fabric can be glued—to a panel to provide tooth. Alternatively, you can apply the mortar layers with successively diluted additions of casein glue. I prefer to apply mesh screen or heavy, coarse burlap to the panel. Nail the mesh screen or apply burlap with casein glue to a wet panel of birch plywood or other rigid support. If you have applied burlap to a rigid panel, you must let it dry overnight. Before you begin the rough coat, wet down the panel. To make the panel more receptive to the rough coat, rub a thin coat (skim coat) of mortar mixture into the plywood and fabric or screen covering. To make a skim coat, take a small amount of the stiff rough coat mixture and combine one part of water with it to create a slurry or loose mixture.

Trulisatio: rough coat

Three parts filler: coarse marble chips, crushed brick, or crushed unglazed clay tile
One part lime putty

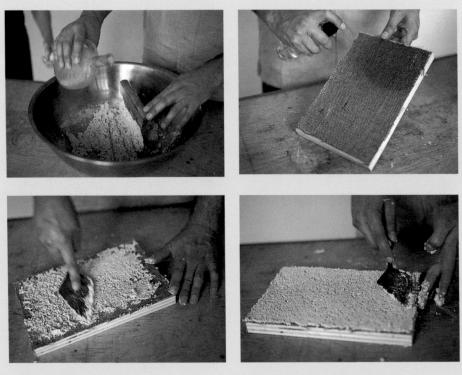

Rough coat: *trulisatio*. From top, left to right: Combining lime putty with course marble chips or marble meal; wetting down the burlap-prepared panel; application and smoothing out of rough coat with wet trowel; finished rough coat on panel—not scored with a comb because it is sufficiently rough.

You may wish to eliminate the rough coat, because it is not absolutely necessary on a portable panel. But, because of its porous quality that will hold moisture, it will allow more time to work on the painting, and the use of the rough coat will give you a sense of how large frescos are produced. Many artists also prefer having the substantial feel of the rough coat when applying the brown coat. Mix and apply a skim coat as described on p. 197. Mix the rough coat's dry ingredients; then add just enough clean water to make a stiff paste, and mix again. With a wet trowel, lay down a ¼-inch (0.6 cm) thickness of the rough coat and level it with the trowel. If the marble chips are not sufficiently rough, you can scratch the surface with a metal comb in a random pattern to provide a key for the next mortar layer. It is important that the surface of this layer does not dry out. Keep the surface wet by spraying with water as the rest of the rough coat begins to set. The setting time should be about fifteen minutes, depending on the humidity conditions in the environment where you are working.

Arriccio: brown or underpainting coat

Three parts filler: coarse sand
One part lime putty

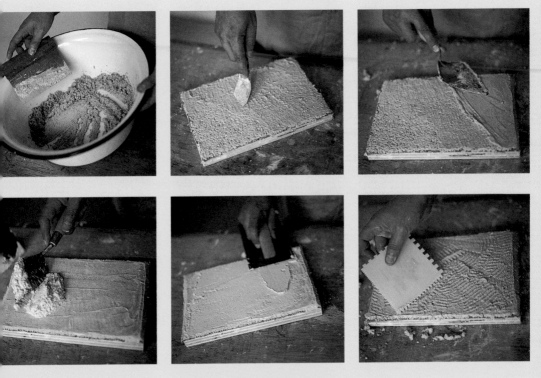

wn coat: *arriccio*. From top, left to
t: Using a metal pastry cutter to
bine lime putty with coarse sand;
ying a skim coat over the rough coat;

brown coat, skim coat, rough coat;
applying and smoothing out the brown
coat over skim coat over the rough coat;
scoring with a comb.

While the rough coat sets, mix the brown coat in the same manner as you mixed the rough coat. Before the surface dries out, with a wet trowel apply a skim coat (prepared in the same manner as for the rough coat) of the brown coat to ensure adhesion. Then apply and build a ¼- to ½-inch (0.6 to 1 cm) brown coat evenly and smoothly with a wet trowel. Score with a comb to create a tooth; again, spray with water as the surface of the layer sets and before a crust begins to form.

Arenato: sand coat

Two parts filler: fine sand or marble dust
One part lime putty

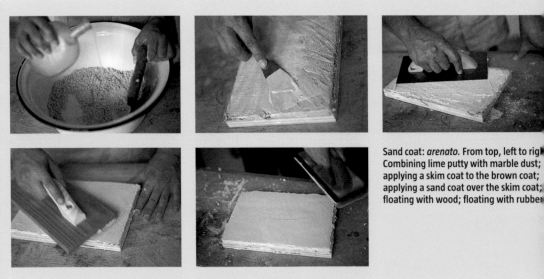

Sand coat: *arenato*. From top, left to righ▮
Combining lime putty with marble dust;
applying a skim coat to the brown coat;
applying a sand coat over the skim coat;
floating with wood; floating with rubbe▮

The *arenato* is similar to the *arriccio* and is sometimes left out. Again, as with the *trulisatio*, the *arenato* will facilitate more painting time, and it will allow you to experience the process of creating a fresco more fully. It also provides a more gradual progression from the coarse layer to the fine, rich, fat painting layer of lime putty and fine marble dust or fine sand, producing a sound construction similar to that of an oil painting's "fat to lean" construction.

While the brown coat sets, mix the sand coat. Begin to apply the sand coat after the water on the surface of the brown coat has disappeared and, as with the brown coat, before the surface dries out. As with the previous coat, you may want to apply a skim coat to ensure adhesion, and then apply a second coat. Trowel on, smoothly and evenly, with a wet trowel a ¼- to ½-inch (0.6 to 1 cm) thickness. Before the surface sets, gently smooth it with a wooden float to provide a slightly textured surface or a rubber float for a smoother surface. Lightly splatter the surface with the plasterer's brush dipped in water and dip the float in water to keep it from sticking to the surface. Go over the surface in one direction or in a circular motion, holding the float flat against the panel until the surface is smooth. Let the surface of the sand coat dry for one or two days before applying the painting coat.

PAINT LAYER

Preparing pigment pastes for fresco painting

p of suggested palette for fresco painting.

Preparing pigments for fresco.

What you will need:

Dry, lime-proof pigments
Small glass jars with plastic lids and glass cups
Distilled water
Glass muller
Large glass palette with sand-blasted surface (see Chapter 5, p. 121)
Palette knife
Painting knife
Glass spoons
Glass wand
Glass dropper (pipette)
Oxgall (a wetting agent for pigments, which are difficult to disperse in distilled water)

Due to the alkaline action of lime and the acidity of air in some regions, only some pigments have the stability to remain permanent. During the great age of fresco in the Italian Renaissance, the palette was surprisingly limited. The heart of the palette was the earth pigments exemplified in Masaccio's *The Tribute Money* (see p. 202). Vigorously applied broad bands of modeled earth pigments contributed to the revolutionary naturalism of the volumetric figures and the rhythmic flow of the narrative sequence. The colors and forms available to Masaccio reflect the place and social context of Florence in the early Renaissance. The beauty of the fresco palette was its natural harmony. To produce a successful painting that reflects place and social context may require few colors in the present age as well. Complete lists of pigments safe for fresco painting are available from manufacturers.

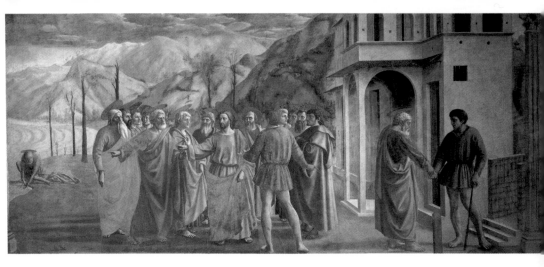

Masaccio
The Tribute Money
c.1424
Fresco
8 ft 4 in x 19 ft 8 in (2.5 x 5.9 m)
Brancacci Chapel, Santa Maria
del Carmine, Florence

In fresco, the most permanent colors are the earth pigments. Masaccio used grays, browns, brick reds, golden yellows, and muted greens—colors that can be extracted from natural clays.

Suggested sample pigments for fresco painting

- Black: vine black, Mars black
- Red: red oxide, *terre pozzuoli*, cinnabar, irgazine red, irgazine scarlet, irgazine orange, alizarin crimson
- Yellow: Mars yellow, French yellow ocher, raw sienna, Indian yellow, Hansa yellow
- Green: chromium oxide, green earth, green raw umber, Verona green
- Brown: raw umber, burnt umber, burnt green earth
- White: bianco San Giovanni, gesso di Bologna, zinc white, titanium white
- Violet: Mars violet, cobalt violet
- Blue: cobalt blue, pure ultramarine blue

For each pigment you intend to use, take dry pigment from the container to the glass palette with a palette knife or glass spoon. Some pigments are very fine and fly around, making them difficult to combine with distilled water. If you find it necessary, add a drop of oxgall to tame the pigments for grinding. Sprinkle a mound of pigment with distilled water and, with a circular motion, grind pigment and water with a glass muller, a palette knife, or a painting knife until you have a tough paste. Use a painting knife or palette knife to drop the paste into a glass jar, but before you put on a lid, cover the pigment paste with a small amount of distilled water so that it will not dry out. These pigment pastes will last indefinitely. You can also purchase prepared pigment pastes (color concentrates). The painting coat can be applied when your pigments are prepared and set out ready for use.

Intonaco: painting coat

(The final smooth plaster layer into which the finished painting is to be executed)
One part filler: fine sand or fine marble dust
One part lime putty

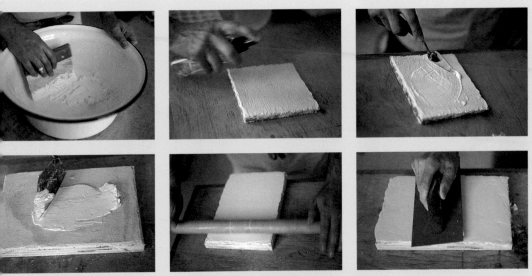

ting coat: *intonaco*. From top, left to
:: Combining lime putty, fine marble
, and milk of lime; wetting down the
panel; applying the skim coat; applying
the *intonaco*; smoothing with a wooden
roller; smoothing with a finishing trowel.

On a clean surface free of any material left over from the other mortar layers, mix the dry ingredients of the painting coat as smooth as possible in a clean container. If you need extra moisture to make it more fluid, mix in milk of lime, which is the limewater that lies on top of the lime putty. Before applying the painting coat, spray the sand coat so that the surface is thoroughly wet. Let the water absorb into the plaster, and then lay down a skim coat with a clean, dampened trowel. Wait for about fifteen minutes and then lay down a ⅛-inch (0.3 cm) layer of *intonaco* by slowly running a clean, dampened trowel held in a slightly tilted position. The painting coat should be thin. Let the surface settle for a few minutes, then smooth out the painting coat with a wet wooden float going in one direction, or a moistened wooden (or glass) roller rolled once over the surface. This step will eliminate popping or bubbles in the surface. I have found that the application of a skim coat minimizes the formation of bubbles or popping. Next, using a metal float or a finishing trowel in one direction or in a continuous circular motion held flat to the surface, polish the mortar to a fine finish. If you prefer a surface with some texture, finish it with a wooden float by gently going over the surface in one direction. Give the surface a light spray of water and then let it draw back for a half hour or so.

Cover only the areas of the surface that can be painted in one day. If you are using a small- to medium-size panel, it will be possible to complete a painting in one session. If not, unpainted areas of the painting coat must be cut away at the end of the day. A fresh mixture of the painting coat must be applied to unpainted areas just before the next painting session begins.

METHOD

Cartoon and transfer

What you will need:

Paper and tracing paper
Stylus or pouncing wheel
Terre pozzuoli or raw umber pigment in a muslin pouch tied with a string
Muslin
Charcoal

Method of transfer, from left to right:
Creating a muslin transfer; piercing the tracing paper with a pouncing wheel; soaking brushes.

Transfering a cartoon to a painting coat, from left to right: Muslin with charcoal— incising; painting coat—charcoal cartoon transferred; cartoon incised without charcoal; cartoon transferred to paper as an example of pouncing.

While you are waiting for the *intonaco* to be ready, prepare your cartoon for transferring to the painting surface and soak your brushes in clean water for half an hour.

Create a cartoon or use one that you have created ahead of time and then trace it onto thin muslin with charcoal. To see the image clearly, place the cartoon on a light table, or tape it to a window with light coming through. For the pouncing method, trace your cartoon onto a piece of tracing paper to create a *spolvero* (a secondary cartoon created to preserve the original). Then place your *spolvero* on top of a piece of folded muslin to create a cushion and run the pouncing wheel (a small spiked wheel) over the lines. For the pouncing method, take a small square of muslin, fill it with an earth pigment such as raw umber or *terre pozzuoli*, and tie it with a string. After you have let the painting coat dry out

for up to half an hour, see if it holds a slight indentation, made by gently pressing a fingertip into the surface. Then, if the surface is ready, transfer your cartoon by pouncing (see Chapter 3, p. 80, and opposite) or incising.

For the incising method, lay the muslin face up on the fresh *intonaco* and follow the lines with the stylus (small, pointed, pencil-shaped instrument) to leave an incised line in the plaster along the drawing lines. I prefer to have a faint charcoal line as well as the incised line. To achieve this, you must reverse your cartoon image by turning it over on the light table before you proceed to transfer it to the muslin. Then lay the muslin face down on the *intonaco* and follow the lines with the stylus. For the pouncing method, lay the perforated cartoon on the fresh *intonaco* and gently run the pouch filled with pigment over the lines. The pigment will sink into the *intonaco* to make faint dotted lines, reproducing the design of the cartoon.

Painting into wet lime plaster with pigment pastes

What you will need:
Fresco brushes: use light, soft hair brushes, such as sable and squirrel, and fine soft
 synthetic brushes, soaked in water for half an hour before use
Bristle brushes for miscellaneous uses
Pigment pastes
Glass palette
Glass jars or dishes, and porcelain palette
Distilled water
Glass dropper (pipette)
Glass wand
Glass spoon
Palette knife
Water atomizer for spraying surface and moistening colors in the mixing jars or cups

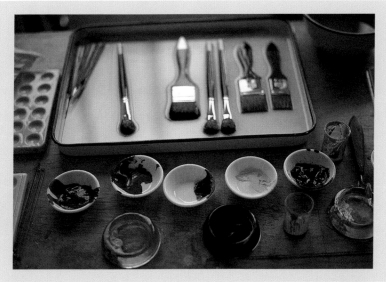

Fresco painting setup: brushes, pigment pastes, utensils, and tools for fresco painting.

When you are ready to use a pigment paste, dig a bit out of the jar and put it into another clean glass receptacle. With a glass dropper, add distilled water. Mix with a glass wand to a fluid cream consistency for application to the *intonaco* surface. For a sheer veil of color, add more distilled water and mix again.

Fresco painting calls for simplicity and understanding of the limitations of the medium. The layers are applied in quick, loose washes. Indirect painting—painting in layers to achieve final tones—is carried out by first applying washes of large, broad, transparent tones of color in general areas. Use a swift, sure, and delicate brushstroke with a soft hair brush to ensure that the damp surface of the plaster is not disturbed or scrubbed, and to maintain freshness of color.

There are three phases of wash painting. The first layer is a thicker wash, the second is a more liquid/cream consistency, and the third is more watery. Each successive layer has more distilled water added to the pigment mixture. After the first, thicker layer of color sinks into the plaster, the thin, creamier washes of colors can be applied to gradually deepen tones. The third, more watery, sheer veils of color combine optically to create a final color. Color complements can be used for shadows.

Three shades of each color can be used to describe value variations by starting with the color full-strength and making each shade lighter by diluting with distilled water. Leave the surface of the *intonaco* bare for white and highlights, similar to using the white of paper in watercolor. When you are about to finish, focus on small details and corrections, applying the final accents of darks and bright, clear colors, and whites and near-whites if you need them in addition to the white of the *intonaco* surface.

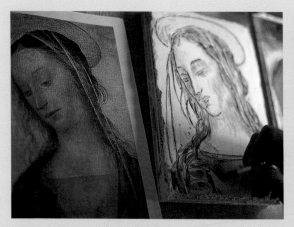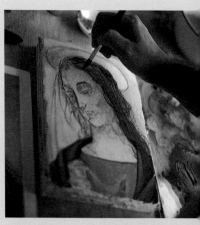

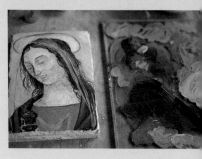

Painting in layers with strokes of liquid color into wet-lime plaster—three stages (clockwise from the top).

On a small panel, you may have up to four hours per painting session, depending on local humidity conditions. If you are well prepared, you may be able to finish a painting in one session. Spraying the surface with distilled water can provide a longer painting session, but when the *intonaco* begins to dry out, it is time to stop for the day. Areas that have not been painted must be cut away. Look for an edge of the completed area (not in the middle of a plane of continuous color), such as a division or line between two colors, because it can be difficult to match color and consistency from one painting session to the next. Use a plastic palette knife to score along the line and cut into the painting coat. With the putty knife, scrape away the remaining painting coat.

Before applying the next session's *intonaco,* wet the edges of the cut by spraying with distilled water to allow the new lime plaster to stick.

For a direct painting technique, you can take the pigment pastes you need from their jars and physically mix them with white before you lay the *intonaco*. Three tints of each color can be produced by using pure color for the darkest, adding a bit of white for the next, and a bit more white for the third shade. Then you can paint in one layer by swiftly creating light and dark tints where needed and adding the final accents as described for indirect painting. While still wet, the white mixtures may appear translucent, but they will actually dry much lighter.

For both indirect and direct painting methods, as the surface dries, the paint will appear slightly lighter in value. If you need to make any small corrections, wait for at least a month for the surface to dry completely for more successful color matches. Small corrections can be made *a secco* with egg tempera or casein (see Chapter 7 for preparation instructions).

TECHNIQUE

◄

La Villa di Livia e la Pittura di Giardino (detail)
*c.*40–20 BC
Fresco
Height (approx) 4 ft (1.2 m)
Palazzo Massimo alle Terme, Rome

The Roman palette consisted of lampblack, bone charcoal from cow or horse, Egyptian blue from copper ore, brown from native earth, green from Egyptian green earth, lime white, yellow ocher, and red from Pozzuoli in Italy. It was stable in fresco and the most-used palette in Italy. The initial layers of fluid color absorbed more deeply into the *intonaco*, allowing the natural forms depicted to soften, lighten, and merge into the background. This gave the illusion of deep space when juxtaposed with the top layers.

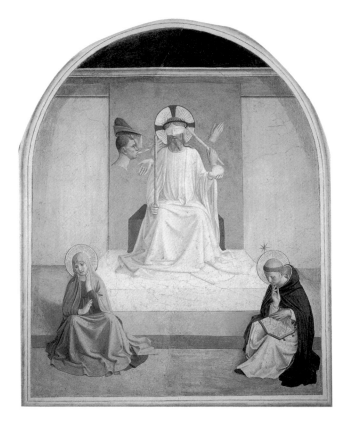

◄

Fra Angelico
The Mocking of Christ
1438–43
Fresco
6 ft 4 ¾ x 5 ft 2 ⅜ in (1.9 x 1.5 m)
San Marco Convent (Cell 7), Florence

This and other frescoes in cells at the Sa
Marco Convent were created to facilitate
the contemplation of the Dominican mo
who occupied them. The restrained pale
reflects the austerity of the practice that
took place there.

◄

Detail from the Tomb of the Triclinium
c.470 BC
Fresco
Height (approx) 6 ft (1.8 m)
Tarquinia, Italy

Large-scale painting was widely practic
in the ancient Mediterranean world. Th
paintings of the celebrated Greek paint
such as Apelles are all lost, so painted
tombs are the only evidence of these e
paintings. Those of Tarquinia are the
richest. A thin screen of plaster wash w
applied to the solid tufa walls of cave
chambers. Designs were sketched in
charcoal or chalk, and then a range of
organic dyes or pigments was used for
color and shading. Reds, yellows, and
ochers were extracted from local iron
oxides, and a local green was derived f
malachite. Blue and violet were impor

Exercise: copying a fresco or creating an original piece

Copy a fragment or detail of a fresco from an image in this chapter or create an original piece using subject matter such as a found object, landscape, or portraiture. Using a viewfinder to isolate a fragment of a fresco to copy or a scene of your still life, landscape, or portrait (see Chapter 3, p. 68, for instructions to make a viewfinder), create a *quadrettatura* sketch in charcoal or graphite that has a faint graphite grid the same size as your panel to use as a cartoon. Since you will not be making a large work, you will not need to make a scaled-up cartoon from your *quadrettatura*. Trace your cartoon onto muslin with charcoal and transfer to a wet, lime-plastered panel with a stylus, and continue the entire process as described above.

sferring the cartoon of Pontormo's angel from *The Annunciation* (see p. 195) onto muslin.

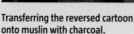
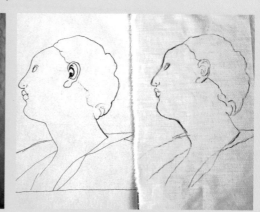

oon.

Transferring the reversed cartoon onto muslin with charcoal.

Reverse of cartoon (reinforced with ink for greater clarity—optional) and muslin transfer.

After I had prepared the cartoon, I prepared a small wooden panel by surfacing it with casein glue and then laying down rough burlap. After a day, I sprayed the panel with water and let it run off. Then with the tip of a slightly wet trowel, I applied the *trulisatio*, *arriccio*, and *arento*. I leveled the *arento* with a moistened wooden float and let the panel set for a day. I prepared my colors and put my soft sable and squirrel brushes in water to soak. I applied the *intonaco* all over the *arento* surface and smoothed the surface several times with a moistened trowel. I let the surface of the *intonaco* settle for a few minutes before going over it with a moistened wooden roller, then I smoothed it out with a dampened finishing trowel. A half hour later, I transferred my cartoon by laying my muslin transfers with charcoal face-

down firmly onto the *intonaco* and incising the lines with a stylus. I began to paint by applying veils of color with broad strokes such as a sheer mixture of raw umber for the background of the angel. With a long, flexible, round squirrel brush that formed a sharp point, I quickly laid in the garments using three shades of each color made by mixing distilled water into the pigment pastes to produce progressively diluted versions of each color. I laid in an initial coat of burnt sienna for the hair on the angel, and I painted in strands with pale yellow ochre and raw umber. To finish the portrait, I applied black or near-black on areas such as the crease of the lips, the nostril, and the inner, interior edge of the eye. I outlined the profile to provide emphasis for viewing from a greater distance.

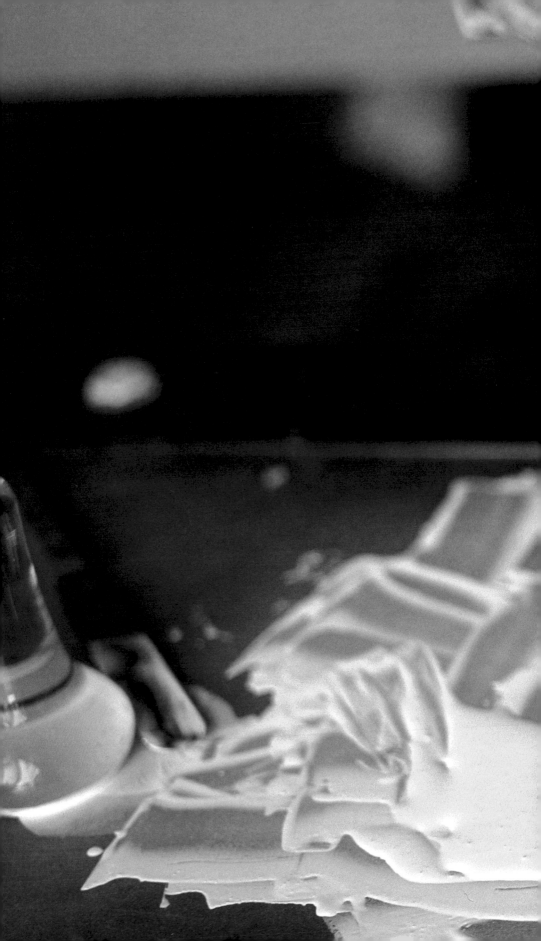

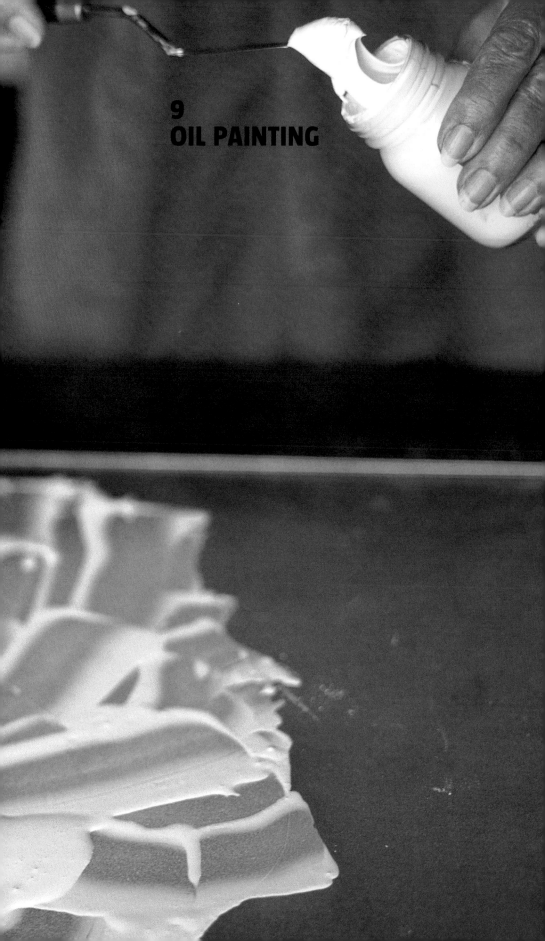

**9
OIL PAINTING**

The dynamic processes of oil painting are, to a degree, those of nature. Dynamics is the science of the motion of bodies that mutually act on one another. Leonardo da Vinci observed that blue is produced in nature when thin, colorless vapor is interposed between the eye and darkness or depth beyond, as in the blue of the sky and in the blueness of distant dark objects. Smoke when seen against a dark object appears blue, but when seen against a light object or a light sky, it looks brown. A thin film of white oil paint spread over a warm, dark hue can produce coolness and may spontaneously create blue. The blueness produced in a picture by the interposition of a light medium before darkness (especially if the darkness is warm) will have a subtle luminosity. In the Venetian practice of oil painting (the main focus of this chapter), degrees of both warm and cool tints could be obtained dynamically by layering colors or placing them adjacent to each other on the painting surface, as opposed to mixing the colors on the palette before applying them to the painting surface.

Oil painting, the most enduring and widely used historic method of painting as we know it today, began in the fifteenth century and evolved gradually over several centuries. For easel painting, there was no smooth, linear transition from egg tempera to oil painting. Some artists used the oil medium, adapting it to their style without exploring the intrinsic effects of oil. Others added oil to egg tempera to extend its workability, and still others added egg to oil paint to influence its handling properties. Oils had been used by painters since the fifth century for various purposes, such as an adhesive for gilding (applying metals such as gold to the painting surface) and for glazes over gilding within paintings that were bound in tempera.

During the fifteenth century, artists began to select oils for painting that dry to a solid film with prolonged exposure to air—drying oils such as linseed, walnut, and poppy—and they began to use drying agents such as metallic umber pigment. Painters began to use oils that had been employed for two centuries in functional rather than fine-art painting. As drying oils came into use for easel painting, the oil medium gradually replaced the predominant use of egg tempera, as it more adequately recorded new ideas and accommodated changing styles and themes. Tempera painters employed a process of building the pictorial space of shapes and forms in a linear fashion instead of using seamless transitions of broad strokes of fluid color or multiple glazes to create shapes, forms, optical color mixing, and atmospheric space.

Oil paint does not dry immediately like other media. It allows for a seamless blending of colors as opposed to the fine network of hatched lines in a tempera painting that serves to blend colors optically when viewed from a distance. Artists were pursuing new challenges such as larger compositions, which required flexible supports, portable paintings for palaces, and secular subjects. Although landscapes were used in the backgrounds of egg tempera paintings and great delicacy could be accomplished with time and patience, a more atmospheric pictorial space could easily be achieved with a versatile medium such as oil paint, because the paint is fluid and can be easily fused into delicate, less linear transitions.

After seeing paintings in Naples by the early Dutch artists Hans Memling (1440–94) and Jan van Eyck (?–1441), who, with his brother Hubert, perfected the use of dry pigments mixed directly with linseed and/or walnut oil for application to wood panels, the Sicilian artist Antonello da Messina (c. 1430–77) returned to Venice in 1476, where it is thought that he introduced oil techniques for painting on wood panels. He and other Venetian

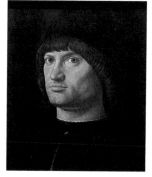

Diego Velázquez
Joseph's Coat Brought to Jacob (detail)
1629
Oil on canvas
7 ft 3 ¾ in x 8 ft 2 ⅜ in (2.2 x 2.5 m)
Patrimonio Nacional, Monastery of
San Lorenzo de El Escorial, Madrid

While this painting documents a biblical event, the brushwork and canvas operate in tandem to record the material presence of the event of painting.

Hans Memling
Tommaso di Folco Portinari
c.1470
Oil on wood
17 ⅜ x 13 ¼ in (44.1 x 33.7 cm)
The Metropolitan Museum of
Art, New York

Antonello da Messina
Portrait of a Man (Il Condottiere)
1475
Oil on wood
15 x 13 ¼ in (38 x 35 cm)
Louvre Museum, Paris

Leonardo da Vinci
Ginevra de'Benci
c.1474
Oil on panel
15 x 14 ⅜ in (38.2 x 36.7 cm)
National Gallery of Art, Washington, DC

painters began to apply oil glazes over tempera underpaintings. These paintings were still considered tempera paintings. Giorgio da Castelfranco (c.1477–1510), known as Giorgione, created the first Venetian oil paintings on canvas. Although the initial flourishing of the Venetian method of oil painting took place in Italy (the painters Tiziano Vecelli [c.1485–1576], known as Titian, and Jacopo Robusti [c.1518–94], known as Tintoretto, applied oils throughout the painting), the Spanish painter Diego Velázquez (1599–1660) can be considered the first to use oils exclusively on canvas without employing the systems of tempera painting.

One painter personally followed the trajectory of oil painting as a primary medium. The Venetian painter Giovanni Bellini (c.1435–1516) began his career with pure egg

tempera, then he started to glaze with oil, and finally he used oil colors with visible brushstrokes instead of glazes. Bellini introduced atmosphere and was the first Venetian painter to develop the humanistic Renaissance style fully, yet he kept his strong emotional attachment to Christian subjects. He fused the oil painting innovations of Flemish art with the emphasis on drawing of Florentine art (where the artist worked out the composition through drawings that were transferred to the primed support), creating an early Renaissance spring-like freshness referred to as the "Venetian synthesis." The Flemish found that oil paint allowed for smooth transitions such as cast shadows and subtle chromatic effects achieved through glazing, and that oil paint could produce the illusion of light permeating a space. The primary focus for the Venetian School was the rich, glowing, all-over tone created by the building up of color, layer by layer. The emphasis on drawing took place at the painting stage. Without the carefully worked out and transferred drawings so important to the Florentines, the Venetians made compositional revisions while painting.

▶

Giovanni Bellini
Madonna and Child
1480–5
Oil on panel
20 ⁹⁄₁₆ x 16 ⁵⁄₁₆ in (52.3 x 41.5 cm)
National Gallery, Washington, D.C .

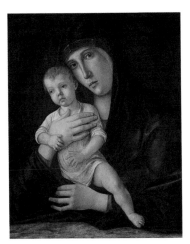

PROPERTIES

Oil painting possesses a great versatility of technique, absence of color change when the painting dries, ease of manipulation within a wide range of color and tonal effects, freedom to combine opacity and transparency, and linear and tonal areas in the same work. The light weight of the canvas allows for large-scale, portable work.

The defects of oil colors, such as cracking, yellowing, and darkening, can be eliminated or minimized by correct handling and the proper choice of materials.

Drying oils such as linseed oil, walnut oil, and poppyseed oil are the binder for pigments in oil painting, but the most commonly used binder is linseed oil. You can make oil paint and painting medium with all of these oils. Poppyseed oil is the palest and yellows less than linseed oil; for that reason, it is especially good for making white oil paint, and it dries more slowly than linseed and walnut oil. Walnut oil dries more slowly than linseed oil

and is said to be capable of producing fine, detailed lines. It is preferred by some painters because of the rich, crystalline painting medium it can provide. Drying oils have the ability to form a solid film when exposed to air, providing a rich, luminous surface.

The oil painting process results in a complicated construction produced by the application of successive layers. The support can be a rigid panel or flexible canvas. The size layer (a solution of rabbit-skin glue and water) seals the support and protects canvas from the destructive influences of the oil binder. Then a gesso ground (a solution of chalk, rabbit-skin glue, and oil, if necessary) is applied to provide a receptive, even surface for the paint layer. Optional layers are an *imprimatura* (sheer veil of color) applied on top of the gesso, and after that an *abbozzo* (sketch) or pale drawing can be applied with charcoal, chalk, watercolor, egg tempera, or ink. The painting can begin with the *grisaille*, a monochromatic underpainting, sometimes referred to as the "dead color." Or it can begin with a polychromatic underpainting.

There are two methods for creating an oil painting:

1. Indirect painting, in which local color is built up using a systematic interchange layering of warm, dark transparent glazes and cool white or near-white glazes (referred to as scumbling) with varying degrees of translucence and opacity. The technique is referred to as *glazing* for the sheer dark hues that are naturally transparent, such as indigo blue. When applied over white or near-white, glazing creates warmth, whether the hues are warm or cool. Scumbling is the thin application of white or near-white opaque colors such as Naples yellow. The white or near-white creates relative coolness when applied over dark hues. In Italian there is one word, *velare* ("to veil") for both glazing and scumbling.

2. Direct painting, in which the paint is applied in one layer or *alla prima* ("at the first"). The final effects are achieved in the initial application of paint.

Something always to keep in mind when painting in oil is *the rule of fat over lean*. Layers of color with more oil (fat) should be applied over an underpainting that contains less oil and is therefore less flexible (lean). Painting thin, or lean, colors over fat colors may cause the work to crack after aging. The thin overpainting would not be able to adjust to the underpainting's expansions and contractions due to temperature and atmospheric changes.

Outline of the technique
- Prepare the surface of the support: canvas or panel.
- (Optional) Lay down an *imprimatura*: a thin layer or veil of color made with distemper or mineral spirits.
- (Optional) Create an *abbozzo* (sketch) directly on the canvas with charcoal, chalk, watercolor, egg tempera, or ink.
- Create a *grisaille* (monochromatic underpainting) or polychromatic underpainting.
- Paint indirectly using glazing and scumbling, or directly, wet-into-wet, on canvas or panel.

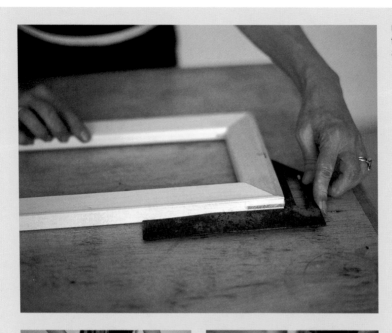

Use an L-square ruler to ensu~ that the stretcher corners are~ at right angles.

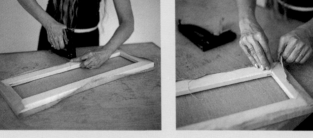

Hold the fabric taut and star~ by stapling the fabric with o~ or two staples in the middle of each stretcher bar.

Then work your way out from the center on each stretcher bar little by little, alternating sides as you go to keep the tension even un~ you get close to the corner and then carefully fold in th~ corners and staple them to the stretcher bars.

Canvas

It is not necessary to work on canvas when painting in oil; however, since oil paint is a more flexible medium, I will suggest working with canvas throughout this chapter to allow for a less cumbersome creation of larger works. In addition, canvas offers a physical texture analogous to that of the rough surface of a piece of cold-pressed paper. The materials will sink into undulations in places and rest on top in others, providing an additional element of visual interest and play. If you choose to use a panel prepared with true gesso, please refer to an earlier chapter (6 or 7) for instructions on preparing the panel and the application of traditional gesso. The methods in each are a bit different, but both are appropriate for an oil painting surface.

You can also use a half-chalk gesso on a panel. It will reduce the absorbency and solubility of the true gesso surface. Some oil painters prefer a smooth, flawless surface with less absorbency to enhance the rich qualities of oil upon immediate application; for this purpose, half-chalk gesso has the added quality of serving as a sealant. You can follow the description below for preparation and application of half-gesso for panel as well as canvas.

Preparing a stretched canvas with half-chalk gesso

What you will need:

Rabbit-skin glue

Water

Double boiler

Glass wand

Bologna chalk

Sun-thickened linseed oil or linseed stand oil

Soft, wide varnish brush

Spatula

Stretcher bars and canvas or linen

Staple gun and L-square ruler

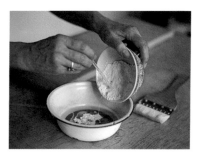

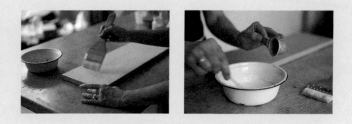

(Clockwise from top)
Mix Bologna chalk with warm glue solution, and then add one third of one part linseed stand oil to the cooled, thick Bologna chalk/glue solution. Then add the rest of the glue solution and apply the half-chalk gesso to the canvas.

Half-chalk gesso, also known as emulsion ground, is a solution of true gesso with sun-thickened linseed oil or linseed stand oil added for flexibility. It is one of a few grounds suitable for preparing a flexible surface for the application of oil paint. An oil ground, or the application of one or two very thin coats of true gesso are acceptable as well. I will limit my explanation to half-chalk gesso.

> *Glue recipe:* Soak one part rabbit-skin glue in fifteen parts water for one hour until it swells. Warm the glue to form a translucent solution. Do not boil; boiling may compromise the adhesive properties. Test the glue with two fingers. If your fingers stick together, the glue has been properly mixed and is ready to use.

Prepare the rabbit-skin glue solution and apply a thin layer of it with a soft, wide varnish brush to the surface of the stretched canvas. Set aside one part of the rabbit-skin glue solution and one part Bologna chalk.

Mix the Bologna chalk with only enough warm glue solution to produce a consistency of thick cream. Let the mixture cool, then add one third of one part linseed stand oil or sun-thickened linseed oil one drop at a time while stirring vigorously with a glass wand, then in progressively larger amounts. The mixture will thicken. This is a sign that the vigorous stirring has finely dispersed the oil droplets and that the mixture has been emulsified. Now add the remaining glue solution to the mixture until it has a more brushable consistency.

Apply a thin coat of the solution to the canvas surface with a soft, wide brush. If necessary, scrape off and smooth the surface with a spatula or painting knife so that the coating is very thin. After an hour, when the surface has superficially dried, apply a second, very thin coat. You may apply up to four very thin coats. Each coat should be applied perpendicular to the last coat. Wait at least one day before beginning the painting.

What you will need:
Cold-pressed linseed oil or walnut oil
Dry pigments and palette knife
Painting knife
Glass palette with sand-blasted surface
 (see Chapter 5, p. 121)
Glass muller
Glass spoons and wands
Small glass jars with lids
Plastic wrap
Oxgall (disperse aid)

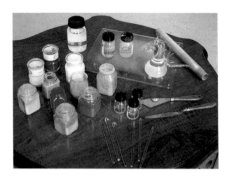

Making your own oil paints can result in the highest-quality colors, because you will have the option of using pure pigments without additives. Producing your own oil colors can be more economical, and it is an excellent way to get to know the properties of individual colors. Each dry pigment has unique qualities and requires a slightly different quantity of oil. Some colors can benefit from the addition of beeswax, resins, and other ingredients, but to get you started, I will suggest the simplest means to create oil colors. If you wish to go further, you will see books I recommend in Further Reading.

Most pigments can be mixed with oil. Some exceptions, which literally do not mix with oil, are caput mortuum, red bole, manganese black, graphite, and Paris blue. Here is a list of pigments to get you started: Indian yellow, Naples yellow, nickel titanium yellow, cadmium yellow light, Hansa yellow light, cadmium yellow deep, cadmium orange, cadmium red middle, permanent red, cadmium red deep, quinacridone red, vermilion substitute, ultramarine blue, ultramarine violet, indigo, cobalt blue, viridian green, chrome oxide green, *terre verte*, cadmium green, Mars yellow, raw sienna, *terre pozzuoli*, raw umber, burnt umber, Mars red, Mars brown, Mars black, ivory black, lampblack, titanium white, zinc white.

If you wish to purchase ready-made oil colors, to achieve the best results and to experience the true qualities of individual colors and pigments, I recommend purchasing the highest quality of oil paint, no matter what stage you are at as an artist. Low quality oil colors contain fillers other than pigments.

Making oil paints

As a general rule, one part cold-pressed linseed oil is used for every one to three parts dry pigment. With a glass spoon or palette knife, take the pigment from the container and place it on a prepared glass palette (see Chapter 7 for preparation instructions). Bear in mind that a few pigments are very fine and unruly, so using a disperse aid such as oxgall will help prevent particles from flying around. To very fine powders, add a few drops of oxgall and work the pigment into a paste with a palette knife.

With a palette knife, slowly work the oil into the pigment to form a firm paste. Then, if you are making larger amounts of paint (and to be certain that all pigment particles are dispersed into a smooth paste), alternate the use of the palette knife with a glass

muller in a figure-eight motion. The initial mixing and subsequent use of the muller should take about twenty minutes altogether. Use as little oil as possible to achieve a stiff paste, as more oil can always be added if, after you have worked the pigment paste, you still find it to be dry and powdery. It is somewhat difficult, conversely, to add pigment to make the colors less oily. Moreover, adding too much oil can cause yellowing, cracking, and wrinkling in the finished painting.

Store oil paint in glass jars with lids. Before putting on a lid, cover the pigment with a piece of plastic wrap to prevent the top of the paste from drying and forming a skin.

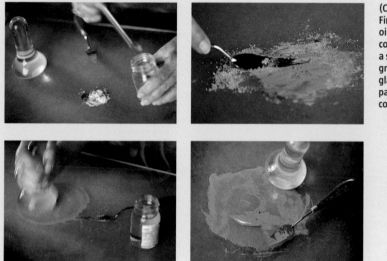

(Clockwise from top left) First add cold-pressed linseed oil to the pigment, then combine oil and pigment with a spatula. Once this is done, grind the mixture with the glass muller. The resulting oil paint should have the consistency of a stiff paste.

TOOLS AND BRUSHES

What you will need:
Large, soft varnish brush
Bristle brushes
Hair brushes such as sable, fitch, or squirrel
Synthetic brushes
Soft cotton rags
Palette knife
Glass palette
Glass jars
Olive oil soap and mineral spirits to
 clean the brushes

Clean brushes on a rag with a small amount of mineral spirits and then thoroughly wash them with olive oil soap and water. Finally, lightly run your brushes over the bar to leave a bit of olive oil residue to condition your brushes.

Beginning the oil painting

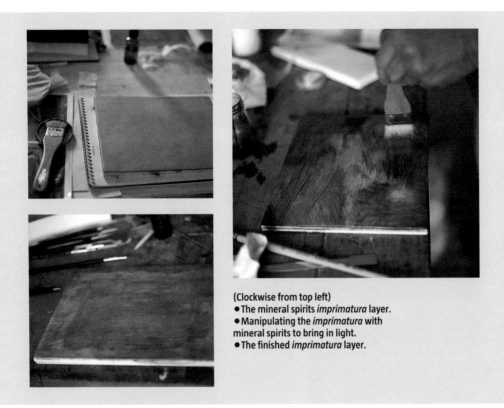

(Clockwise from top left)
- The mineral spirits *imprimatura* layer.
- Manipulating the *imprimatura* with mineral spirits to bring in light.
- The finished *imprimatura* layer.

Imprimatura

An *imprimatura* is a sheer veil of color that is applied with a soft, wide varnish brush onto the gesso ground. Alternatively, you could also consider adding dry pigment directly to your gesso to make a toned ground. Because of the optical quality of the brilliant white gesso, I prefer the *imprimatura,* which allows the gesso ground to show through the thin layer to provide a source of light from within the painting. The toned ground reduces this effect.

Imprimatura can be made in a few ways. To produce the liquid, dry pigment can be mixed with mineral spirits or distemper (see Chapter 7, p. 181, for instructions on distemper preparation, or see the rabbit-skin glue recipe on p. 142, which is the binder for distemper). *Imprimatura* made with mineral spirits and with distemper works differently. Distemper *imprimatura* dries quickly, in just a few hours, and does not move with the application of oil paint. Mineral spirits *imprimatura* dries within a day and will be somewhat pliant when oil paint is applied. Both qualities are desirable, depending on the needs of the individual work.

With a glass wand, thoroughly mix one part pigment to fifteen parts mineral spirits or distemper—for example, one grape-sized amount of pigment with fifteen parts of liquid—in a jar and apply to the dry gesso ground with a varnish brush. The measurements can vary, but the glaze should be transparent to allow the white of the gesso to show through. The artists of the Venetian School often used a dark, reddish-brown *imprimatura* that could begin the warm/cool, dark/light interchange of the painting process.

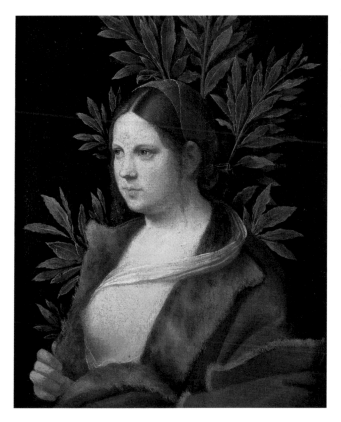

Giorgione (Giorgio Barbarelli
da Castelfranco)
Portrait of a Young Woman (Laura)
1506
Oil on linen on wood
16 ⅛ x 13 ⅛ in (41 x 33.5 cm)
Kunsthistorisches Museum, Vienna

An *abbozzo* is a pale sketch or drawing that can be applied with charcoal, chalk, watercolor, egg tempera, graphite, or ink. All the media I have mentioned will become subdued through the painting process, except graphite. Graphite will maintain a more dominant, metallic presence and remain obvious when the painting is complete. Some artists find this a desirable element, because, among other qualities, it gives physical evidence of the drawing. Begin to construct the pictorial space by completing a rough, pale sketch on the painting surface. Remove excess pigment from charcoal or chalk with a soft, dry brush or a feather so it will not contaminate the color of the underpainting.

Abozzo.

Underpainting

There are a number of ways to create an underpainting that will establish the value structure—forms described in terms of degrees of lightness from dark to light—and serve as a guide for building up the composition.

The *imprimatura* can be a substitute for a monochromatic underpainting with or without an *abbozzo* having been applied. It can vary in color according to need and it can be executed in three values to create a tonal underpainting, by making three solutions with mineral spirits or distemper as the liquid vehicle—one more concentrated, the second more diluted, and the third more diluted than the last. Apply with soft brushes. The distemper will dry within a few hours, whereas the mineral spirit solution could take up to a day to dry.

A *grisaille* is a monochromatic underpainting, created in shades of gray to indicate gradation and modeling. You can make diluted paint solutions with distemper, mineral spirits, or pigment ground into oil with added mineral spirit. Apply with soft brushes.

◀

Margaret Krug
Nokomis
1998
Pigmented oil and mineral spirits
8 x 8 in (22.3 x 22.3 cm)
Collection of the artist

First I applied a sheer Naples yellow *imprimatura* layer with slightly pigmented mineral spirits. To provide a variety of grays, I used raw umber mixed with indigo, earth green, and Payne's gray. I ground and mixed the pigments with linseed oil and mineral spirits to make diluted colors, then applied them over the *imprimatura* to create a *grisaille* underpainting. I used the pale *imprimatura* for my lightest value. I chose to leave the painting unfinished.

An underpainting can be created using what is called "underpainting white." Mix one part thickly ground white oil color (traditionally flake white/lead white)—itself combined with very little oil—with one part white tempera color, which is white pigment ground in equal parts of distilled water and egg yolk, to create an underpainting white of a thick cream consistency. If you wish, add a little yellow ocher pigment and grind it in well with a palette knife so that the color is not overly cold. For this method, use a relatively dark *imprimatura* veil to facilitate the creation of the dark and middle tones. To achieve this, apply the underpainting white in varying degrees of thickness, like drawing with white chalk on black slate to create shadows.

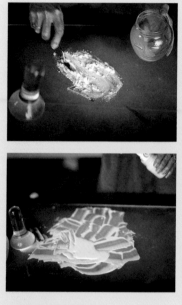

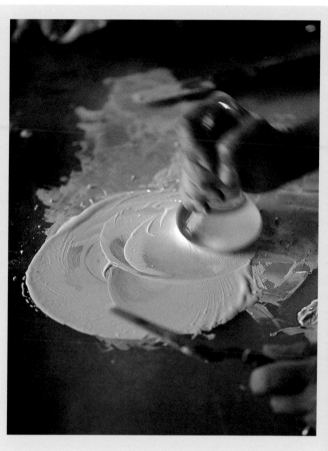

Underpainting white:
First make the white egg tempera, then add an equal amount of lead white oil paint to the prepared tempera. Finish by grinding the egg tempera and oil paint together with a glass muller.

To create three values, use the dark *imprimatura* veil as the darkest value or tone; apply thin layers of underpainting white, letting the *imprimatura* show through, for the middle value or tone; and apply a thicker layer of color for the lightest value or tone. The use of underpainting white promotes quick drying due to the addition of egg tempera. Work could be carefully continued in an hour or two if the surface is dry to the touch, and the underpainting white can be used throughout the entire process of painting as the white for scumbling, to which you can add any hue in a small amount to facilitate the desired inflection of color. To create a polychromatic underpainting, this first layer of color can be blocked out in diluted oil colors as a guide for building up the composition and the color effects.

No matter which method you choose, the painting should be within a narrow value range and very light, but well defined at this stage. It should be a pale ghost of the finished work. The lights should be darker and the darks lighter than you anticipate for the final work. To build the forms and details in local color there are two techniques: indirect and direct. You could use both in a single painting, as the oil medium allows for a variety of approaches.

◄

Isabel Bishop
Young Woman
1937
Oil and egg tempera on Masonite®
30 x 21 ¼ in (76.2 x 54 cm)
Pennsylvania Academy of the Fine Arts,
Philadelphia

**Young Woman is painted in the indirect oil
method with an egg tempera underpainting
on a gessoed panel.**

Applying local color

Traditionally, the core of an indirect painting is the underpainting on a dark veil of color
on a white gesso ground. Complete the *abbozzo* and one type of underpainting.
Depending on the method you have chosen, it may be necessary to let the underpainting
dry for up to two days. Then you can begin to apply local and tonal color by glazing with
transparent dark hues and scumbling with white or near-white semiopaque hues. Apply
paint with a soft brush, a palette knife, a soft rag, or a combination of these tools. For the
early stages, when I am using commercially produced colors that contain too much oil,
I squeeze out the amount of paint I will use onto a paper towel and let the excess oil leach
out into the towel. There should be little or no gloss in the early stages of indirect oil
painting. Sheer (transparent) dark glazes, made with pure oil color with no mineral spirits
or oil added and spread out with a brush or rag, should be dry in appearance. The white
and near-white hues can be made with the underpainting white or a white low in oil
content, such as flake white (lead white). Small additions of hues such as yellow ocher or
earth green can be added in dry pigment form or prepared oil paint form and mixed well
with white pigment for relative warmth or coolness. The underpainting white, which
contains egg tempera, will dry quickly and allow for more sheer dark glazing on top.

As with egg tempera, indirect oil painting is systematic. You can employ the formulas
for the application of local color described in Chapter 7 on egg tempera for sky, landscape,
drapery, hair, and flesh. However, instead of applying a network of fine lines to create a
veil of color, you can simply smooth on a sheer solid veil of color with a brush or rag.

If you are painting a landscape, apply a dark *imprimatura* such as *terre pozzuoli*.
To create a value structure and guide for building your composition, apply a white
underpainting using the *imprimatura* as the darkest value. Spread the white very thinly for
the medium tone and less thinly for the lightest tone. For the sky, paint the blue tint as

described in Chapter 7 and continue as I have suggested, but apply solid veils of color instead of fine, hatched lines. The *terre pozzuoli* will serve well to warm the green of the foliage, which can look cold when applied over white gesso. Before applying the foliage colors, apply pure black to tree trunks and a mixture of black and red earth where greens will be applied. If the painting appears dull or muddy at any time, the underpainting white can be applied to ensure freshness before applying a subsequent dark glaze.

A pure and effective way to paint the flesh in oil, employed most successfully by the painter Jean-Auguste-Dominique Ingres, is to leave the flesh areas untouched by an *imprimatura* or underpainting, and follow the method I have described in Chapter 7 by applying one or two thin layers of *terre verte*, mixed with white, on top of the white gesso. Finally, shade with raw umber or *verdaccio*, apply the *rosetta*, apply the flesh tints, and continue as I have suggested. The cool *terre verte* interchanged with the warm *rosetta* will enrich the flesh tones.

Although there should be no glossy surface while the painting is in progress, you can gradually begin to add a small amount of mineral spirits to the colors and then finally use an oil painting medium. When the whole painting is completed, there may be a gloss.

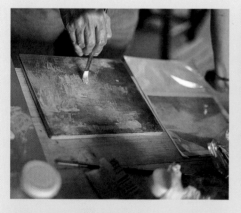
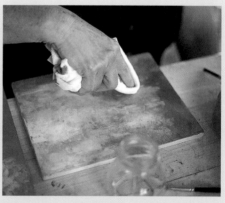

(Clockwise from top left)
First apply the underpainting white onto the *imprimatura*, then rub off the underpainting white with a soft cotton rag in the appropriate areas. Then you can start building color with glaze.

A simple oil painting medium

The glazing technique is simple, but the physical construction of an oil painting is complex. The addition of a complicated painting medium can lead to the deterioration of the painting surface. It is best to use a simple painting medium that does not include a varnish. Dammar or other varnishes can be dissolved with subsequent applications of glazes that include a solvent, and they can be removed during cleaning or restoration. The simple oil painting medium is made from one part mineral spirits and two parts linseed stand oil or sun-thickened linseed oil or walnut oil (which does not dry as quickly as linseed oil, but provides a richer more crystalline quality preferred by some painters).

Mix a bit of painting medium with oil paint to make a thin, transparent film and apply it with a soft brush or a soft rag. To hold to the fat-over-lean rule, delay mixing paint with the painting medium until you are close to the final stage of the painting. If you need to apply additional glazes, you can add a bit more medium to each subsequent layer, or add one drop of oil to your painting medium before you add it to the paint for an additional glaze. An attribute of oil paint, especially when glazing, is slowness in drying time. Dryers can be added, but I would not recommend them as they add undesired complexity that can cause damage such as cracking. To promote drying, you can add the pigment metallic umber, which acts as a dryer for linseed oil.

Use as little painting medium as possible to avoid yellowing or darkening, which is caused by the use of excess oil. You can avoid the use of a painting medium altogether by applying a dry underpainting and mechanically spreading the paint into a thin film with a rag or bristle brush.

To help prevent stippling (small dots of color), thin scumbling should be swept in masses. Work over the entire surface to provide a broad pictorial effect, and to enhance a unified whole. When glazing or scumbling, attempt to cover the entire painting with a dark, warm glaze in one layer and a cool, semiopaque layer in the next layer. Cover the painting more thoroughly in some areas than in others, as needed, and then use a soft rag to remove any excess of the veil of color where it is needed. This will provide pictorial unity.

To prevent a dark hue from sinking into another dark hue, sheer dark glazes should always be applied over relatively light areas, not over darker areas. As an occasional alternative, you can add a bit of white to the sheer dark hue. The white is viscous, has body, and creates texture, so a sheer dark veil, over the white, will adhere to the indentations made in the paint layer by the brushstrokes. This can produce modulations in color similar to those found in nature. The white can be applied throughout the painting process to provide freshness.

Apply bright strokes throughout before the final glaze. As you are about to complete the painting, you can apply a final sheer dark glaze to lower and harmonize the bright, minute touches of the unglazed painting. Any areas that need freshness or emphasis can receive an application of underpainting white.

Finally, a precaution to keep in mind while painting indirectly in oil: if oil is added too quickly during the indirect oil painting process, the clear, luminous effects could be displaced by a soupy, incoherent mix.

TECHNIQUE: INDIRECT PAINTING

Indirect painting consists of building local color using a systematic interchange, which involves layering warm, transparent glazes and cool white or near-white semiopaque glazes. I will focus on the technique employed by the painters of the Venetian School— Giorgione, Giovanni Bellini, Titian, and Tintoretto—and ultimately the Spanish painter Velázquez. The structural use of color, the departure from the linear strategies of the egg tempera easel painters, and the use of opulent, billowing forms are some of the concerns for which fifteenth-century Venetian artists turned to oil painting. The pictorial effect is achieved by the contrast of light and shadow, and the interchange of warm and cool hues.

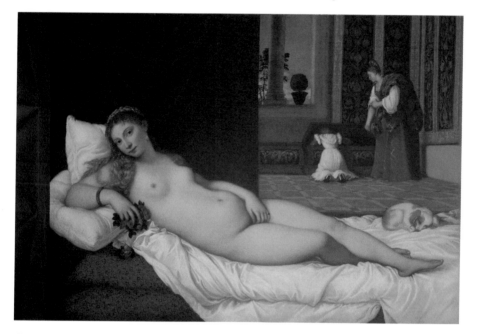

▲
Titian
The Venus of Urbino
1538
Oil on canvas
46 ¾ x 64 ¹⁵⁄₁₆ in (119 x 165 cm)
Uffizi Gallery, Florence

The aim of the Venetian School painters was the perfection of coloring to produce, for example, tints of great tenderness in the flesh by passing light pigment very thinly over relative darks. A warm red mixed with a small amount of black to provide darkness was glazed with a lighter tint to produce a cool pearl finish. Conversely, passing a diaphanous, relatively dark color over a lighter color could ensure delicacy in the warm tones. The Venetian painters wished to achieve a pleasing balance and a constant, even, slight interchange between cold and warm hues. There can be more power in the freshness produced by light over dark than in that of a solid cool tint. More real luminosity is to be found in a glazed color than in an atomic mixture of an opaque direct painting. Light is not just reflected from the surface but it is traveling through veils of color, and it is refracted and reflected from the lower layers. In their dynamic relationship, the colors in the upper layers influence the appearance of those in the lower layers.

▼ (below)
Giorgione
The Tempest
c.1507
Oil on linen
32 ¾ x 28 ¾ in (83 x 73 cm)
Galleria dell'Accademia, Venice

A highly refined, exquisite delicacy in paint handling was reserved for the final stages of the painting, while the initial approach in the underpainting was rough and boldly vigorous.

▶
Francisco de Goya y Lucientes
Countess of Altamira and Daughter, Maria Agustina
c.1787–8
Oil on canvas
76 ⅞ x 45 ¼ in (195 x 115 cm)
The Metropolitan Museum of Art, New York

Goya frequently used a light, yellow-red bole *imprimatura* over a white gesso ground. Over the *imprimatura*, he worked freely with white to create an underpainting. Mother-of-pearl tones were achieved through superimposed glazes. He did not force individual colors beyond the overall tone of the painting. Occasionally, he would simply create a *grisaille* underpainting on the gesso ground and lightly glaze it with local colors.

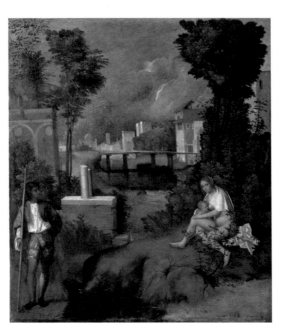

▲
Albert Pinkham Ryder
Toilers of the Sea
c.1880–5
Oil on wood
11 ½ x 12 in (29.2 x 30.5 cm)
The Metropolitan Museum of Art, New

Layers of glaze accumulated as Ryder worked over an image, sometimes for months or years. His use of slow-drying may have led to the ruinous condition Toilers of the Sea. Dense layers of paint have now drifted toward the bottom o panel, but the painting still conveys a brilliant view of an individual artistic vi

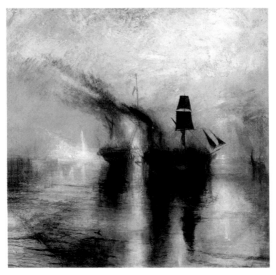

◀
Joseph Mallord William Turner
Peace—Burial at Sea
1842
Oil on canvas
34 ¼ x 34 in (87 x 86.5 cm)
Tate ©2007, London

An abruptly rugged substructure counteracts the softness provided by scumblings with white and glazings, were executed with equal treatment.

anton Macdonald-Wright
Oriental" Synchromy in Blue-Green
18
on canvas
x 50 in (91.4 x 127 cm)
hitney Museum of American Art,
w York

acdonald-Wright intended to create
lume and illusionistic space with color
one. He was the cofounder of an
merican art movement called Synchromy,
ich means "with color." He layered
ors to create optical mixing and used
e science of color to facilitate the
vancing and receding of shapes. He was
pired by the fresco cycles of Michel-
gelo in the Sistine Chapel, where
chelangelo created volume in the
ures with color.

Reinhardt
tract Painting, Blue
3
on canvas
28 in (127 x 71.1 cm)
tney Museum of American Art, New York

irst gaze, *Abstract Painting, Blue*
ears to be a solid blue rectangle, just
hen you enter a room before turning
light, everything appears to be dark.
our eyes adjust, you begin to perceive
angles in various tones of blue. Rein-
t layered and juxtaposed rectangles of
rent shades to create optical mixtures.

▲
Mark Rothko
Blue, Yellow, Green on Red
1954
Oil on canvas
6 ft 5 ¾ in x 5 ft 5 ½ in (1.9 x 1.6 m)
Whitney Museum of American Art,
New York

Rothko layered veils of color to create new
colors optically, using large decorators'
brushes. He drew upon the techniques of
the Old Masters, which encouraged the
luminosity of color, and adapted them to
suit his painting style. To create a ground
color or *imprimatura*, he mixed dry
pigments with a glue solution. Subsequent
veils of color engage in a dynamic
relationship with the ground color.

Amy Sillman
Hamlet
2001–2
Oil on canvas
6 ft x 7 ft (1.8 x 2.1 m)
Whitney Museum of American Art,
New York

Sillman became interested in the idea of narrative sequence because when she works in oil, she feels that she is making a many-layered painting. However, with the finished product, only that top layer, which is a combination of everything that happened, can be seen. In her work she endeavors to expose this layering process for the viewer.

METHOD: DIRECT PAINTING

Franz Kline
Untitled (Study for Mahoning)
c.1951
Ink on paper
9 x 11 ¹³⁄₁₆ in (22.9 x 30 cm)
Whitney Museum of American Art,
New York

Franz Kline
Mahoning
1956
Oil and paper collage on canvas
6 ft 8 in x 8 ft 4 in (2 x 2.5 m)
Whitney Museum of American Art,
New York

Kline created a number of small sketches related to *Mahoning*. With a Bell-Optico projector, he enlarged and projected one of them onto the canvas. The projected sketch provided the composition and served as a guide for the marks to be made. Then he applied paint directly with a large decorators' brush. The spontaneous, wet-in-wet brushstrokes embody speed and strength.

▲

Claude Monet
Rouen Cathedral (detail)
1893
Oil on canvas
35 ⅝ x 24 ¾ in (91 x 63 cm)
Musée d'Orsay, Paris

Monet employed the direct and indirect methods while recording the changing light and atmospheric conditions of the scene from his studio window in Rouen, France. There is heavy impasto in some areas, and almost no paint in other areas such as the sky. He reworked this and other paintings in a series of thirty over a period of three years.

▲

Willem de Kooning
Door to the River
1960
Oil on canvas
6 ft 8 in x 5 ft 10 in (2 x 1.7 m)
Whitney Museum of American Art,
New York

◄

David Park
Four Men
1958
Oil on canvas
4 ft 9 in x 7 ft 8 in (1.4 x 2.3 m)
Whitney Museum of American Art,
New York

An alternative to covering the painting surface layer by layer is the *alla prima*, or direct painting, technique. A painting is completed in one layer, in one session. The paints employed are fairly opaque, applied wet-in-wet. There is a spontaneous approach to design and painterly brushwork. It is as though you are completing the final stage of an indirect painting by applying diluted paint with a large brush or rag to block out and construct the composition, and then to finish the painting with definitive strokes.

Due to the versatility of the oil painting medium, these suggestions are only a beginning. Indirect and direct painting techniques can be combined. Experimentation is encouraged as you begin to understand the medium's properties and vast potential.

VARNISH

An oil painting will take at least a year to dry sufficiently before it can be varnished. If you plan to varnish it, I would recommend storing it up high, away from dust and other environmental contaminants. It is not absolutely necessary, though, to varnish an oil painting, because it is water-resistant. Varnish can yellow over time and can add an all-over gloss. If matte varnish is used, it can appear cloudy and can limit the luminosity of color. Ideally, varnish should be removed and freshly reapplied every forty years.

A traditional varnish is made from dammar resin and turpentine. It is applied with a varnish brush or sponge. A modern synthetic varnish can be sprayed for a thin application. An oil painting can be varnished with wax as well.

TECHNIQUE

Exercises

It can be so very simple to create an effectual oil painting. The Venetian Renaissance painters provided us with the language to create pictorial unity. The thin *imprimatura* layer can maintain a visible presence throughout the painting process to soften and blend the contrasts of warm and cool hues, and dark and light values, into a unified whole.

◄

Margaret Krug
By the Shining Big-Sea-Water
1999
Oil on wood
4 x 5 in (10.2 x 12.7 cm)
Collection of the artist

To initiate and maintain a unified pictorial effect, I applied a Naples yellow *imprimatura* layer over a gesso ground. I created a pale, polychromatic under-painting with dry pigments suspended in solutions of rabbit-skin glue (distemper). Then I applied oil paint in successive veil of warm, translucent dark colors and coo semiopaque light colors to create a subt interchange between warm and cool hu

Exercise 1

Build pictorial unity out of the contrasts of light and shadow, and the interchange of warm and cool hues.

Choose any subject and make a small black-and-white sketch to determine the light-to-dark value transition, and to define the broad, general composition. Prepare your canvas or wood panel with a gesso ground. To provide a hue bias (an all-over dominant color) and unified pictorial effect, apply an *imprimatura* layer. Refer to your sketch as you make a light *abbozzo*. Create a monochromatic or polychromatic underpainting, as described above. Let the painting surface dry for at least two days. While referring to your sketch and the scene, or whatever visual source you have chosen, begin to apply local colors by glazing with sheer dark colors over the underpainting to create warmth. Then, scumble with white or near-white semiopaque oil paint. Continue to apply veils of color evenly throughout the painting until you have a harmonious whole.

Exercise 2

Create a genre painting (a painting portraying a scene from everyday life) with a *doorsien* (Dutch for "view through," or a view that gives a sense of the world outside). A *doorsien* can be a view of an outdoor space or a view into another room.

For this exercise, choose an interior space with an opening, such as a door or window, onto an outdoor space. If you have the opportunity, notice how exterior material at a great distance from you can appear to be relatively cool. Notice from what direction the light is coming. Start by making a sketch to define the broad, general information of the scene, not the particular. Create an *abbozzo* on the prepared painting surface and continue the idea of the sketch into the painting by stating only the large, general areas. Complete an indirect or direct painting, as described above. When you are in the final stages of the painting, apply finishing touches to sharpen and define particular details.

▲
Giovanni Bellini
Nude Young Woman in Front of Mirror
1515
Oil on canvas
24 ¼ x 31 in (62 x 79 cm)
Riverdale-on-Hudson, Massachussetts

▲
Edward Hopper
Sun in an Empty Room
1963
Oil on canvas
29 ¼ x 40 in (74.2 x 101.6 cm)
Private Collection

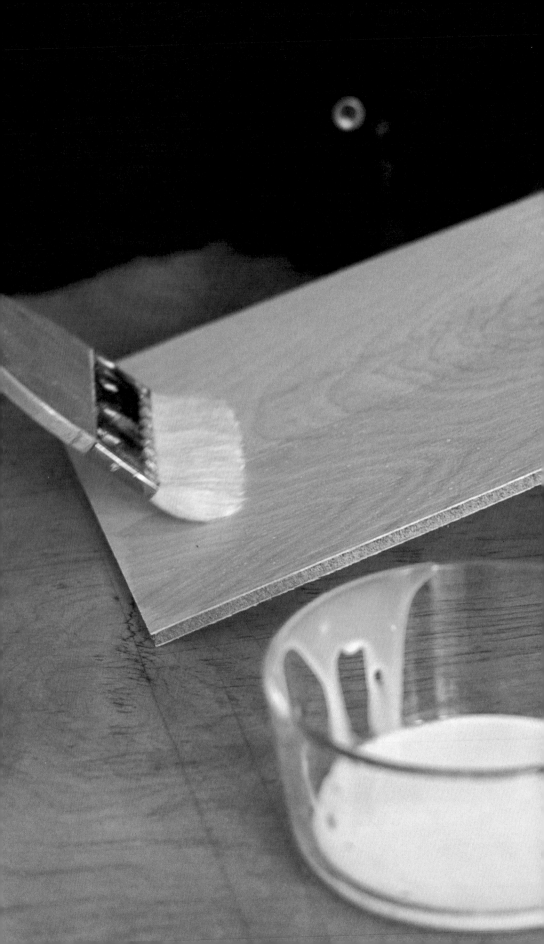

10
ACRYLIC PAINTING

HISTORICAL BACKGROUND

Acrylic resins became popular as artists' paints in the late 1940s. Synthetic paints such as commercial automobile and furniture enamels had been available earlier, and they were used experimentally by Pablo Picasso (1881–1973) and Jackson Pollock (1912–56). Some artists used house paints made from alkyd resins in the 1930s, but it was not until the 1970s that these became available as artists' paints.

Many contemporary artists use acrylic or alkyd paints because they are relatively easy to handle and can appear to be very similar to oil paints. Acrylics and alkyd resin paints do not have the combined rich and translucent nature of oils. They can appear brighter and lend themselves to the application of broad, flat planes of color. Acrylics may be a more suitable substitute to imitate, but not duplicate, the actual characteristics and appearance of tempera painting. It is a good idea to experiment with synthetic paints to determine the ways in which they will be most useful.

Some artists use interference pigments to produce a rich, lustrous surface quality when using acrylics. These pigments are thin transparent flakes, such as mica, coated with a microscopically thin film that has a higher refractive index than that of the flake. These coated flakes, known as platelets, will simultaneously reflect and transmit light. The gradual evolution from oil to acrylic follows the earlier transition from egg tempera to fresco to oil. Understanding historical art processes may lead to the conclusion that synthetic materials are better suited to contemporary artists' needs, and that they can imitate traditional media. Learning experientially will allow artists to integrate these painting systems organically into their unique working process, and to see for themselves that the present and future can grow out of the past. In the end, the materials of painting are pigments and binder applied to a surface.

In this chapter, I will focus on acrylic emulsion paints, as these are the most widely used by contemporary artists. I will refer to acrylic solution and alkyd resin paints in less detail.

Stevens

and Desire

5–7

lic on canvas

x 11 ft 10 in (2.1 x 3.6 m)

ate Collection

work was painted on unstretched
vas stapled to the wall, and on
asion taken off the wall and placed
he floor. Stevens works out her ideas
rocess, responding to the materials
hey in turn react to her movements.

Barbara Takenaga

Venetian Beads

2005

Acrylic on wood panel

24 x 20 in (61 x 50.8 cm)

McKenzie Fine Art, New York

Takenaga's process is slow, repetitive, and
systematic, employing a restricted number
of elements: lines, circles, and a radiating
symmetry. Using thin acrylic paint, she starts
from the center and works toward the edge,
filling the space with dots that change scale
and color. There is a sense of marking time
through accumulation.

Often seen as trippy cosmic explosions,
obsessive pattern paintings, or cartoon-like
scientific diagrams gone awry, the
paintings for Takenaga are about heaven,
sometimes using visual clichés and
sometimes a personal "re-visionism."
Her paintings are alternately elegiac,
evocative, and occasionally funny, with
a visual buzz and sensation.

Acrylic emulsion paints

Acrylic emulsion paints have an acrylic resin emulsified with water as a binder and thinner. Sometimes referred to as polymer colors or synthetic polymer (in museums), acrylic emulsion paints are the most popular synthetic media because of their ease of application and cleanup, nontoxic thinner, and surface flexibility. Also, unlike oil paint, the "fat over lean" rule does not need to be followed. Though the final surface can have a similar appearance to tempera or oil paint, depending on the manner with which the paints are applied, acrylic emulsion paints perform differently. When painted out, a thin film of translucent, milky-white liquid dries rapidly as the water evaporates and the resin forms into a porous, water-resistant, nonyellowing, continuous layer, which does not become brittle with age unless exposed to temperatures below 40°F (4.4°C). Acrylic paintings should not be transported in unheated trucks in cold weather because the paint film could crack. After the painting is completed, it takes a month for the surface to cure, so a painting should be handled carefully during that time or there could be cracking. The dried paint layers may not appear as clear as those produced by oil, acrylic solution or alkyd paints. The dried paint film is less translucent and less saturated.

To date, acrylics are unproven by the test of time, and little data has been collected for developing painting rules to ensure longevity. Since the paint layer becomes porous and will collect dirt, it should be varnished with acrylic solution varnish and not with any of the glossy or matte varnish mediums supplied for use as thinners or extenders. These mediums are just as porous as the paint films and they cannot be easily removed. An alternative to varnishing is to keep acrylic paintings in a portfolio. To clean an acrylic painting, wash with distilled water or vacuum with a portable canister vacuum cleaner. Some artists stain the painting surface with a painting solution consisting of a high ratio of water to binder in order to obtain sheer, dry veils of color. In this case, the painting should not be cleaned with water or varnished, either of which could destroy the surface qualities of the painting.

Each brand of acrylic paint has its own characteristics and may consist of a slightly different formula. When brands are used together, they may blister, bubble, or peel, because the different products may not produce a stable mixture or adhere to one another. Either use everything from the same brand or test before mixing them.

Acrylic solution paints

An acrylic resin dissolved in a solvent of mineral spirits is the binder for these paints; mineral spirits is the thinner. They perform in a similar way to oil paints, but they do not yellow and they are more brittle.

Alkyd resin paints

Less used than the acrylics, alkyd paints have an oil-modified alkyd resin as a binder. The thinner is mineral spirits or gum turpentine. Alkyd resin paints perform in a similar manner to oil paints, but they dry more quickly, usually overnight. Indirect painting in layers is possible without having to wait as long as with oil paint; direct wet-into-wet techniques can also be used. Alkyd paints maintain their flexibility and they do not yellow unless the modifying oil is linseed oil. They are usually modified with safflower, soybean, or tobacco seed oils. You can mix oil paints with alkyds to slow the drying time of alkyd paint, but then yellowing will occur.

ck Close

9

hetic polymer on canvas
x 7 ft (2.7 x 2.1 m)
tney Museum of American Art,
 York

ck Close used a grid format to transfer
iculously, with paint to canvas, each
from a corresponding grid on a
tographic image.

▲

Alan Shields
Little Blue Ferry (Bay-Belly)
1968–9
Thread and synthetic polymer on canvas
10 ft 7 in x 4 ft 10 ¼ in (322.6 x 148 cm)
Whitney Museum of American Art,
New York

Alan Shields combined stained acrylic color
with stitching on unsized, unstretched
cotton-duck canvas which had been
commercially dyed orange. The colors
were used in a similar way to watercolor,
creating rich, subtle tones with broken
colors by pouring, combining, and layering.

Outline of the technique
- Prepare the surface of the support: canvas or panel.
- (Optional) Lay down an *imprimatura*: a thin layer or veil of color made
with acrylic emulsion diluted with distilled water and color concentrate.
- (Optional) Create a sketch directly on the canvas or panel.
- *Grisaille* (monochromatic underpainting) or polychromatic underpainting.
- Paint indirectly using glazing and scumbling, or directly, wet-into-wet, on
canvas or panel.

SUPPORTS AND GROUND

What you will need:
Wood panel or stretched canvas
Acrylic emulsion
Soft, wide, flat varnish brush
Acrylic emulsion "gesso"
Fine sandpaper

Acrylic emulsion paints will adhere to almost any stable surface such as a rigid panel or stretched canvas (see Chapter 4) and stretched paper supports (see Chapter 5), as long as it is clean, non-greasy, and has a surface key (surface porosity to receive the paint).

Acrylic will not injure the painting support, but to reduce absorbency and ensure that the paint will not sink into the surface, size with acrylic emulsion (using a varnish brush), diluted with approximately thirty to fifty percent water for wood panels, canvas, and paper. Do not size with rabbit-skin glue because acrylic does not adhere to the support with rabbit-skin glue in between. Size both sides of an uncradled wood support to prevent warping, then let the support dry for three to six hours.

Acrylic painting does not require a ground because it has enough adhesive to stick to the surface without it. However, a ground should be applied to provide a white surface for the colors to respond to and absorb into. Acrylic emulsion "gesso" primer—referred to as "gesso" because chalk is usually added as in *gesso sottile*—should be used as a ground and applied full strength. Apply two or three coats with the same varnish brush. For an uncradled wood surface, an equal number of coats should be applied to each side. To obtain a very smooth surface, lightly sand each dry coat of acrylic emulsion "gesso." Thoroughly rinse brushes with water between coats and after the gesso application has been completed.

Acrylic emulsion grounds and paints should not be applied over oil-painted surfaces, because the bond may not be stable. In reverse, oil paint applied to the more elastic acrylic paint can cause the oil paint to crack.

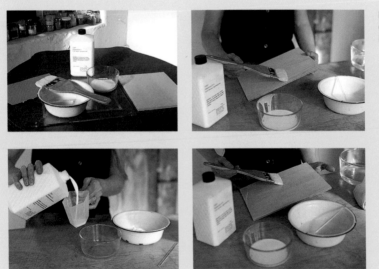

Far left: Support and ground setup.
Left: Applying size.

Far left: Preparing ground.
Left: Applying acrylic emulsion "gesso" ground.

PIGMENTS AND BINDER

What you will need:
Acrylic emulsion binder: Kremer K9 acrylic dispersion
Distilled water
Dry pigments or color concentrates
Palette knife
Glass palette with sand-blasted surface (see Chapter 5, p. 121)
Glass muller
Glass spoons and wands
Small glass jars with lids
Dispersion aid: Orotan 850 (for acrylic)

A suggested color palette includes: reds (quinacridone reds, cadmium reds, napthol reds, iron oxide reds); oranges (cadmium orange); yellows (cadmium yellows, Hansa yellows, iron oxide yellows); greens (phthalocyanine green, chromium oxide opaque); blues (phthalocyanine blue, ultramarine blue, cerulean blue, cobalt blue); purples (quinacridone violets); blacks (ivory black, Mars black, iron oxide black); and whites (titanium white and zinc white).

Pigments should be purchased in the form of color concentrates, which are pigments ground into a paste in water. Dry pigments can be difficult to grind into the acrylic emulsion binder without having been previously ground into a paste with water and a dispersion aid, such as Orotan, if necessary. Some pigments are unruly and benefit by the addition of a drop or two of a dispersion aid as you grind them into a paste with water. You can prepare these pigment pastes yourself ahead of time and keep them on hand in lidded jars (see Chapter 7, p. 162, for instructions on the preparation of pigment pastes).

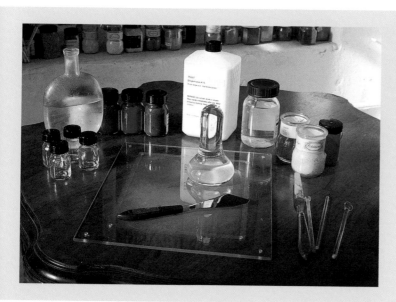

Preparing acrylic emulsion paints

Acrylic paints are easy to prepare. Grind prepared pigment pastes and acrylic emulsion binder in the same manner as you would pigments and oil to make oil paint (see Chapter 9). The process goes much more quickly and the paint must be put into a jar with a lid immediately, or the water will evaporate. As a reminder, when you first begin to make your own paint, always start by making small quantities. Manipulating large quantities of materials can be challenging and frustrating when you begin, especially with acrylic, as the water content evaporates quickly.

Acrylic emulsion paint recipe
- One part color concentrate or pigment paste.
- Half to one-and-a-half parts of acrylic emulsion binder (Kremer K9 acrylic dispersion); use less for a flat effect and more for a gloss effect.
- Add water as necessary.

An alternative to making your own paint is to purchase a high-quality, ready-made product, such as Golden acrylic emulsion paints.

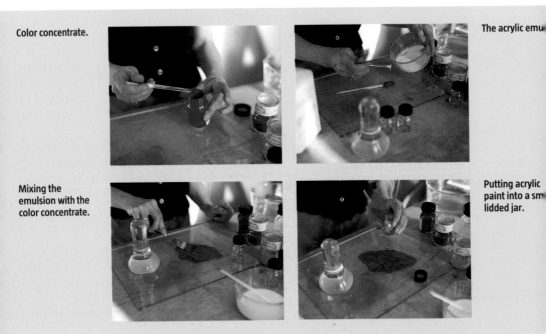

Color concentrate.

The acrylic emu

Mixing the emulsion with the color concentrate.

Putting acrylic paint into a sm lidded jar.

METHOD

What you will need:
A large, soft varnish brush
Bristle brushes
Hair brushes such as sable, fitch, or squirrel
Synthetic brushes
Soft cotton rags
Palette knife
Painting knife
Glass palette
Palette scraper
Glass jars
Olive oil soap

Tools and brushes

Tools and brushes are the same as those used for oil painting, but they must be cleaned immediately after use. If paint is allowed to dry on your brush, it is almost impossible to remove. Keep brushes in a bath of water during a painting session. Do not let them stand in a glass of water, as this could permanently bend the bristles, rendering the brushes useless. Synthetic brushes hold their shape and do not become soft and limp when soaked in water as natural bristle brushes do. Wash all brushes with olive oil soap at the end of your working session.

Far left:
Preparing
imprimatura—
pigment and acrylic
emulsion diluted
with distilled
water.

Left:
Applying
imprimatura.

On a surface prepared with sizing and ground, begin to apply the paint layer with a preliminary underpainting, such as *imprimatura*, monochromatic *grisaille* painting, or polychromatic underpainting (see Chapter 9, page 220). An *imprimatura* can be prepared by using a color concentrate mixed sparingly with an acrylic emulsion binder, such as Kremer K9 acrylic dispersion, and water as needed. You may want to transfer a cartoon or create a sketch with chalk, charcoal, or loose paint directly on the prepared surface.

To build the forms and details in local color, there are two techniques: indirect and direct painting. The two techniques may be used in a single work.

Mark Innerst
Beacon
2000
Acrylic on board
20 ½ x 24 ¾ in (52.1 x 62.9 cm)
Paul Kasmin Gallery, New York

Mark Innerst has explored a broad range of subject matter, but his method of production remains consistent. Innerst begins with photographs or multiple drawings to create an image that he transfers to the painting surface. First, he applies a saturated red underpainting. Then he builds up and blocks out the composition with alternate layers of luminous brushstrokes on pools of paint in oil, acrylic, and varnish.

Indirect painting

Indirect painting consists of building local color using a systematic interchange, layering warm transparent glazes and cool white or near-white semiopaque glazes. Paint can be diluted with water and/or gloss or matte medium for thin veils of color, and applied thickly or thickened with gel medium to create areas of semiopaque impasto: thick, heavy brushwork or crisp, delicate textures on smoother paint surfaces. Impasto works well with acrylic emulsion paints as the paint film is more flexible, so thick layers will not crack like oil paint. It is possible to over-thin with water so that the paint lacks enough binder to hold the pigment. Mix gloss or matte medium into the paint to facilitate adhesion of a thinned-out color to the painting surface.

Terre pozzuoli has been applied over yellow in the sky area. Land forms being underpainted with burnt umber.

Land forms have been underpainted with burnt umber. Manganese blue mixed with white is glazed over the *terre pozzuoli* over yellow for the sky area.

Reinforcing land forms by applying *terre verte* over burnt umber.

When painting in layers, an acrylic painting can be created in a similar manner to an oil painting. However, it will happen much more quickly, as an acrylic paint film can dry to the touch almost immediately, depending upon the amount of water or medium added. Colors will combine optically as subsequent layers of color are applied. An indirect acrylic painting can be completed in one session, while an indirect oil painting may take many weeks or even months to complete.

Direct painting

When the *alla prima,* or direct painting, technique, is employed with acrylic paint, brushstrokes set quickly. Paints can be applied wet-into-wet. A light spray mist of water to the painting surface or the addition of a retarder to the paint will extend the drying time. With the addition of a gel medium, you can enhance painterly brushwork and allow for greater degrees of impasto. You can use a large brush or rag to block out large areas of color and a smaller brush or a stick to define more precise passages quickly.

Varnish

Wait for at least one month for an acrylic painting to cure. Clean thoroughly with distilled water and a soft cotton cloth. Let it dry thoroughly. Apply acrylic solution varnish (Golden's MS/UVLS: a mineral spirits soluble varnish) with a soft, lint-free varnish brush, according to the manufacturer's instructions.

application of white mixed with blue is
gling wet-into-wet with land forms
 have had an additional underpainting
ndigo and Indian yellow to produce a
m green.

Wet-into-wet reinforcement of land forms.

After more reinforcement of the land forms, indigo is quickly added wet-into-wet to the sky area to mingle and bleed into the land forms.

TECHNIQUE

Exercises

Exercise 1

Now that you have gone through this text, try experimenting with combining media to create a work that may be identified as a drawing with painterly inflections, or that may be identified by its materials as a painting that is mostly drawn. You may want to draw on a stretched canvas or paint on paper.

▲

Julie Mehretu
Seven Acts of Mercy
2004
Ink and synthetic polymer on canvas
9 ft 6 in x 21 ft (2.8 x 6.4 m)
The Dennis and Debra Scholl Collection, Miami

Julie Mehretu creates small drawings on polyester film, vellum, or paper which elaborate on specific focal points of one idea, such as the wind's crosscurrents or the atmosphere's nebulous explosions. Bits of the small drawings are layered together in her large paintings. She sketches her imagery, then projects, enlarges, stencils, or copies her drawings onto the canvas. She then applies a synthetic polymer and silica mixture over the surface of the canvas. On this smooth, transparent layer she adds another complex layer, using the same small drawings for source material, which create a dense composition with distinct strata, telling different pieces of a story.

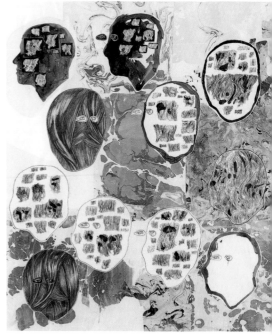

Exercise 2

Experiment with imitating one of the tempera techniques explained in Chapter 6. Apply acrylic emulsion sizing and acrylic "gesso" ground to a wooden panel as instructed on page 240 of this chapter. Proceed with the steps explained for the exercises of one of the tempera techniques in Chapter 7, using acrylic emulsion instead of egg tempera, casein, or distemper.

Exercise 3

Experiment with imitating one of the oil painting techniques explained in Chapter 9. Apply acrylic sizing and acrylic emulsion "gesso" to a stretched canvas. Proceed with the steps explained in Chapter 9 using acrylic emulsion paint instead of oil.

▲

ter
__itled__
■6
✓lic ink, graphite, gesso, and hand-
▪ted marbleized paper on paper
✓₈ x 42 ⅜ in (121 x 107.6 cm)
tney Museum of American Art,
✓ York

ter has combined drawing and painting
terials and processes to create a work
t is identified as a painting.

Jay DeFeo
Crescent Bridge I
1970–2
Acrylic and mixed media on plywood
4 ft x 5 ft 6 ½ in (121.92 x 168.9 cm)
Whitney Museum of American Art,
New York

DeFeo transformed photographs of her dental bridge, which contained two of her own teeth and two dentures, by tearing, cutting, and reassembling the pieces into a photo collage she used as a study for the painting. Employing illusionistic perspective, she painted volumetric forms with a smooth enamel surface in deep shadow and light. Contrasting shiny passages with matte surfaces, she achieved a tactile quality in low relief. She found that the pearliness and translucency of the character of the object it represented (teeth) could be emulated in the medium. She physically manipulated the painted forms in relief by scoring and chipping away to create a sense of materiality. DeFeo described her painting process: "It's trial and error, laying and layering, and, like my life, it's additive and subtractive, a constructive and destructive process—and so it was with *Crescent Bridge*."[19]

Glossary

Abbozzo: Sketch or pale drawing applied as a guide to the final painting.

Acrylic emulsion paint: Also referred to as polymer colors, or synthetic polymer, this water-based paint is currently the most popular synthetic media.

Acrylic solution paint: This acrylic resin-based paint performs in a similar way to **oil** paints, but does not yellow and is more brittle.

Aerial perspective: Usually regarded as an adjunct to **linear perspective,** an illusion of recession is achieved by the depiction of atmospheric effects.

Alkyd resin paint: These have as their base an oil-modified alkyd resin and perform in a similar manner to **oil** paints, but dry more quickly.

Arenato: The sand coat in **fresco** painting (comprising fine sand and lime putty).

Arriccio: Preliminary plaster layer spread on the masonry in **fresco** painting (comprising coarse sand and lime putty).

Assemblage: Three-dimensional work of art created by combining elements such as found objects and/or elements produced by the artist.

Atmospheric perspective *see* **Aerial perspective**

Awl: Pointed instrument for making small holes.

Binder: Also referred to as **vehicles**, they hold the **pigments** and fix them to a **support**.

Body color *see* Gouache

Broken colors: Produced by **optical mixtures**, they can be created by letting warm and cool hues flow together on the painting surface.

Calligraphic line: Free-flowing continuous movement resembling handwriting.

Capillary action: In **fresco**, the action by which pigments are absorbed into the wet lime plaster, becoming part of the surface.

Capriccio: A landscape in which identifiable monuments and sites have been rearranged according to the artist's imagination.

Cartoon: Full-sized, detailed drawing on paper, used in the transfer of a design to a painting.

Casein tempera: Water-resistant tempera derived from the dried curds of skimmed milk dissolved in distilled water, with the addition of a small amount of borax as an emulsifier.

Charcoal: Produced as sticks that come in various degrees of hardness and thickness.

Collage: A two-dimensional pictorial composition of paper, fabrics, and other materials glued onto a surface.

Color: In this book, color is discussed in terms of **tone** (created by varying the color's light and dark quality), **tints** (light tones created by adding white or water), **shades** (dark tones created by adding black), **hue** (the quality by which one color is distinguished from another, such as red from yellow), **value** (gradation of tone from light to dark, no matter what the color), **intensity** (quality by which a strong color is distinguished from a weaker one—the brightness, strength, or purity of a color).

Colored pencil: Lightfast pigments encased in wood. Pastel pencils, unlike **pastels**, can be sharpened.

Contour line: The line following the outer edge of forms to describe volume.

Crayon: Any drawing medium in stick form within the fine arts.

Cross contour line: Similar to a **contour**, but goes across forms to describe volume.

Cross-hatching *see* Hatching

Dammar resin: Traditionally used in **varnish**.

Deckle edges: Rough, unfinished edges left by the metal frame, or deckle, of a pulp mold when making handmade paper.

Direct painting: Also known as *alla prima* or "wet into wet," this involves no preliminary drawing and the painting is begun and completed in one painting session.

Disperse aid: Also known as a **wetting agent**, it is used to tame dry pigments that resist being combined with a binder. **Oxgall** is used for **egg tempera, casein, distemper, fresco, oil,** and **watercolor**. **Oraton** is used for **acrylic**.

Distemper: Made with dry pigments dispersed in warm animal glue. While in use, it must be kept warm.

Drawing: The act of creating a mark on paper.

Drying oils: The binders for pigments in **oil** painting.

Egg tempera: Made by combining pure pigments with egg yolk.

Encaustic painting: Dry pigments mixed with molten wax, applied to a support, and fused with a heat source.

Encausticate: To apply a layer of wax onto the painting surface.

Etched line: Created by using a sharp instrument to press into the drawing surface.

Ferrule: Cylindrical device at the end of a paintbrush handle that holds the hairs.

Fresco: True fresco (*buon* fresco) involves applying raw pigments directly *into* rather than *onto* damp plaster. *A secco* fresco is painting onto the dry plaster layer.

Frottage: The action of laying paper over a textured surface and rubbing it with a crayon to make a printed impression on the paper.

Gesso: Solution of chalk or gypsum and rabbit-skin glue and/or other binding materials, which is applied onto a surface (such as canvas or wood) to provide a receptive, even surface for the paint layer. **Gesso sottile** (true gesso) or glue gesso: rabbit-skin glue solution combined with chalk or gypsum. **Half-chalk gesso** (also known as emulsion ground): solution of true gesso with sun-thickened linseed oil or linseed stand oil added for flexibility. **Acrylic gesso**: chalk or gypsum combined with acrylic emulsion. **Casein gesso**: chalk or gypsum combined with casein solution.

Gesture line: The rendering of the general characteristics of the subject—its mass, movement, weight, and shape.

Glass muller: Flat-bottomed instrument used since antiquity for grinding paints by hand.

Glazing: Generally used in **oil** and **acrylic** painting, it is the application of a thin layer of transparent color over another to create warmth and luminosity.

Gouache: Opaque watercolor sometimes referred to as **body color**; it is made by mixing the color pigments of watercolor with white.

Graphite: Crystallized form of carbon, either encased in wood (as a pencil) or produced as sticks, crayons, or powder.

Grisaille: **Underpainting** executed in shades of gray, and usually used for **oil painting**.

Ground: The initial layers (usually including **sizing**) applied to the support as the receptive surface for the paint layer.

Gum arabic: Water-soluble gum that is the most transparent of all the painting binders.

Hatching and cross-hatching: Hatching employs fine, closely set parallel lines to create tonal variations. Cross-hatching is a series of drawn lines crossing the first at an angle.

Hue *see* Color

Impasto: The texture created by the movement of the brush—often used in reference to thick, heavy brushwork.

Implied and blurred lines: Broken, smudged, blurred, or erased lines.

Imprimatura: Translucent layer of pigment in a binder which is applied to a **gesso** ground.

Incised line *see* Etched line

Incising: Following the lines of an image with a stylus or any pointed instrument to make an indentation on the surface.

India ink: Aso known as **shellac ink**, it is made of carbon-black pigment ground in water with shellac, the latter making them water-resistant.

Indirect painting: The building-up of **local color** by layering warm, dark, transparent glazes and cool white or near-white glazes (referred to as **scumbling**).

Ink water drawing: The application of an ink and-water mixture to a transferred or drawn image to make it permanent.

Installation: A work of art made for a specific site and intended to surround the viewer.

Intensity *see* Color

Intonaco: The final smooth plaster layer into which the finished **fresco** painting is executed.

Iron-gall ink: Ink that is almost black when first applied, but turns brown with age.

Laid paper: Paper with pattern of the wire mesh in the paper tray.

Lead pencil: Pencil made of **graphite** and clay encased in wood.

Linear perspective: Represented objects appear to recede in space by being drawn progressively smaller and closer together towards a horizon.

Linseed oil: Commonly used **drying oil** in **oil** painting.

Local color: The true color of an object or scene in ordinary daylight.

Oil painting: Pigments are ground in oil, and then applied to a primed canvas.

Oil painting medium: Mixture used in **glazing** provides a rich, crystalline quality.

Optical color mixture: Created by using overlays of color to create another—a layer of blue over red produces violet.

Oraton *see* Disperse aid

Oxgall *see* Disperse aid

Paint: Defined simply as pigment combined with a binding medium to hold the pigment and fix it to a support.

Paper: Felted mass of interlaced plant fibers. In sheet form it is the most common support for **drawing** and **watercolor** painting.

Pastel: Crayon composed of pigments and very little binder—usually gum tragacanth.

Pencil: The common lead pencil is made of graphite and clay encased in wood. Pencils with more pure graphite are softer and produce a darker mark. Pencils can also be charcoal, conté, colored, litho, and pastel.

Pigment: Color in a finely powdered state.

Pigment paste: Pigment combined with distilled water and mixed to a stiff consistency.

Pouncing: Used in **fresco** painting. A small bag filled with pigment is tapped over a **cartoon** with small holes punctured along its lines in order to duplicate a design onto the wall or panel.

Pouncing wheel: Small wheel device made to run along a design of a **cartoon** in order to perforate the lines.

Quadrettatura: Small drawing divided into a grid, and enlarged in proportion to the full-scale size of a cartoon.

Rag paper: Strong, acid-free paper made from old cotton and linen cloth.

Rubbing *see* Frottage

Scumbling: A light opaque tone, usually white or near-white, painted over a darker one to achieve a relatively cool pearlescent effect.

pia ink: Made from cuttlefish or squid ink, the
e can range from black to yellow-brown.

ade see **Color**

ape and volume: Shape and volume
resent height, width, and depth of a form.

ellac ink see **India ink**.

houette: Portrait, design, or image in profile
a single hue.

verpoint: Drawing using a piece of silver wire
erted into a mechanical pencil or silverpoint
lder; it leaves a faint gray line that darkens as
arnishes.

opia: A full-scale sketch with earth-red
ment on fresh plaster, made as the artist's
eliminary guide for a **fresco** painting.

ing: A very dilute solution of glue or resin
ually applied as the first layer to a painting
face to reduce its absorbency or porosity.

etch: Spontaneous preliminary drawing
painting.

m coat: A preliminary thin coat of mortar
xture to make the panel or wall receptive to
plaster layers required for **fresco.**

atial illusion: Line (**linear perspective**) or tone
mospheric perspective) indicating the
pression of three-dimensionality and depth on
at surface.

olvero see **Transfer**

uaring: To facilitate the transfer of an image,
ansfer is ruled off in squares and transferred
a surface that has the same number of ruled-
squares.

Stippling: Small dots of color.

Study: Detailed preliminary drawing for working
out ideas and methods for a finished piece.

Stumping: Blending and smudging charcoal,
pencil, pastel, or crayon with a **tortillon**.

Stylus: Pointed, pencil-shaped instrument.

Sumi ink: Similar to **india ink**, a term for Chinese
or Japanese ink dried and molded into sticks.

Support: The structure (e.g., paper, wooden
panel, or canvas) on which a drawing or painting
is made.

Texture: There are three types of texture: the
actual texture of the materials, such as that
produced by conté crayon on paper; represented
texture, which imitates the texture of the
subject; transferred texture, which is produced by
frottage.

Thumbnail sketch: Small, concise drawing
(usually a 1-inch [2.5 cm] square) representing
the main features of an object or scene.

Tone see **Color**

Tortillon: Tightly-rolled stump of paper for
blending marks made by graphite, charcoal,
crayon, and pastel.

Transfer: Secondary **cartoon**, known as a
spolvero, created to preserve the original cartoon
from which it is traced and then used to transfer
to the painting surface.

Trulisatio: One of the mortar layers in **fresco**
painting, this is the first coat—the rough coat,
which is made of crushed brick, crushed unglazed

clay tile, or marble meal combined with a small
amount of lime putty.

Underpainting: Painting layer (such as
imprimatura and **grisaille**) that establishes the
value structure and serves as a guide for building
up the composition of a work.

Value see **Color**

Varnish: Protective layer usually used in **oil** and
acrylic paintings that provides a uniform surface
and modifies the appearance of the
paint layer.

Vehicle see **Binder**

Verdaccio: Monochromatic **underpainting** used
in traditional **egg tempera** and **fresco** painting
for outlining and modeling.

Volume see **Shape and Volume**

Viewfinder: Made by cutting a small opening,
usually 1 inch (2.5 cm) square, into a card. It is
used to frame and isolate the forms to be drawn
or painted.

Wash: Liquid composed of water, in which color
brushed from cakes of pigment or liquid color is
suspended and distributed evenly across a
surface. It is used in **watercolor**, **acrylic**, and
other liquid painting media.

Watercolor: Named for its diluent—water—
instead of its binding medium, gum arabic.

Wetting agent see **Disperse aid**

Wove paper: Paper formed on a tightly woven
mesh tray that has left no visible marks.

ther Reading

wing and Seeing

ers, Josef. *Interaction of Color*, 2 vols., revised
and expanded edition. New Haven,
Connecticut and London: Yale University
Press, 2006.

heim, Rudolf. *Art and Visual Perception: A
Psychology of the Creative Eye*, revised and
expanded edition. Berkeley: University of
California Press, 2004.

ton, Dore. *Twentieth-Century Artists on Art*.
New York: Pantheon Books, 1985.

helard, Gaston. *The Poetics of Space*.
Translated by Maria Jolas. Boston: Beacon
Press, 1994.

asch, Moshe. *Giotto and the Language of
Gesture*. Cambridge and New York:
Cambridge University Press, 1987.

esch, Otto. *The Drawings of Rembrandt*, 6
ols., 2nd edition. Edited by Eva Benesch.
ondon: Phaidon, 1973.

ger, John. *Selected Essays and Articles: The
ook of Things*. Harmondsworth and New
ork: Penguin, 1972.

—. *The White Bird: Writings*. Edited by Lloyd
pencer. London: Chatto and Windus, 1985.

s *The Sense of Sight: Writings*. New York:
Pantheon Books, 1985.

ram, Anthony. *One Thousand Years of
Drawing*. New York: E.P. Dutton, 1966.

, Claudia, and Teel Sale. *Drawing: A
ontemporary Approach*, 5th edition.
elmont, California: Wadsworth, 2004.

gman, George B. *Constructive Anatomy*. New
ork: Dover, 1973.

ino, Italo. "Visibility," in *Six Memos for the
Next Millennium*. Cambridge, Massachusetts:
Harvard University Press, 1988.

mings, Paul. *Twentieth-Century American
rawings: The Figure in Context*. Washington,
.C.: International Exhibitions Foundation,
984.

Edwards, Betty. *The New Drawing on the Right
Side of the Brain*. New York: Putnam, 1999.

Elkins, James. *The Object Stares Back: On the
Nature of Seeing*. New York: Simon and
Schuster, 1996.

Foçillon, Henri. *The Life of Forms in Art*, reprint.
Translated by Charles Beecher Hogan and
George Kubler. New York: Zone Books, 1992.

Goldman, Paul. *Looking at Prints, Drawings and
Watercolours*. Malibu, California: J. Paul
Getty Museum, 1988.

Green, Eleanor. *John Graham Drawings*. New
York: André Emmerich Gallery, 1985.

Grabar, Oleg. *The Formation of Islamic Art*,
revised edition. New Haven, Connecticut and
London: Yale University Press, 1987.

Hale, Robert Beverly. *Drawing Lessons from the
Great Masters*, reprint. New York: Watson-
Guptill, 1989.

Hancock, Jane, and Stefanie Poley (eds.). *Arp*.
Stuttgart: Gerd Hatje, 1986.

Hunter, Dard. *Papermaking: The History and
Technique of an Ancient Craft*, reprint. New
York: Dover, 1978.

Ivins, Jr., W. M. *How Prints Look: Photographs
with a Commentary*. Revised and expanded by
Marjorie B. Cohn. Boston: Beacon Press,
1987.

Kahlo, Frida. *The Diary of Frida Kahlo: An Intimate
Self-portrait*. With an introduction by Carlos
Fuentes. New York: Harry N. Abrams, 1995.

Kertess, Klaus. *Willem de Kooning: Drawing
Seeing/Seeing Drawing*. Santa Fe, New
Mexico: Arena Editions, 1998.

Knobler, Nathan. *The Visual Dialogue: An
Introduction to the Appreciation of Art*, 3rd
edition. New York: Holt, Rinehart, and
Winston, 1980.

Kosinski, Dorothy. *The Artist and the Camera:
Degas to Picasso*. Dallas: Dallas Museum of
Art, 1999.

Lippard, Lucy. *Eva Hesse*. New York: New York
University Press, 1976.

Marks, Claude. *From the Sketchbooks of the Great
Artists*. New York: Thomas Y. Crowell, 1972.

Martin, Agnes. *Writings*. Edited by Dieter
Schwarz. Stuttgart: Cantz, 1992.

Mendelowitz, Daniel M. *A Guide to Drawing*, 5th
edition. Fort Worth, Texas: Harcourt Brace
Jovanovich, 1993.

Munsell, Albert H. *A Color Notation: An Illustrated
System Defining All Colors and Their Relations
by Measured Scales of Hue, Value, and
Chroma*, 2 vols., reprint. With an introduction
by Royal B. Farnum. Whitefish, Montana:
Kessinger, 2004.

Nicolaides, Kimon. *The Natural Way to Draw: A
Working Plan for Art Study*, reprint. Boston:
Houghton Mifflin, 1975.

O'Keeffe, Georgia. *Some Memories of Drawings*.
Edited by Doris Bry. Albuquerque: University
of New Mexico Press, 1974.

Ruskin, John. *The Elements of Drawing: In Three
Letters to Beginners*, reprint. With an
introduction by Lawrence Campbell. New
York: Dover, 1971.

———. *The Laws of Fésole: A Familiar Treatise on
the Elementary Principles and Practice of
Drawing and Painting, as Determined by the
Tuscan Masters*, reprint. New York: Allworth
Press, 1996.

Simmons III, Seymour, and Marc S.A. Winer.
Drawing: The Creative Process. Englewood
Cliffs, New Jersey: Prentice Hall, 1977.

Stiles, Kristine, and Peter Selz. *Theories and
Documents of Contemporary Art: A
Sourcebook of Artist's Writings*. Berkeley:
University of California Press, 1996.

Sturken, Marita, and Lisa Cartwright. *Practices of
Looking: An Introduction to Visual Culture*.
Oxford and New York: Oxford University
Press, 2001.

Tannenbaum, Judith. *Vija Celmins*. Philadelphia:
Institute of Contemporary Art, 1992.

Turner, Jane. "Drawing," in *The Dictionary of Art*,
Volume 9. New York: Grove, 1996.

Turner, Silvie, and Birgit Skiöld. *Handmade Paper Today: A Worldwide Survey of Mills, Papers, Techniques and Uses*. New York: Frederic C. Beil, 1983.

Watrous, James. *The Craft of Old-Master Drawings*, reprint. Madison: University of Wisconsin Press, 2002.

Weschler, Lawrence. "Vanishing Point: David Hockney's Long and Winding Road," *Harpers Magazine* (June 2005).

Zegher, Catherine de, and Hendel Teicher (eds.). *3 X Abstraction: New Methods of Drawing—Hilma Af Klint, Emma Kunz, Agnes Martin*. New Haven, Connecticut and London: Yale University Press, 2005.

Zöllner, Frank (ed.). *Leonardo da Vinci, 1452–1519: The Complete Paintings and Drawings*. Cologne: Taschen, 2003.

Painting

Anderson, Maxwell L. *Pompeian Frescoes in The Metropolitan Museum of Art*. New York: Metropolitan Museum of Art, 1987.

Anfam, David. *Franz Kline: Black & White 1950–1961*. Houston, Texas: Houston Fine Arts Press, 1994.

Baxandall, Michael. *Painting and Experience in Fifteenth-Century Italy: A Primer in the Social History of Pictorial Style*, 2nd edition. Oxford: Oxford University Press, 1972.

Bell, Julian. *What is Painting? Representation and Moden Art*. London and New York: Thames and Hudson, 1999.

Bockemühl, Michael. *J.M.W. Turner, 1775–1851: The World of Light and Colour*. Cologne: Taschen, 1993.

Bristow, William A. "True Gesso and Other Truths," *Art & Academe*, Volume 1/1 (Fall 1988).

Brown, Hilton, Richard Newman, and Richard J. Boyle (eds.). *Milk and Eggs: The American Revival of Tempera Painting, 1930–1950*. Chadds Ford, Pennsylvania: Brandywine River Museum, 2002.

Brown, Jonathan, and Carmen Garrido. *Velázquez: The Technique of Genius*. New Haven, Connecticut and London: Yale University Press, 1998.

Canaday, John. *Techniques*, in Metropolitan Seminars in Art series, Portfolio 8. New York: Metropolitan Museum of Art, 1958.

Carr, Dawson W., and Mark Leonard. *Looking at Paintings: A Guide to Technical Terms*. Malibu, California: J. Paul Getty Museum, 1992.

Cennini, Cennino, *The Craftsman's Handbook: The Italian "Il Libro dell'Arte,"* reprint. Translated by Daniel V. Thompson, Jr. New York: Dover, 1960.

Colalucci, Giancuigi. "Fresco," in *The Dictionary of Art*, Volume 11. New York: Grove, 1996.

Delamare, François, and Bernard Guineau. *Colors: The Story of Dyes and Pigments*. New York: Harry N. Abrams, 2000.

Doerner, Max. *The Materials of the Artist and Their Use in Painting, with Notes on Techniques of the Old Masters*, reprint. Translated by Eugen Neuhaus. New York: Harcourt Brace, 1984.

Doxiadis, Euphrosyne. *The Mysterious Fayum Portraits: Faces from Ancient Egypt*, reprint. New York: Harry N. Abrams, 2000.

Dunkerton, Jill, *et al. Giotto to Dürer: Early Renaissance Painting in the National Gallery*. New Haven, Connecticut and London: Yale University Press, 1991.

Eastlake, Charles Lock. *Methods and Materials of Painting of the Great Schools and Masters*, 2 vols. New York: Dover, 1960.

Elkins, James. *What Painting Is: How to Think about Oil Painting using the Language of Alchemy*. New York and London: Routledge, 1999.

Finch, Elizabeth, and Anastasia Aukeman (eds.). *Rajasthani Miniatures: The Welch Collection from the Arthur M. Sackler Museum*. New York: The Drawing Center, 1997.

Gottsegen, Mark David. *The Painter's Handbook*, revised and expanded edition. New York: Watson-Guptill, 2006.

Green, Jane, and Leah Levy (eds.). *Jay DeFeo and "The Rose."* With a foreword by Marla Prather. New York: Whitney Museum of American Art, 2003.

Groenewegen-Frankfort, H.A., and Bernard Ashmole. *Art of the Ancient World*. Englewood Cliffs, New Jersey: Prentice Hall, 1972.

Guptill, Arthur L. *Watercolor Painting, Step-by-Step*, 2nd edition. Edited by Susan F. Meyer. New York: Watson-Guptill, 1967.

Haskell, Barbara. *The American Century: Art & Cutlure 1900–1950*. New York: Whitney Museum of American Art in association with W.W. Norton, 1999.

Higgins, Reynold. *Minoan and Mycenaean Art*, revised edition. New York: Frederick A. Praeger, 1997.

Hills, Paul. *The Light of Early Italian Painting*. New Haven, Connecticut and London: Yale University Press, 1987.

———. *Venetian Colour: Marble, Mosaic, Painting and Glass, 1250–1550*. New Haven, Connecticut and London: Yale University Press, 1999.

Homer, William Innes, and Lloyd Goodrich. *Albert Pinkham Ryder, Painter of Dreams*. New York: Harry N. Abrams, 1989.

Honour, Hugh, and John Fleming. *The World History of Art*, 7th edition. London: Laurence King, 2005. As *The Visual Arts: A History*. Upper Saddle River, New Jersey: Prentice Hall, 2005.

Hyman, Timothy. *Sienese Painting: The Art of a City Republic*. London and New York: Thames and Hudson, 2003.

Januszczak, Waldemar. *The Techniques of the Great Masters of Art*. Secaucus, New Jersey: Chartwell Books, 1985.

Kahane, P.P. *Ancient and Classical Art*. Translated by Robert Erich Wolf. New York: Dell, 1967.

Kemp, Martin (ed.). *Leonardo on Painting: An Anthology of Writing*. New Haven, Connecticut and London: Yale University Press, 1989.

Kirsch, Andrea, and Rustin S. Levenson. *Seeing Through Paintings: Physical Examination of Art Historical Studies*. New Haven, Connecticut and London: Yale University Press, 2000.

Klepac, Lou. *Giorgio Morandi: The Dimension of Inner Space*. Sydney: Art Gallery of New South Wales, 1997.

Laurie, A.P. *The Painter's Methods and Materials*, reprint. New York: Dover, 1967.

Levey, Michael. *From Giotto to Cézanne: A Concise History of Painting*, reprint. London and New York: Thames and Hudson, 2000.

Levin, Gail. *Synchromism and American Color Abstraction 1910–1925*. New York: Whitney Museum of American Art, 1978.

Lloyd, Christopher. *Fra Angelico*. London: Phaidon, 1993.

Massey, Robert. *Formulas for Painters*. New York: Watson-Guptill, 1967.

Mattera, Joanne. *The Art of Encaustic Painting: Contemporary Expression in the Ancient Medium of Pigmented Wax*. New York: Watson-Guptill, 2001.

Mayer, Ralph. *The Harper Collins Dictionary Art Terms & Techniques*. Revised by Stevan Sheehan. New York: Harper Collins, 1991.

Meiss, Millard. *The Great Age of Fresco: Giotto t Pontormo*. New York: Brazillier, 1970.

Nordmark, Olle. *Fresco Painting: Modern Methods and Techniques for Painting in Fres and Secco*. New York: American Artists Grou 1947.

Pearce, Emma. *Artists' Materials: Which, Why a How*. London: A & C Black, 1992.

Philips, Lisa. *The American Century: Art & Cultu 1950–2000*. New York: Whitney Museum o American Art in association with W.W. Norton, 1999.

Pliny, *Natural History*, Books 35 & 36. Translat by H. Rackham and D.E. Eichlolz. Cambridge Massachusetts: Harvard University Press, 1963.

Polcari, Stephen. *Abstract Expressionism and th Modern Experience*. Cambridge and New York: Cambridge University Press, 1991.

Protter, Eric (ed.). *Painters on Painting*, reprint New York: Dover, 1997.

Rewald, Sabine. *Balthus*. New York: Harry N. Abrams, 1984.

Rice, Danielle. "Encaustic Painting," in *The Dictionary of Art*, Volume 10. New York: Grove, 1996.

Seitz, William C. *Abstract-Expressionist Painting America: An Interpretation Based on the Wo and Thought of Six Key Figures*. Cambridge, Massachusetts: Harvard University Press, 1983.

Seymour, Pip. *The Artist's Handbook: A Comple Professional Guide to Materials and Techniques*. London: Arcturus, 2003.

Spivey, Nigel. *Etruscan Art*. London and New York: Thames and Hudson, 1997.

Stavitsky, Gail. *Waxing Poetic: Encaustic Art in America*. Montclair, New Jersey: Montclair Museum, 1999.

Sultan, Altoon. *The Luminous Brush: Painting with Egg Tempera*. New York: Watson-Gup 1999.

Thompson, Jr., Daniel V. *The Materials and Techniques of Medieval Painting*, reprint. N York: Dover, 1956.

———. *The Practice of Tempera Painting, Materials & Methods*. New York: Dover, 19

Tuchman, Maurice. *The Spiritual in Art: Abstra Painting 1890–1985*. New York: Abbeville Press, 1986.

Walker, Susan. *Ancient Faces: Mummy Portrai from Roman Egypt*. New York: Metropolita Museum of Art, 2000.

Wehlte, Kurt. *The Materials and Techniques of Painting*. Translated by Ursus Dix. New Yor van Nostrand Reinhold, 1975.

Weiss, Jeffrey. *Mark Rothko*. New Haven, Connecticut and London: Yale University Press, 1998.

Websites

Acrylic Painting:
www.goldenpaints.com/justpaint

Art in Context: www.artincontext.org

ArtCyclopedia: www.artcyclopedia.com

ArtLex art dictionary: www.artlex.com

Metropolitan Museum of Art, Timeline of Art History: www.metmuseum.org/toah.splash.htm

Museum of Modern Art, New York: www.moma.org

San Francisco Museum of Modern Art, Makin Sense of Modern Art: www.sfmoma.org

Web Museum, Paris: www.ibiblio.org

Whitney Museum of American Art, New York: www.whitney.org/learning

ger, John. *Selected Essays and Articles: The
of Things*. Harmondsworth and New York:
uin, 1972, p. 165.

hman, Maurice. *The Spiritual in Art: Abstract
ng 1890–1985*. New York: Abbeville Press,
1986, p. 240.

nnini, Cennino. *The Craftsman's Handbook:
talian "Il Libro dell'Arte."* Translated by
el V. Thompson, Jr. New York: Dover, 1960,
, 3.

ton, Thomas. *New Seeds of Contemplation*.
n: Shambhala, 2003, p. 219.

mmelman, Michael. *The Accidental
erpiece: On the Art of Life and Vice Versa*.
York: The Penguin Press, 2005, p. 162.

[6] Protter, Eric (ed.). *Painters on Painting*. New
York: Dover, 1997, p. 24.

[7] Lee, Janie C. *Claes Oldenburg Drawings in the
Whitney Museum of American Art*. New York:
Whitney Museum of American Art in association
with Harry N. Abrams, 2002, p. 18.

[8] *Giorgio Morandi*. 1961.

[9] Berger, John. *The Sense of Sight*. New York:
Pantheon Books, 1985, p. 206.

[10] Redon, Odilon. *À Soi-même: Journal
(1867–1916): notes sur la vie, l'art et les artistes*.
Paris: Conti, 1961, p. 128.

[11] Protter, Eric (ed.). *Painters on Painting*. New
York: Dover, 1997, p. 84.

[12] Berger, John. *The Sense of Sight*. New York:
Pantheon Books, 1985, p. 217.

[13] Berger, John. *The Sense of Sight*. New York:
Pantheon Books, 1985, p. 214.

[14] Protter, Eric (ed.). *Painters on Painting*. New
York: Dover, 1997, p. 177.

[15] Yau, John. *Forest Bess*. New York: Hirschl &
Adler, 1988.

[16] Haskell, Barbara. *Agnes Martin*. New York:
Whitney Museum of American Art in association
with Harry N. Abrams, 1992, p. 109.

[17] "Looking Long and Hard at Morandi," *New
York Times*, October 14, 2004.

[18] De Antonio, Emile, and Mitch Tuchman.
Painters Painting. New York: Abbeville Press,
1984, p. 97.

[19] Green, Jane, and Leah Levy (eds.). *Jay DeFeo
and "The Rose."* New York: Whitney Museum of
American Art, 2003.

ety Guidelines

e made some suggestions within the
ters, and this section should be read as well.
would like to recommend reading *Artist
re* by Michael McCann (New York, 2001),
h is an excellent resource book covering all
cts of safety in the studio, including care,
ling, and disposal of materials, the use of
us protective equipment, and the possible
ical hazards of gases, vapors, dusts, and
es.

o maintain safety in the studio, general
edures in brief include:

o not eat, drink, or smoke while using artists'
erials, and do not use a kitchen or a
room as a studio.

ash your hands, tools, and supplies after
g artists' materials.

ead the labels on all artists' materials.

ever use artists' materials on your skin, for
preparation, or other uses for which they
e not intended.

eep your studio clean and as free of dust as
ible. Wet mop your studio to pick up dust.

ear a dust mask that has been approved for
s and mists while handling pigments, soft
els, and powdered graphite.

Vhen handling toxic pigments, such as lead
e, you will need to wear a respirator. The
rs must be changed often.

All pigments are potential irritants in dry
form. Pigments labeled *toxic* can have fatal
effects. Pigments incorporated into a binder can
be safely used. As soon as you remove pigment
from the container, douse with a bit of distilled
water from a pipette before mixing with a
binder, unless you will be making encaustic paint
or oil paint. For encaustic, you can combine the
pigment with beeswax, melt it immediately, and
then let it cool. You can keep the paint in this
form indefinitely. For oil paint, you can douse
with a bit of oxgall (a wetting agent) or oil if you
plan to grind the pigment and oil immediately.

• Pigments in dry pastel form remain dusty, so
toxic pigments should not be used in dry pastels.

• Highly toxic pigments should be not be used in
dry form at all.

• When you purchase dry pigments that are in
bags, put them into jars immediately for safe
use. Opening and closing a jar does not cause the
pigments to become airborne as readily as
opening a bag does.

• When transferring any art material to a
container, transfer the label or make a new label
to indicate the material.

• Keep artists' materials that have not been
tested for use by children out of their reach.

• Do not use artists' materials that have not

been tested and determined to be nontoxic on
items intended for children.

• Do not use artists' materials that have not
been determined to be nontoxic if you are
pregnant.

Avoid skin contact with highly toxic materials
such as lead white or vermilion paint and
pigment. These pigments and paints can be
absorbed through the skin.

• Wear latex surgical gloves.

• Use barrier cream. Use a water-based one for
oil media and an oil-based one for water media.

• Wear rubber gloves when cleaning up the
studio, tools, and brushes.

• Always work in a well ventilated studio.

• While painting with encaustic or using
beeswax for other techniques, do not let it smoke
at all. The smoke is toxic.

• Fixatives are toxic. Use all fixatives outside.

I have recommended the use of mineral spirit
instead of turpentine for the oil painting method
in this book. It is regarded as being less toxic than
turpentine. Both are toxic if inhaled and both can
be absorbed through the skin. Do not let either
touch your skin. If you need to remove oil paint
or other material from you skin, wash your skin
with a cleanser.

ure Credits

Purchase with funds from Philip Morris, Inc. 81.15. Photograph by Gamma One Conversions. Courtesy Nolan/Eckman Gallery, New York. **47**: BM. **48**: J. Paul Getty Museum, Los Angeles 84.GG.919. **50**: BM/ Alinari, Florence. **51**: Pierpont Morgan Library, New York. Mrs. Landon K. Thorne Collection. **53** (top): WMAA. Purchase with funds from the Wilfred P. and Rose J. Cohen Purchase Fund and the Richard and Dorothy Rodgers Purchase Fund 92.20. Photograph by Jerry L. Thompson. **53** (bottom): © Frank Piatek, Photo: James Prinz. Courtesy Roy Boyd Gallery, Chicago. **55**: WMAA. Purchase with funds from Peggy and Richard Danziger 78.55. Photograph by Geoffrey Clements.

CHAPTER THREE

58: Museum Boijmans van Beuningen, Rotterdam. **59**: J. Paul Getty Museum, Los Angeles 85.GB.218 verso. **60** (top): Collection of the artist, Lisbon, Portugal. **60** (bottom): Hilma af Klint Foundation, Sweden. **61**: © 2007 Banco de México Diego Rivera & Frida Kahlo Museums Trust. Av. Cinco de Mayo No. 2, Col. Centro, Del. Cuauhtémoc 06059, México D.F. **63**: Collection of the artist. **66** (top): WMAA. Gift of Howard and Jean Lipman 81.23.1. Photograph by Sheldan C. Collins. © ARS, NY, and DACS, London 2007. **66** (bottom): WMAA. Purchase with funds from the Lily Auchincloss Foundation, Vivian Horan, The List Purchase Fund, the Neysa McMein Purchase Award, Mr. and Mrs. William A. Marsteller, the Richard and Dorothy Rodgers Fund, and the Drawing Committee 83.34. Photograph by Sheldan Collins. **68**: WMAA. Purchase with funds from The Lauder Foundation – Leonard and Evelyn Lauder Fund, Gilbert and Ann Maurer, and the Drawing Committee. Photograph by Geoffrey Clements 85.52. © ARS, NY, and DACS, London 2007. **70**: WMAA. Purchase with funds from the Mr. and Mrs. M. Anthony Fisher Purchase Fund 82.19. Photograph by Sheldan C. Collins. Courtesy Cheim & Read. **72** (bottom left): Musée Rodin, Paris. **73** (bottom): Sterling and Francine Clark Art Institute, Williamstown, Massachusetts 1955.1716. **74** (bottom): Louvre, Paris/Bridgeman Art Library. **75** (top): WMAA. Purchase, with funds from The Lauder Foundation — Evelyn and Leonard Lauder Fund 99.51. Photograph by Sheldan Collins. © Claes Oldenburg. **75** (bottom): MMA. Robert Lehman Collection, 1975 1975.1.704. Photograph © 1990 The Metropolitan Museum of Art. **76** (top): WMAA. Purchase with funds from the Drawing Committee 83.42. Photograph by Sheldan Collins. Courtesy Betty Cunningham Gallery, NY. **76** (bottom): Gift of the Ian Woodner Family Collection. 273.2000. © 2006 Digital image, The Museum of Modern Art, New York/Scala Florence. **77** (bottom): WMAA. Gift of Sergio Stella 82.7. Photograph by Sheldan Collins. **78** (left): WMAA. Purchase with funds from the Neysa McMein Purchase Award 65.42. Photograph by Geoffrey Clements. © Ellsworth Kelly. **78** (right): WMAA. Fiftieth Anniversary Gift of Edith and Lloyd Goodrich in honor of Juliana Force 82.48. Photograph by Gamma One Conversions. © ARS, NY, and DACS, London 2007. **79** (left): BM. **79** (right): Collection of the author. **80** (top): National Gallery, London. Presented by the National Art Collections Fund following a public appeal 1962. **81**: © 1990. Photo Scala, Florence. **85** (top): WMAA. Purchase with funds from the Contemporary Committee 2001.228. Image courtesy of Sikkema Jenkins & Co. Courtesy David McKee Gallery, New York. **85** (bottom): WMAA. Purchase with funds from the Mr. and Mrs. Isidore M. Cohen Purchase Fund 85.73. Photograph by Sheldan Collins. © DACS, London/VAGA, New York 2007.

CHAPTER FOUR

88 (top): Bayerische Staatsgemaldesammlungen, Collection Modern Art at the Pinakothek der Moderne Münich and Kunstdia–Archiiv ARTOTHEK, Weilheim, Germany. **88** (bottom): © 1990. Photo Scala, Florence – courtesy of the Ministero Beni e Att. Culturali. **89**: Lillie P. Bliss Collection. © 2006 Digital image, The Museum of Modern Art, New York/Scala, Florence. **90** (top): WMAA. Purchase with funds from Susan Morse Hilles in honor of John I.H. Baur 74.72. Photograph by Robert E. Mates. © The Estate of Joan Mitchell. **90** (bottom): Staatliche Museen, Berlin. Bildarchiv Preussischer Kulturbesitz, Berlin. **91**: © Tate 2007, London. © ADAGP, Paris, and DACS, London. **92** (top): WMAA. Purchase. Photograph by Sheldan Collins. **92** (bottom): Ny Carlsberg Glyptotek, Copenhagen. **93** (top): © 1990. Photo Scala, Florence. **93** (bottom): © 1990. Photo Scala, Florence – courtesy Ministero Beni e Att. Culturali. **94** (left and right): © Studio Fotografico Quattrone, Florence. **95**: © 1994. Photo Scala, Florence. **96, 97** (left): © Photo Josse, Paris. **97** (right): Courtesy of Davis & Langdale Company, New York. **98**: Courtesy of Hirsch & Adler Modern, New York. **99**: WMAA. Gift of the Eli Broad Family Foundation and purchase with funds from the Painting and Sculpture

Committee 94.67. Photograph by D. James Dee. Courtesy Ronald Feldman Fine Arts, New York. **103**: WMAA. Purchase 73.36a–b. Photograph by Jerry L. Thompson. **104** (bottom): WMAA. Purchase 54.34. Photograph by Sheldan Collins. © The Joseph and Anni Albers Foundation/VG Bild–Kunst, Bonn, and DACS, London 2007. **105** (top): MMA. Purchase, Rogers Fund and The Kevorkian Foundation Gift, 1955, 55.121.10.5 obv. Photograph © 1980 The Metropolitan Museum of Art. **107** (top): WMAA. Purchase with funds from the Friends of the Whitney Museum of American Art 69.31. Photograph by Geoffrey Clements. © Clyfford Still estate. **107** (bottom): Collection Emily Fischer Landau, New York. Fischer Landau Center for Art FL 166. © ARS, NY, and DACS, London 2007. **109** (top): Private Collection/ Christie's Images/Bridgeman Art Library. **109** (bottom): MMA. Purchase, Mrs. Samuel P. Reed Gift, Morris K. Jesup Fund, Maria DeWitt Jesup Fund, John Osgood and Elizabeth Amis Cameron Blanchard Memorial Fund, and Gifts of Robert E. Tod and William Gedney Bunce, by exchange, 1985 1985.117. Photograph © 1996 The Metropolitan Museum of Art.

CHAPTER FIVE

112: WMAA. Lawrence H. Bloedel Bequest 77.1.16. Photograph by Sheldan Collins. **113**: Arthur M. Sackler Museum, Harvard University Art Museum, Cambridge 1995.78. **114** (top): Albertina, Vienna. **114** (bottom): © Tate 2007, London. **115**: Private Collection, Bologna. © DACS 2007. **130** (bottom): Lillie P. Bliss Collection. 9.1934.a. © 2006 Digital image, The Museum of Modern Art, New York/Scala, Florence. **131**: WMAA. Purchase with funds from the Friends of the Whitney Museum of American Art and Charles Simon 68.16. Photograph by Sheldan Collins. **132**: WMAA. Gift of Norman Dubrow 81.28.1. Photograph by Sheldan Collins. Courtesy Gallery Paul Anglim, San Francisco. **134** (bottom right): Photograph by Jerry L. Thompson. **135** (bottom): WMAA. Lawrence H. Bloedel Bequest 77.1.17. Photograph by Sheldan Collins. **136** (top): WMAA. Exchange 50.2. Photograph by Steven Sloman. **136** (bottom): WMAA. Purchase with funds from The Lauder Foundation – Leonard and Evelyn Lauder Fund, Gilbert and Ann Maurer, and the Drawing Committee. Photograph by Geoffrey Clements 94.69 © ARS, NY, and DACS, London 2007. **137**: WMAA. Purchase with funds from Beth Rudin DeWoody and Joanne Leonhardt Cassullo 2005.186. Photograph by Sheldan Collins. © Amy Cutler, Courtesy Leslie Tonkonow Artworks + Projects, New York.

CHAPTER SIX

141 (top): WMAA. Fiftieth Anniversary Gift of the Gilman Foundation Inc., The Lauder Foundation, A. Alfred Taubman, Laura–Lee Whittier Woods, and purchase 80.32. Photograph by Geoffrey Clements. © DACS, London/VAGA, New York 2007. **141** (bottom left): WMAA. Gift of the Artist 90.9. Photograph by Sheldan C. Collins. © DACS, London/VAGA, New York 2007. **141** (right): Württembergisches Landesmuseum, Stuttgart. **146**: BM. **150**: Antikensammlung, Münich. **151** (top): Collection of the Artist. Photograph by Jerry L. Thompson. **151** (bottom left): WMAA. Gift of Dr. Lawrence Werther 91.88.1. Photograph by Geoffrey Clements © DACS, London/VAGA, New York 2007. **151** (right): WMAA. Gift of the American Contemporary Art Foundation Inc., Leonard A. Lauder, President 2002.275. Photograph by Jerry L. Thompson. © DACS, London/VAGA, New York 2007. **154**: © Joan Nelson. Courtesy Robert Miller Gallery, New York. **155**: Solomon R. Guggenheim Museum, New York. Purchase with funds contributed by Sidney Singer, 1976, 77.2288. © ARS, NY, and DACS, London 2007.

CHAPTER SEVEN

159: National Gallery, London. Bought with a contribution from the National Art Collections Fund, 1944. **167, 180**: J. Paul Getty Museum, Los Angeles 82.PB.72 & 85.PA.24. **169** (top), **171** (bottom): © 1990. Photo Scala, Florence – courtesy of the Ministero Beni e Att. Culturali. **172** (top left and right): © 1990. Photo Opera Metropolitana Siena/Scala, Florence. **172** (bottom left and right): WMAA. Gift of Mr. and Mrs. Roy R. Neuberger 51.19. Photograph by Geoffrey Clements. © ARS, NY, and DACS, London 2007. **173**: Courtesy of the Artist. **174** (left): Musée National d'art moderne. Centre Georges Pompidou, Paris. Bridgeman Art Library/ Peter Willi. © ADAGP, Paris, and DACS, London 2007. **174** (right), **178** (top), **181, 183**: Photograph by Jerry L. Thompson. **178** (bottom): Munch Museum, Oslo, Norway. © 1990. Photo Scala, Florence. © ADAGP, Paris, and DACS, London 2007.

CHAPTER EIGHT

186 (top left): © 1992. Photo Scala, Florence. **186** (right), **187** (bottom), **188** (left and right), **195** () © 1990. Photo Scala, Florence. **186** (bottom), **208** and bottom): © 1990. Photo Scala, Florence – cour of the Ministero Beni e Att. Culturali. **187** (top), **189** and right), **190, 202**: © Studio Fotografico Quattro Florence. **191**: WMAA. Gift of Faith Golding 99.33.1. Photograph by Geoffrey Clements. © ARS, NY, and D London 2007. **192** (top): © 2007 Banco de Mexico Rivera & Frida Kahlo Musuems Trust. Av. Cinco de M No 2, Col. Centro, Del. Cuauhtemoc 06059, Mexico **192** (bottom): Commissioned by the Trustees of Dartmouth College, Hanover, New Hampshire.© D/ 2007. **195** (top right): Church of Sant'Agostino, Emp Italy. **195** (top right): Church of Santissimi Apostoli, Florence. **195** (bottom left): © 2001. Photo Scala, Florence. **196**: Courtesy of the Artist. **207**: © Vince Pirozzi, Rome fotopirozzi@inwind.it.

CHAPTER NINE

213 (top): © 1990. Photo Scala, Florence. **213** (bott left): National Gallery of Art, Washington, D.C. Ailsa Mellon Bruce Fund 1967.6.1a obv. Image © 2006 Bo Trustees, National Gallery of Art, Washington. **213** (bottom center): MMA. Bequest of Benjamin Altm 1913, 14.40.626-27. Photograph © 1981 The Metrop Museum of Art. **213** (bottom right): Louvre, Paris. © Photo Josse, Paris. **214**: National Gallery of Art, Washington, D.C. Samuel H. Kress Collection 1939.1. Image © 2006 Board of Trustees, National Gallery o Washington. **221**: Kunsthistorisches Museum, Vienna/Bridgeman Art Library. **224**: Courtesy of the Pennsylvania Academy of Fine Arts, Philadelphia. He Gilpin Fund 1938.2. **227, 228** (center left): © Studio Fotografico Quattrone, Florence. **228** (top): MMA. R Lehman Collection.1975, 1975.1.148. Photograph © 1 The Metropolitan Museum of Art. **228** (center right): MMA. George A. Hearn Fund, 1915, 15.32. Photograp © 1989 The Metropolitan Museum of Art. **228** (botto Tate © 2007, London. **229** (top left) WMAA, New Yor Purchase 52.8. Photograph by Sheldan Collins. **229** WMAA. Purchase. Photograph by Sheldan Collins. **22** (bottom left): WMAA. Gift of Susan Morse Hilles 74.2 Photograph by Robert E. Mates. © ARS, NY, and DAC London 2007. **229** (right): WMAA. Gift of the Americ Contemporary Art Foundation Inc., Leonard A. Laude President 2002.261. Photograph by Jerry L. Thompsc © Kate Rothko Prizel & Christopher Rothko ARS, NY, DACS, London 2007. **230** (top): WMAA. Purchase wi funds from the Contemporary Committee 2003.306 **230** (center): WMAA. Purchase with funds from the Drawing Committee and Kathleen and Richard S. Ful 2000.114. Photograph by Sheldan C. Collins. © ARS, and DACS, London 2007. **230** (bottom): WMAA. Purc with funds from the Friends of the Whitney Museum American Art 57.10. Photograph by Steven Sloman. © ARS, NY, and DACS, London 2007. **231** (bottom): © Paul M.R. Maeyaert. **231** (top right): WMAA. Purc with funds from the Friends of the Whitney Museum American Art 60.63. Photograph by Sheldan Collins. © The Willem de Kooning Foundation, New York/ AR NY, and DACS, London 2007. **231** (bottom): WMAA. Purchase with funds from an anonymous donor 59.2 Photograph by Robert E. Mates. Courtesy David Berg Gallery, San Francisco. **232**: Photograph by Jerry L. Thompson. **233** (left): © 1996. Photo Scala, Florence **233** (right): Private Collection. Photo Neil Greentree.

CHAPTER TEN

236: Courtesy of Mary Ryan Gallery, New York. **237**: McKenzie Fine Art, New York. Photograph by D. James Dee. **239** (left): WMAA. Purchase with funds Mrs. Robert M. Benjamin 69.102. Photograph Geoffr Clements. **239** (right): WMAA. Purchase with funds the Larry Aldrich Foundation Fund 69.45. Photograp Geoffrey Clements. **244**: Paul Kasmin Gallery, New Y **246** (top): The Dennis and Debra Scholl Collection, Miami. Courtesy The Project, New York and Los Ange **246** (bottom): WMAA. Purchase with funds from the Drawing Committee 2006.45. Photograph by Sheld Collins. **247**: WMAA. Purchase with funds from Dani Benton 2002.279. Photograph by Jerry L. Thompson © ARS, NY, and DACS, London 2007.

Every effort has been made to contact the copyright holders, but should there be any errors or omissions would be pleased to insert the appropriate acknowledgment in any subsequent edition of this publication.

 Laurence King Publishing have paid DACS' vis creators for the use of their artistic works